Masters of Venice

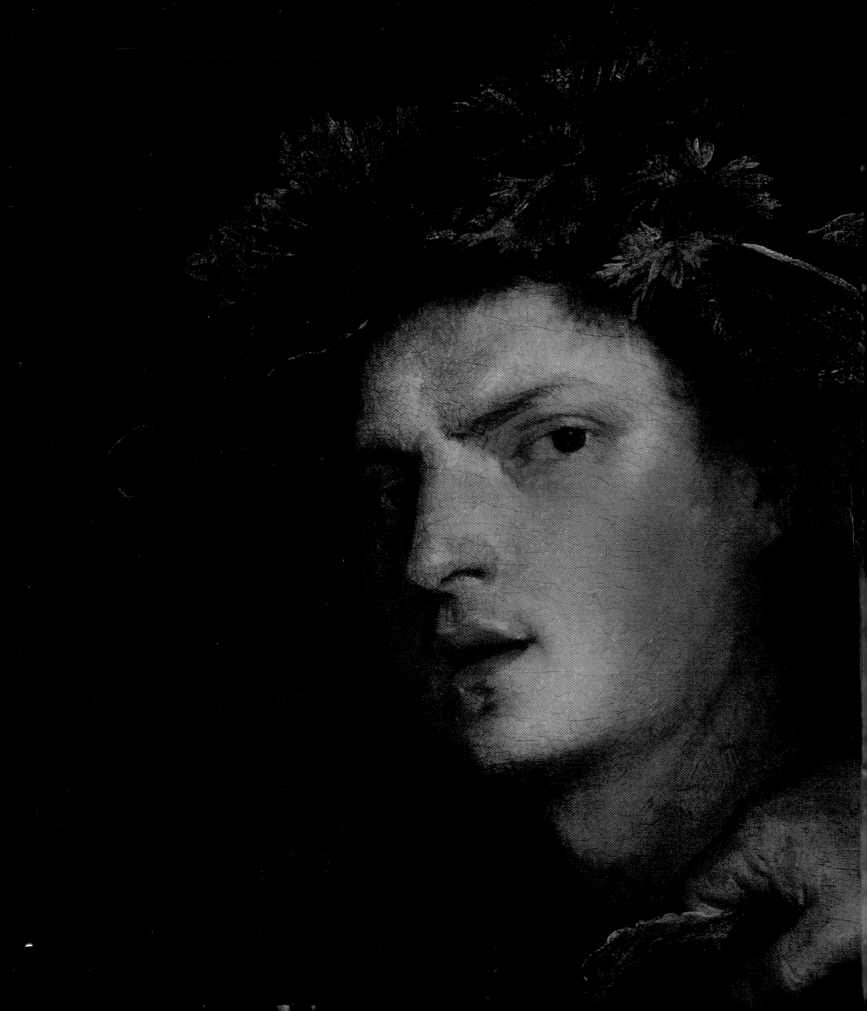

Masters of Venice

RENAISSANCE PAINTERS OF PASSION AND POWER

FROM THE KUNSTHISTORISCHES MUSEUM, VIENNA

EDITED BY SYLVIA FERINO-PAGDEN AND LYNN FEDERLE ORR

FINE ARTS MUSEUMS OF SAN FRANCISCO

DELMONICO BOOKS • PRESTEL
MUNICH LONDON NEW YORK

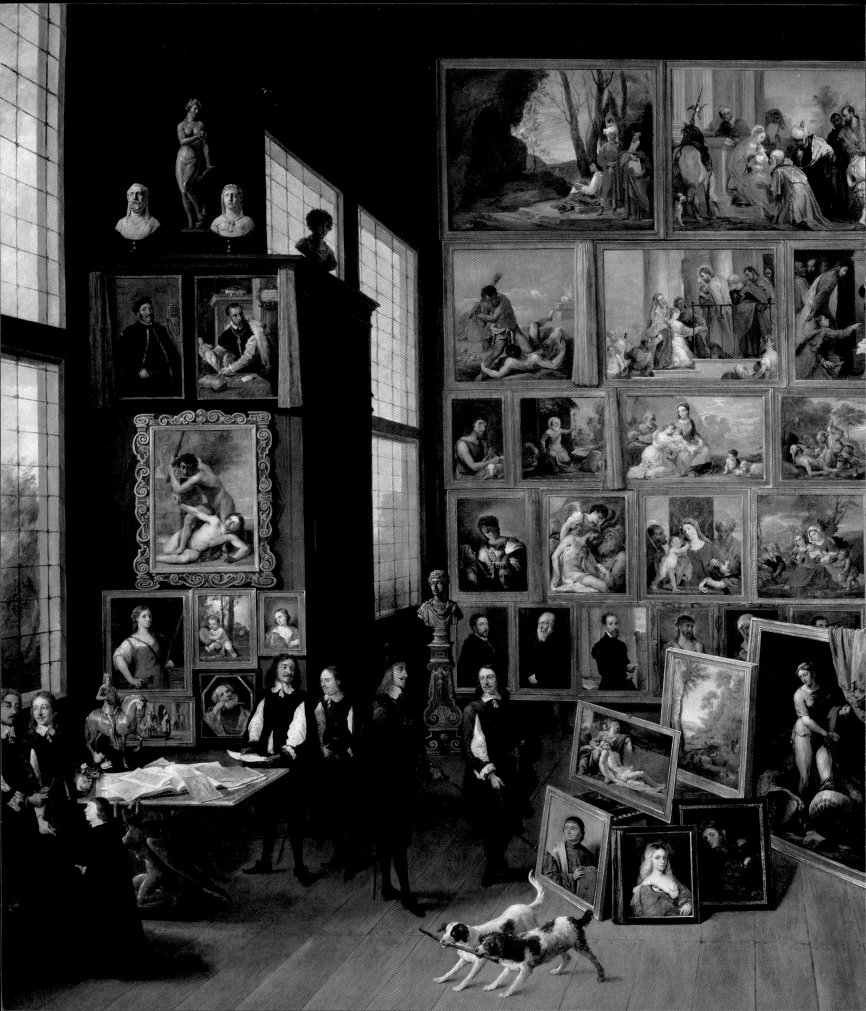

Contents

Foreword

IN AN UNPRECEDENTED GLOBAL PARTNERSHIP, THE FINE ARTS MUSEUMS OF SAN FRANCISCO AND THE Kunsthistorisches Museum, Vienna, are proud to present *Masters of Venice: Renaissance Painters of Passion and Power*, an exhibition of Venetian masterpieces that were once part of the extraordinary collection of the royal Habsburg family. One of the world's four great imperial museums, along with the Hermitage in Saint Petersburg, the Louvre in Paris, and the Prado in Madrid, the Kunsthistorisches has been a mecca for art connoisseurs since its founding in the nineteenth century. When the Fine Arts Museums learned that the collection of Venetian paintings would be deinstalled temporarily to make way for a special exhibition, we moved rapidly to seize this once-in-a-lifetime opportunity to introduce such exquisite and canonical artworks to American audiences. Many of these paintings have been unseen on these shores until now.

Featuring fifty masterworks by artists of true genius, *Masters of Venice* is the first Italian-focused exhibition mounted by the Fine Arts Museums since *Treasures from the Basilica of Saint Francis of Assisi* (1999–2000). Yet the institution has collected Italian art throughout its history, and in 1938 the Museums' Legion of Honor hosted the landmark *Venetian Painting from the Fifteenth Century through the Eighteenth Century*, the first major exhibition of Venetian Renaissance painting to be staged in America. It is fitting that this new presentation showcasing Venetian taste, cultivated in and inspired by the opulence of Venice itself, should be unveiled exclusively at the de Young in San Francisco, a modern seaside city whose inhabitants are equally susceptible to the sensual delights of the natural environment.

The painters of Renaissance Venice translated a revolutionary appreciation for the beauty of nature into a mode of artistic representation that took full advantage of the poetic potential of rich atmospheric effects and lustrous color. And it is indeed an exceptional experience to confront the singular achievements of Venetian painting through the world-renowned holdings of the Gemäldegalerie (Picture Gallery) of the Kunsthistorisches Museum. As recounted in the introduction to this catalogue, the Habsburgs' collection of Italian paintings took shape during the sixteenth and seventeenth centuries through the strategic acquisitions of Emperor Maximilian II, Emperor Rudolf II, and Archduke Leopold Wilhelm. Among the spectacular artworks that form its core are Mantegna's tortured *Saint Sebastian*, Titian's mysterious *Bravo (The Assassin)* and sumptuous *Danaë*, and a rare group of paintings by the enigmatic Giorgione, including *Portrait of a Young Woman (Laura)* and *The Three Philosophers*. The Kunsthistorisches also owns exemplary works by Tintoretto, Veronese, Palma Vecchio, Bordone, and Bassano, among others, revealing the full range of Venetian accomplishment in the Renaissance era.

It has been both a privilege and a pleasure for our institutions to collaborate on this unique undertaking. First and foremost we thank Sylvia Ferino-Pagden, director of the Gemäldegalerie, for her wise and collegial partnership on the exhibition and catalogue. In Vienna, Francesca Del Torre Scheuch, Davide Dossi, Petra Fischer, Verena Hofer, Ilse Jung, Elke Oberthaler, Michael Odlozil, Emily Schwedersky, Ina Slama, Agnes Stilfried, Ágnes Szökrön, and Stefan Zeisler also made invaluable contributions to the project. In San Francisco, we are grateful to all of the staff who helped make the presentation a reality, most particularly Lynn Federle Orr, the Museums' curator in charge of European art. Thanks are also due to Nadia Alaee, Steve Brindmore, Krista Brugnara, Melissa Buron, Therese Chen, Julian Cox, Stuart Hata, Bill Huggins, Juliana Pennington, Sheila Pressley, and Bill White for their efforts on behalf of the project. For their work on this catalogue, overseen by Karen Levine and Leslie Dutcher at the Fine Arts Museums, we thank the contributing authors, our trade copublishing partner Mary DelMonico and her colleagues at Prestel, designer Katy Homans, editor Jennifer Boynton, and translator Chris De Angelis.

This extraordinary presentation would not have been possible without the generous sponsorship that enabled us to bring these precious masterpieces to San Francisco. We extend special thanks to our major patrons, Penny and James George Coulter and the San Francisco Auxiliary of the Fine Arts Museums; exhibition patrons Athena and Timothy Blackburn and the William G. Irwin Charity Foundation; and sponsors T. Robert and Katherine Burke, the Samuel H. Kress Foundation, Mrs. James K. McWilliams, and Greta R. Pofcher. We are grateful to Wells Fargo and the S. D. Bechtel, Jr. Foundation for underwriting education programs presented in conjunction with the exhibition. *Masters of Venice* is also supported by an indemnity from the Federal Council on the Arts and the Humanities.

John E. Buchanan, Jr.
Director of Museums
Fine Arts Museums of San Francisco

Sabine Haag
General Director
Kunsthistorisches Museum, Vienna

Introduction:
Venetian Renaissance Paintings
at the Kunsthistorisches Museum

SYLVIA FERINO-PAGDEN

The wealth of the collections in Vienna's Kunsthistorisches Museum—which today includes paintings and decorative arts as well as armor, Greco-Roman and Egyptian antiquities, coins, and musical instruments—represents only part of the rich holdings assembled by the imperial house of Habsburg. Under a succession of rulers invested with the title of Holy Roman Emperor and through the assumption of power in Spain, the Habsburg domain grew to dominate much of Europe between the thirteenth and eighteenth centuries. The Habsburgs' famous manuscripts are now in the Österreichische Nationalbibliothek (Austrian National Library), their drawings and prints are in the Graphische Sammlung of the Albertina, and their collections of natural objects are in the Naturhistorisches Museum (Museum of Natural History) and Museum für Völkerkunde (Museum of Ethnology).

Over the centuries, as the imperial collections grew, they were moved several times and housed in different buildings. They were finally installed in two new museums—the Kunsthistorisches Museum and the Naturhistorisches Museum—built in Vienna at the behest of Emperor Franz Joseph I and designed by architects Karl von Hasenauer and Gottfried von Semper. The Viennese museums are part of a group of important public buildings that adorn a grand boulevard known as the Ringstrasse, which had been constructed along the route of the old city walls. All of these structures—the university, City Hall, Parliament, the former Imperial Theater, and the Opera House—were built in the "Ringstrasse style," which was marked by a historicist attitude toward the past. Each building was designed in the manner that seemed to express or represent its purpose most clearly: the theaters and

Fig. 1
The grand staircase of the Kunsthistorisches Museum, Vienna

Fig. 2
The facade of the Kunsthistorisches Museum, Vienna

museums feature a kind of Neo-Renaissance style, Parliament was built in the vernacular of classical Greek architecture, and City Hall is Neo-Gothic. The Kunsthistorisches Museum (fig. 2) and the Naturhistorisches Museum, which are of the same size and style, face each other across a wide square, not unlike the de Young Museum and the California Academy of Sciences in San Francisco's Golden Gate Park. In 1891 the Kunsthistorisches was formally opened by the emperor. The sumptuous interior decoration (fig. 1) comprises marble and stucco lustro as well as wall paintings by various artists, among them Julius Victor Berger, Mihály Munkácsy, Hans Makart, and the young Gustav Klimt.

By the early nineteenth century, the imperial holdings had attained a definitive and rather idiosyncratic character as a large princely private collection. Other public museums, such as London's National Gallery or Berlin's Gemäldegalerie, acquired most of their paintings in the nineteenth century. The Kunsthistorisches in Vienna, however, reflects the tastes of Habsburg collectors from previous centuries as well as the dynasty's political alliances. German and Flemish painting forms the core of Vienna's Gemäldegalerie, or Picture Gallery, but Italian painting is also extremely important. It was only at the beginning of the nineteenth century that the Italian trecento and quattrocento became vastly popular; today they occupy pride of place at London's National Gallery, Washington's National Gallery of Art, New York's Metropolitan Museum of Art, and Berlin's Gemäldegalerie. Yet works from these periods barely register at the Kunsthistorisches, with the exception of the fabulous paintings by Andrea Mantegna that are included in this exhibition (pls. 1–3). Apart from a few isolated works, the Habsburgs' collection of Italian art begins with sixteenth-century painters. Similarly, the dearth of French and English works, the relatively small number of Dutch paintings, and the great numbers of portraits compared to narrative, mythological, religious, or allegorical paintings reflect the dynasty's territorial dominions and its political ties to the other ruling families of Europe.

In the sixteenth century, Emperor Maximilian II was particularly interested in art: he not only summoned the Milanese artist Giuseppe Arcimboldo to his court in Vienna but also negotiated for paintings by Titian in Venice. However, Maximilian's son, Emperor Rudolf II, was the first great Habsburg collector. A patron of both the arts and the sciences, he acquired celebrated paintings by Parmigianino and Correggio, Titian's *Danaë* (pl. 23), and a series of the twelve months by Bassano (see fig. 16). But it was in the mid-seventeenth century that the wheel of fortune turned for princely collecting.

Around the mid-1600s, largely because of dramatic political events in Europe, many famous art collections were dispersed, only to come together again in new places with new owners. In 1647–1648, at the end of the Thirty Years' War (a violent conflict between Catholics and Protestants), Prague was sacked and plundered by Sweden. As a result, much of Emperor Rudolf II's collection was transferred to Protestant Stockholm. Soon thereafter, the Italian paintings were taken from Sweden to Rome by the former Queen Christina, who had abdicated the Swedish throne to practice Catholicism.

Fig. 3
Tiziano Vecellio, called Titian (ca. 1488–1576)
Ecce Homo, 1543
Oil on canvas
95¼ x 142⅛ in. (242 x 361 cm)
Gemäldegalerie of the Kunsthistorisches
Museum, Vienna

The Italian paintings from Rudolf's collection were ultimately sold in Rome in 1689. Another famous collection that came onto the market belonged to the Gonzaga family. That collection had been honed over centuries by famous art lovers such as Isabella d'Este and her husband, Francesco Gonzaga; their son Federico; and all of their illustrious descendants down to Vincenzo II Gonzaga. It was he who, between 1627 and 1629, finally had to sell to King Charles I of England. However, during the English Civil War, Oliver Cromwell overthrew the British monarchy. The king was executed in 1649, and his precious art collection was dispersed through the famous Commonwealth Sale. In fact, numerous British aristocrats were forced to auction their collections on the European mainland. It is the collections of George Villiers, the first Duke of Buckingham, and James, the third Marquess (later Duke) of Hamilton, that constitute the nucleus of the paintings at the Kunsthistorisches.

The most important collector of Venetian paintings among the Austrian line of the Habsburg

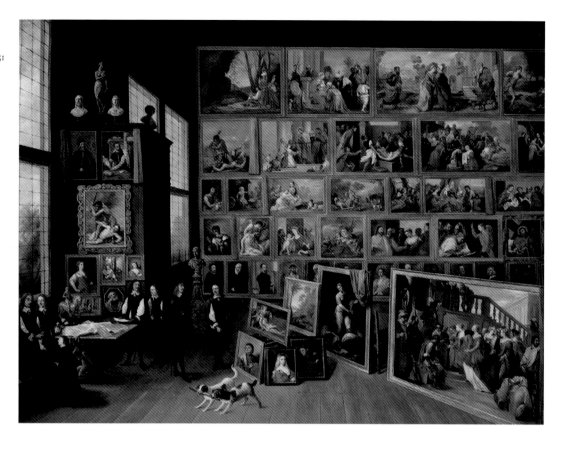

dynasty was Archduke Leopold Wilhelm, the youngest son of Emperor Ferdinand II. An inventory of the archduke's art collection, compiled in 1659, contains 517 Italian paintings; 800 Dutch and German paintings; 542 sculptures, small bronzes, and other works, some of which can be identified as objects in the Kunstkammer of the Kunsthistorisches; and 343 drawings, some now in the Graphische Sammlung of the Albertina. The archduke's famous collection of tapestries and religious objects, as well as his library, underscores the remarkable breadth of his interests. While still in Austria, he sent agents to scout for important works in Rome, Naples, Venice, and Madrid. In fact, according to the seventeenth-century Venetian author Carlo Ridolfi, the archduke already had a Bellini Madonna in his collection.

At the apex of a complex ecclesiastical, political, and military career, Leopold Wilhelm served as governor of the Netherlands from 1647 to 1656. The time and place of his governorship proved particularly providential for his bent for collecting. Upon arriving in Brussels, the archduke started acquiring both early and contemporary masterpieces by Flemish and Dutch painters for himself and for his brother, Emperor Ferdinand III. When, due to the civil war in England, the Buckingham and Hamilton collections began arriving in Amsterdam and Antwerp to be sold, Leopold Wilhelm realized that this was a once-in-a-lifetime opportunity. At the Buckingham auction of 1650, he bought for the emperor's

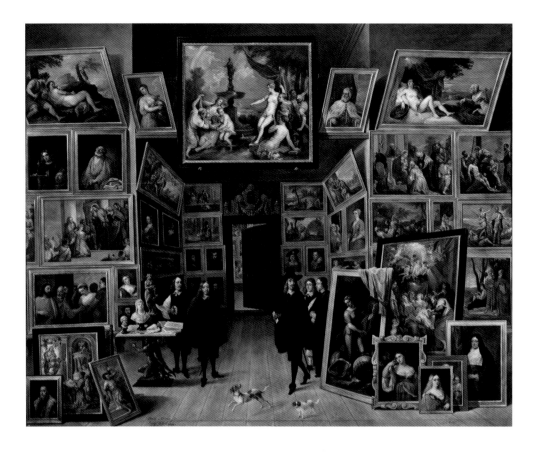

Fig. 5
David Teniers the Younger (1610–1690)
Archduke Leopold Wilhelm in His Gallery in Brussels,
1647–1651
Oil on canvas
41¼ x 51⅜ in. (104.8 x 130.4 cm)
Museo Nacional del Prado, Madrid

collection paintings by great names and of a grand scale, mainly to replace artworks lost in Sweden's sack of Prague. Among those acquisitions were Titian's *Ecce Homo* (fig. 3); Veronese's *Anointing of David* (pl. 46), which has been newly restored for the San Francisco exhibition; Tintoretto's panels showing scenes from the Old Testament; and Bassano's *Hercules and Omphale*. For his own pleasure, Leopold Wilhelm acquired the Hamilton collection, including Giorgione's *Portrait of a Young Woman (Laura)* (pl. 6) and *The Three Philosophers* (pl. 7) as well as Titian's *Gypsy Madonna* and *The Bravo (The Assassin)* (pl. 21). Venetian painting was heavily represented in both collections, and many of these paintings remain touchstones at the Kunsthistorisches today. Though it seems that Leopold Wilhelm did not participate directly in the Commonwealth Sale, possibly as a sign of respect for a reigning house that had fallen, some of the works in the archduke's collection did indeed come from the holdings of Charles I, including, for example, Titian's *Lucretia and Her Husband, Lucius Tarquinius Collatinus* (pl. 20), *Woman in a Fur Coat*, and perhaps even *Portrait of Isabella d'Este, Marchioness of Mantua* (pl. 10), along with works by other Italian artists. These paintings were most probably purchased from dealers or offered to Leopold Wilhelm through intermediaries.

Among the most famous Italian paintings acquired from the Hamilton collection were Raphael's *Saint Margaret* and seventeenth-century works by Guido Reni, Domenico Fetti, and Valentin de Boulogne. The Venetian paintings included canvases by the sixteenth-century masters Bellini,

Giorgione, Titian, Palma Vecchio, Lotto, Savoldo, Pordenone, Bassano, Tintoretto, Veronese, and Palma Giovane, many of which are included in the present exhibition. Paintings by Titian and other Venetians were particularly cherished by the Spanish and Austrian lines of the Habsburg dynasty after Emperor Charles V had elected Titian as his preferred portrait painter and conferred on him the Order of the Golden Spur.

In 1967 the art historian Klára Garas published, among a number of inventories of the Hamilton collection, a very interesting list that was compiled in French and probably dates to 1649. In it, many works listed under the correct names in the earlier Hamilton inventories were reattributed to Titian and Giorgione to make the holdings more appealing for a Habsburg collector.

Leopold Wilhelm himself provided the most effective visual documentation of the burgeoning Habsburg collection. To satisfy his pride as collector, the archduke had himself portrayed in his galleries on more than one occasion by his Flemish court painter, David Teniers the Younger. In each of these famous "painted galleries," which Leopold Wilhelm gifted to various relatives, he made sure to include a selection of canvases that would surprise those for whom the scenes were intended. In the picture made for his brother Ferdinand III and Ferdinand's wife, Eleonora Gonzaga, at the court in Vienna, Leopold Wilhelm is shown surrounded by the vast collection of Italian paintings (fig. 4). For his cousin King Philip IV of Spain, Leopold Wilhelm put Titian's mythological *poesie* on provocative display (fig. 5), and he may have suggested the inclusion of other works possibly bought by his predecessors, such as *Diana and Callisto*.

Another instrument used by the archduke to publicize his magnificent new collection was a catalogue in book form featuring an etched illustration of each work: the *Theatrum pictorium*, or Theater of Painting, published in 1660 (fig. 6). This exceedingly original endeavor, also undertaken by Teniers, was begun with a focus on the most cherished part of the collection, the Venetian and Italian paintings. The circumstances for the book's production were far from ideal, given the archduke's surprising departure from Brussels with a large part of the collection in 1656. Teniers, however, had had the foresight to create very small copies of all of the paintings, and these served as models for prints made by artists such as Lucas Vorsterman, Nikolaus van Hoy, Jan van Troyen, and Peter van Lisebetten. Yet the engravings are by no means accurate reproductions of the original works, and they often show drastic changes of format. It is understandable that Charles Patin, the famous seventeenth-century French physician and collector, considered them "copies that deform the originals and alter the most beautiful things in the world: all one sees are the mistakes of the artist, and none of the excellence of these grand ideas." The *Theatrum pictorium* is nonetheless a valuable historical resource: it helps identify works that were later given away, removed, or stolen from the imperial collection. Importantly, it also offers a glimpse of how the paintings were displayed in Vienna, on the upper floor of the Stallburg.

Given the limitations of visual documentation at that time, we are lucky that Archduke

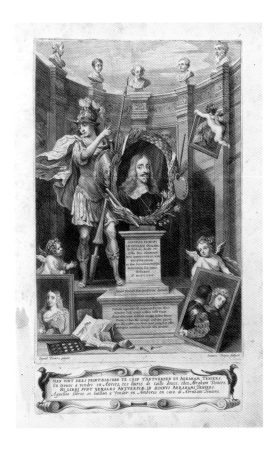

Leopold Wilhelm also commissioned a written inventory of his collection—a 1659 document that remains an important resource for evaluating attributions. In some cases, the authorship of particular paintings changed from one inventory to the next. The artists' names differ not only from those listed in the inventories of the Venetian merchant-collector Bartolomeo della Nave, which date from little more than twenty years earlier, but also from those in the various Hamilton inventories, drawn up between 1641 and 1649, and in the *Theatrum pictorium*.

The full story of the odysseys made by the Habsburg artworks emerged only in 1952, when Sir Ellis Waterhouse published sales lists documenting the paintings in the Hamilton collection that had come from various Venetian collections. At last the provenance of the paintings could be traced back to their city of origin, to the collections of della Nave; to the aristocratic Priuli family; and to the Belgian painter, collector, and merchant Nicolas Regnier. In Waterhouse's opinion, the Kunsthistorisches' paintings are among the best documented in the world. And, indeed, the history of the collection reflects the exquisite taste of some of Europe's greatest acquisitors. Today, Vienna's grand Picture Gallery maintains the character of a privileged royal collection, presenting splendid examples of the schools of European painting that greatly appealed to its imperial owners. Among the museum's most celebrated holdings are the fifty sixteenth-century Venetian masterpieces included in this exhibition, many traveling to America for the very first time.

Masters of Venice

SYLVIA FERINO-PAGDEN

When he first saw Venetian painting, the Flemish artist Peter Paul Rubens is said to have exclaimed, "Here is true painting!" The French Impressionist Paul Cézanne believed that "what we call painting was invented by the Venetians." The art addressed by both masters, hundreds of years apart, is without a doubt that of sixteenth-century Venice, produced by the very artists represented in this exhibition: Giorgione, Titian, Tintoretto, Veronese, Bassano. Each formulated and expressed himself in his own artistic language, but their cumulative contributions revolutionized painting for centuries to come.

Some argue that artistic creations owe their qualities to the specific context in which they come into existence, and this is certainly true of Venetian painting. Venice itself, hovering surreally between heaven and water, may well be one of the largest works of art ever created by human hands. From the elements of water and air, and from all of their resulting climatic manifestations—the clouds and rain, the red of dusk and dawn, the fog and haze—the city appears like a subtly colored yet vivid dream, and it has seduced every first-time visitor since the Middle Ages.

HISTORY, POLITICS, AND RELIGION

Venice is one of the very few Italian cities that cannot claim ancient Roman origins. During the fifth and sixth centuries, when the Huns and Lombards invaded from the north, the mainland population retreated, settling the area of the Venetian lagoon and learning how to explore and control the land and the sea. Over the course of the centuries, as subjects of the Byzantine Empire and under the rule of a dux (later doge), they strove for independence and developed a distinctive form of government. In the late thirteenth century, participation in politics and the right to vote were limited to noblemen, initially to those from eight hundred families and, in the sixteenth century, extended to two thousand families. The patrician law of inheritance allowed aristocrats over the age of twenty-five to hold office but did not permit dynastic succession: councils, officials, and even the doge were elected by the aristocracy. Below the nobility were the *cittadini*, or citizens. The third and largest group was the *popolani*, who were the craftsmen, traders, and servants to the aristocracy.

Although this class structure was intended to prevent social mobility, Venetian *cittadini* could gain considerable power and influence through membership in the large, socially oriented brotherhoods known as the Scuole Grandi. Prominently involved in state ceremonies, the Scuole Grandi offered both status and prestige to their members, and they were important patrons of art, architecture, and music. Only a *cittadino* could hold the position of Cancelliere Grande (or grand chancellor),

Fig. 7
Giovanni Bellini, *Young Woman at Her Toilette*, 1515
(detail of fig. 13)

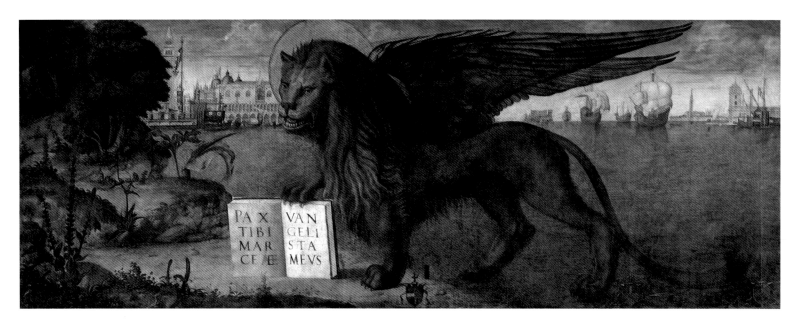

Fig. 8
Vittore Carpaccio (ca. 1460–ca. 1526)
The Lion of Saint Mark, 1516
Tempera on canvas
51⅛ x 144⅞ in. (130 x 368 cm)
Palazzo Ducale, Venice

one of the highest offices in the Venetian state, and many other chancellery positions were likewise restricted to citizens. This arrangement created a large number of potential commissioners of paintings for public and private spaces, and it partly explains the unique blossoming of Venetian Renaissance painting.

The strong ties between Venetian politics and religion can be easily demonstrated by the fact that the Basilica di San Marco, the burial place of the patron saint and the largest building in the city, was also the chapel of the Palazzo Ducale (or doge's palace), which was annexed directly behind it. As early as 829, the remains of Saint Mark had been stolen from Alexandria and brought to Venice, and they played a crucial role in Venice's struggle to gain religious independence from the sees of Aquileia and Grado.

The well-preserved interiors of the Palazzo Ducale still exemplify the primary themes of public art commissions in La Serenissima—the glorification of the power and might of the maritime republic—even though most of the building was reconstructed after the devastating fire of 1577. A series of paintings shows successive doges being presented to the Virgin, Christ, or the Trinity; in later depictions, it seems as though the Madonna is being presented to the kneeling doge. The representations may appear profoundly different at first glance, but the underlying themes remain sovereignty and strength. San Marco became the state church of Venice, and the figures of Saint Mark and his winged lion the symbols of the Venetian Republic and its religious legitimation (see fig. 8). The state's concept of *civitas* as God's will was thus imposed on all classes of society, and the commissioned paintings were intended to transfigure these merely political claims into an apotheosis under the cover of mythology. In Veronese's ceiling panel in the Palazzo Ducale's Sala del Maggior Consiglio (fig. 9),

Fig. 9
Paolo Caliari, called Veronese (1528–1588)
Triumph of Venice, ca. 1579–1582
Oil on canvas
355⅞ x 228⅜ in. (904 x 580 cm)
Sala del Maggior Consiglio, Palazzo
Ducale, Venice

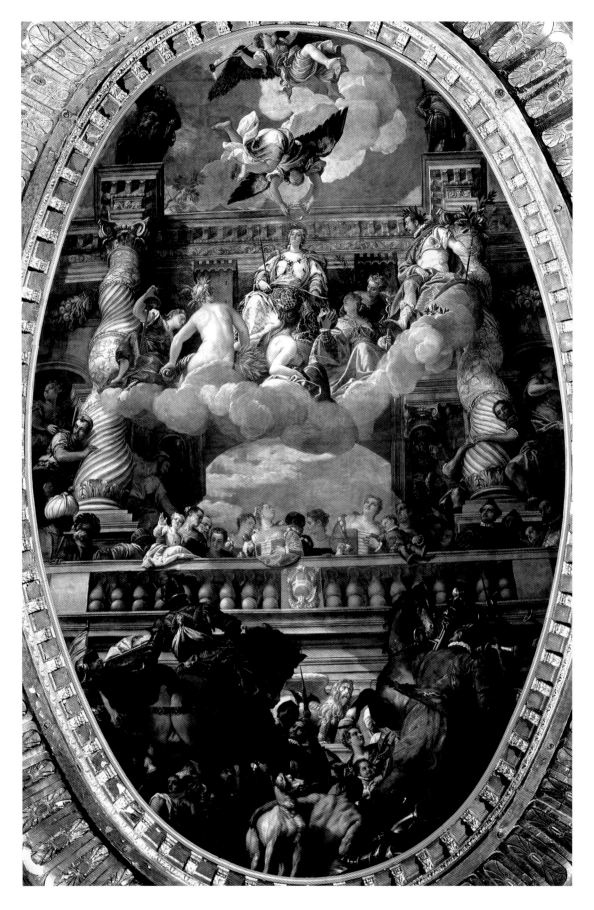

executed between 1579 and 1582, the personification of Venice consecrates the existence of the state to the Divine, suggesting, as pointed out by art historian Eduard Hüttinger, that "eternity and temporality, religion and politics, the world and the overworld, are all united in one."

The brilliant self-projection of the maritime republic was also reaffirmed through magnificent celebrations. Numerous processions, parades, plays, and gatherings were held in honor of the saints of the Scuole Grandi, as the city constantly reminded its citizens of the importance of La Serenissima. On Ascension Day, for example, the *sposalizio del mare* (marriage of the sea), a ceremony with both naval and religious significance, was observed with great pomp. Venetian painters created their own forms of expression to depict such ceremonies, and nowhere else can be found such broad narrative cycles as those by Vittore Carpaccio, Tintoretto, and Veronese, all the way to Guardi in the eighteenth century.

The Republic of Venice was the world's most multicultural city in the sixteenth century: Jews, Muslims, Greeks, Germans, and other northern Europeans lived there and helped to strengthen international trade. Exotic goods—including jewels, textiles, and pigments sought by artists across Europe—came to Venice from the Far East. In fact, painters such as Titian had explicit orders to record especially unusual animals from overseas. Venice's architecture and art incorporated all of these international and multicultural stimuli, synthesizing them into a singular, inimitable aesthetic style.

The city's diversity found expression in its literature. Publishing houses had been established in Venice by the early fifteenth century, and works by the celebrated authors of antiquity as well as contemporary writers were published in various languages. Aldus Manutius was one of the most famous publishers, and his series of often small, lightweight booklets, called Aldine, soon became indispensable to the educated man. In Titian's *Portrait of Benedetto Varchi* (pl. 11), the Italian humanist holds one such volume in his right hand. Venetians debated texts hot off the presses; the literature not only stimulated erudite discussion but also inspired contemporary scholars to produce their own writings. This literary activity naturally found a way into the visual arts, leading to those extraordinarily poetic pictorial creations, the myths and allegories.

FAMILY WORKSHOPS IN COMPETITION

Venice's long history of supporting and nurturing prominent local and resident artists, especially painters, owes its success to a variety of circumstances, including the rather conservative form of government that promoted family enterprises. Venice, more than other cities, teemed with workshops in which several generations of painters produced outstanding works. The fifteenth and sixteenth centuries had brothers Antonio and Bartolomeo Vivarini and Antonio's son, Alvise; Jacopo Bellini and his sons Gentile and Giovanni; brothers Francesco and Tiziano (known as Titian) Vecellio, Titian's son

Orazio, and their cousins Marco and Cesare; and Jacopo Robusti (called Tintoretto) and his children Domenico, Marco, and Marietta. Paolo Caliari (called Veronese) worked with his sons Gabriele and Carlo, and Jacopo da Ponte (known as Bassano) had workshops with his sons Francesco, Leandro, Giambattista, and Gerolamo in Venice and Bassano. In the seventeenth century and beyond, the Riccis, Tiepolos, Guardis, and Canalettos upheld the tradition of family workshops. Knowledge and tools were passed from one generation to the next, profitably continuing the tradition of each atelier.

In addition to the longevity of the family workshops, the Venetian artists themselves, with a few notable exceptions, lived well into old age: many were over seventy, some over eighty, and a few lived even longer. (In a 1571 letter written by Titian to his patron King Philip II of Spain, he claimed to be nearly a hundred years old. He was, in fact, in his eighties at the time, and it is speculated that the artist falsified his age to appear more pathetic to the king, who owed him money.) Drawing on

Fig. 11
Jacopo Robusti, called Tintoretto (1519–1594)
Saint Roch in Glory, 1564
Oil on canvas
94½ x 141¾ in. (240 x 360 cm)
Sala dell'Albergo, Scuola Grande di San
Rocco, Venice

their experience, these older artists were able to formulate mature forms of expression. The city also preferred elderly leaders in positions of power, based on the belief that they would preserve and maintain tradition, and this is confirmed by the remarkable number of portraits of aged officials of the republic: doges (see fig. 10), Camerlenghi (financial magistrates), procurators, and lawyers.

Furthermore, the city's relatively small size meant that Venetian painters, as well as painters from elsewhere working in Venice, knew one another personally: perhaps as master and pupil, as fellow disciples, as friends, as rivals, or maybe even as sworn enemies. Frequently they shared the same clients; often they worked closely together, trying to surpass one another in inventiveness, or borrowing particularly effective motifs. The exhibition *Titian, Tintoretto, Veronese: Rivals in Renaissance Venice* (2009–2010) highlighted the competitiveness among artists in the second half of the sixteenth century, but the rivalries in Venice had already existed much earlier than that.

Most commissions for public artworks were awarded by special committees; they tended to include as many workshops as possible, which is evident in the remaining decorations of the Palazzo Ducale and other official buildings. After the fire in the Fondaco dei Tedeschi, the headquarters of the

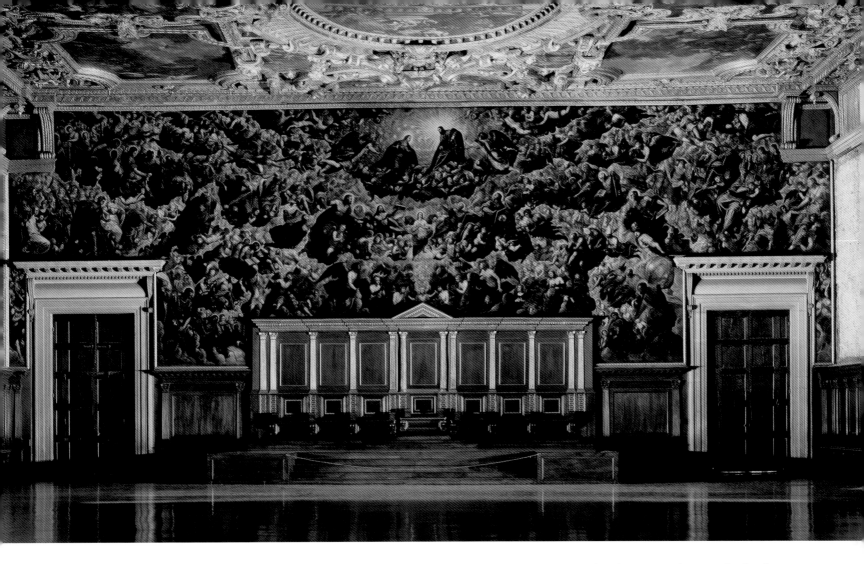

Fig. 12
Jacopo Robusti, called Tintoretto (1519–1594),
and Domenico Tintoretto (1560–1635)
Paradise, 1588–1592
Oil on canvas
275⅝ x 866⅛ in. (700 x 2200 cm)
Sala del Maggior Consiglio, Palazzo
Ducale, Venice

German merchants near the Ponte di Rialto, Giorgione was hired in 1507 to decorate the façade on the Grand Canal, while Titian was charged with the decoration of the façade above the entrance from the street. According to Ludovico Dolce's entry in his *Dialogo della pittura* (Dialogue on painting) of 1557, Titian's *Judith* was praised as being Giorgione's best work, to Giorgione's deep disappointment. Unfortunately, very little of *Judith*, or indeed of any of the two masters' frescoes, has survived in Venetian collections.

When, in 1564, the members of the Scuola Grande di San Rocco asked Giuseppe Salviati, Federico Zuccaro, Veronese, and Tintoretto, among other artists, to present sketches for *Saint Roch in Glory*, events took an unexpected turn. Tintoretto had, in fact, already secretly placed his finished painting in its intended position on the ceiling of the Sala dell'Albergo (fig. 11). Tintoretto had planned to give the painting to the scuola had he not won the competition, well aware that they were not allowed to refuse donations; in the end, he secured a monopoly on commissions from the school for several decades.

The competition for the decoration of the Sala del Maggior Consiglio in the Palazzo Ducale was equally important. After the fire of 1577, Guariento's fourteenth-century *Coronation of the Virgin* was

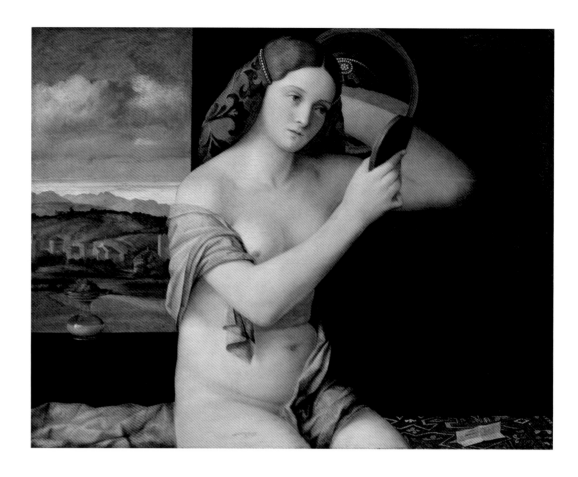

badly damaged and needed to be replaced. Artists such as Tintoretto, Veronese, Zuccaro, Palma Giovane, and Francesco Bassano presented sketches and models to the committee in 1582. The commissioners selected artists of opposing temperaments, Veronese and Bassano, but they apparently never began work on the project. It was only after Veronese's death in 1588 that Tintoretto presented a new proposal and, with the help of his son Domenico, completed the largest painting ever realized on canvas (fig. 12).

THE ARTISTS

The most significant painter of the Venetian cinquecento, and indeed the man who laid the ground-work for the stylistic innovations described here, was Giovanni Bellini. A year before his death in 1516, he painted *Young Woman at Her Toilette* (figs. 7, 13), proving that even as an old man he could create won-derfully poetic works. Rendering the viewer a voyeur, the elegant, lyrical nude, dreamily observing her-self in a mirror, set a new standard for secular painting.

Bellini's superb pictorial language was enriched by contemporary studies of ancient figural sculpture, which also proved fascinating for his brother-in-law, Andrea Mantegna. The three Mantegna works in this exhibition document the artist's homage to antiquity in different yet related

Fig. 14
Antonello da Messina (ca. 1430–1479)
The Virgin and Child with Saints Nicholas of Bari, Anastasia, Ursula, and Dominic (Sacra Conversazione), 1475–1476
Oil on panel
45¼ x 52⅝ in. (115 x 133.6 cm)
Gemäldegalerie of the Kunsthistorisches Museum, Vienna

ways: as proper marble reliefs in the grisailles (pls. 2–3), and as living sculpture in *Saint Sebastian* (pl. 1). Mantegna's passion for classical art was rooted in his desire to understand and reconstruct its physical forms and rules; in this, he anticipated Raphael, Giulio Romano, and other artists who strove to revive ancient ideals of the human body and its postures, gestures, and movements.

Artists in Florence and Rome, however, were far more interested in this purely formal reception of antiquity. More relevant for Bellini and later Venetian painters was the fifteenth-century Sicilian artist Antonello da Messina, who had been profoundly influenced by early Netherlandish oil painting. For the altarpiece of San Cassiano in Venice, fragments of which are now at the Kunsthistorisches in Vienna (fig. 14), Antonello painted a *sacra conversazione*, not as a polyptych but on a single panel, a form that was immediately adopted by the Venetians. Antonello also used oil rather than tempera to bind his pigments. Although Bellini did not use oil exclusively, he achieved greater luminosity, improved transparency, and a new chromatic harmony in his subtle experiments with the medium. Artists from other regions, including Perugino, followed suit.

Bellini influenced a great number of first-generation artists of the cinquecento, and he set in motion the innovations that are the hallmarks of Venetian painting to this day. Inert figures, still noticeable in Bellini's work, were replaced by energetic forms and faces that express emotions. Using specific lighting techniques, artists imbued the landscape with mood and atmosphere, making more dramatic narratives possible. Color became an important expressive tool, as did the increasingly visible brushstrokes.

The entire oeuvre of the highly inventive Giorgione, who died in his thirties of the plague, falls into the first decade of the sixteenth century. Much of Giorgione's imagery remains a mystery, his figures poetically enigmatic and often melancholy. The softened contours in Giorgione's paintings give the impression of a gentle haziness, as if his figures exist in an Arcadia of the distant past. Sebastiano del Piombo developed a rich use of color, but his passion for the monumental forms of Florentine and Roman painting unfolded long before he moved to Rome in 1511. Titian, from the beginning of his career and with the greatest *sprezzatura* (nonchalance), created beautiful, vibrant figures that possess a natural nobility and intensity, and he used them to construct dramatic narratives as well as poetic allegories and religious themes of glorification and deepest grief. His technical brilliance was limitless and resulted in tremendously influential aesthetic innovations. His work was sought after by emperors and popes, and he enjoyed an international career that made him the most important painter in Venice, and possibly the greatest painter ever.

At the beginning of the cinquecento in Venice and on the mainland, there were still artists devoted to the more traditional manner of painting, including Cima da Conegliano, Marco Basaiti, and Vincenzo Catena. Exceptional among this younger generation, although not represented in this exhibition, was the Venice-born Lorenzo Lotto. Oriented more toward a northern style of painting

Fig. 15
Lorenzo Lotto (ca. 1480–1556)
The Virgin and Child with Saints Catherine and James the Greater (Sacra Conversazione), 1527–1533
Oil on canvas
45⅞ x 59⅞ in. (116.5 x 152 cm)
Gemäldegalerie of the Kunsthistorisches Museum, Vienna

than his contemporaries, Lotto created exceptionally personal works that were partly hyperrealistic and partly lyric-poetic (see fig. 15). He worked mostly outside Venice, in Bergamo and surrounding areas, and later in a province of east-central Italy called the Marches (Le Marche). Palma Vecchio came to Venice from Bergamo and, alongside Titian, created the most successful paintings of the second decade of the cinquecento. Younger artists such as Paris Paschalinus Bordone and Bonifazio de' Pitati extended the legacy of their masters through their own work.

The work of artists outside Venice often stimulated debate about artistic methods and philosophies, especially when they visited the city. Although Leonardo da Vinci was in Venice only briefly in 1500, his paintings, and his views on painting, certainly found resonance in Giorgione's work. Albrecht Dürer was in Venice in 1494 and again in 1505, and his work must have especially impressed Lotto. Other artists spent short periods in Venice throughout the cinquecento: Fra Bartolommeo visited in 1508; Michelangelo in 1529; Francesco Salviati in 1539; and Giorgio Vasari in 1541–1542. After living and working in both Florence and Rome, sculptor Jacopo Sansovino moved to Venice in 1527.

The new generation of Venetian artists began to achieve success around the middle of the sixteenth century. They either moved to the city from the mainland—Jacopo da Ponte was originally from Bassano, and Paolo Caliari from Verona—or they were born in Venice, as was Tintoretto. Titian,

the city's grand master, who had become the patriarch of Venetian painting, found his most fierce competitor in the latter.

Today, Tintoretto is considered one of the major Venetian exponents of the *maniera*, the style then popular in Florence and central Italy. Tintoretto admired both Michelangelo and ancient sculpture, and it is possible that the artist possessed a cast of the famous marble bust thought to be of the emperor Vitellius, from the Grimani collection. His preparatory method involved drawing foreshortened figures in squared grid patterns, and the figure of Susanna in *Susanna and the Elders* (pl. 39) was transferred to canvas using just such a grid structure. Initially, Tintoretto employed perspective to distort the pictorial space. He further dramatized his compositions by giving his figures, alone and in bustling crowds, a range of exaggerated movements and postures while highlighting the scene through an expressive use of chiaroscuro and lighting effects. He gradually decreased his use of these stylistic techniques; the visionary, perspectiveless landscapes of the final phase of the Scuola Grande di San Rocco paintings, for example, are deeply moving and profoundly personal.

In contrast, Veronese's paintings demonstrate a great sensitivity for narrative, and they shine with lightness and grace. The artist's compositions and figures are perfectly drawn and he uses audacious color combinations, juxtaposing contrasting tones for an overall result that is a stunning feast for the eyes. In fact, one painting, *The Feast in the House of Levi* (Gallerie dell'Accademia, Venice), drew notice from the Inquisition, which considered its epic opulence and raucous, celebratory atmosphere to be heresy.

Unlike Veronese, Bassano proved to have a preference for nature and rural subjects. An extremely talented artist, he experimented with all genres of painting, finding success with his bucolic depictions of peasants and animals. Venice at the time was finding the sea trade to be increasingly competitive, and many noblemen focused less on their ships and more on their estates on the mainland, where they produced crops that previously had been imported. The Bassano family's popular paintings glorified agricultural work and the daily activities of rural life for the decoration of patrician villas (see fig. 16).

THEORETICAL DISCOURSE ON COLOR

Today, color is recognized as the defining element of Venetian painting, from the radiant medieval Byzantine gold mosaics in the Basilica di San Marco to the brilliant eighteenth-century works of Venetian masters Giambattista Tiepolo and Giovanni Battista Piazzetta. But the triumph of color in Venetian painting occurred in the sixteenth century with Giorgione, Titian, Veronese, and Tintoretto. They ingeniously re-created the distinctive Venetian light, rendering atmospheric phenomena such as fog or mist as well as textures such as skin or velvet in a way that seems almost tangible. The artists

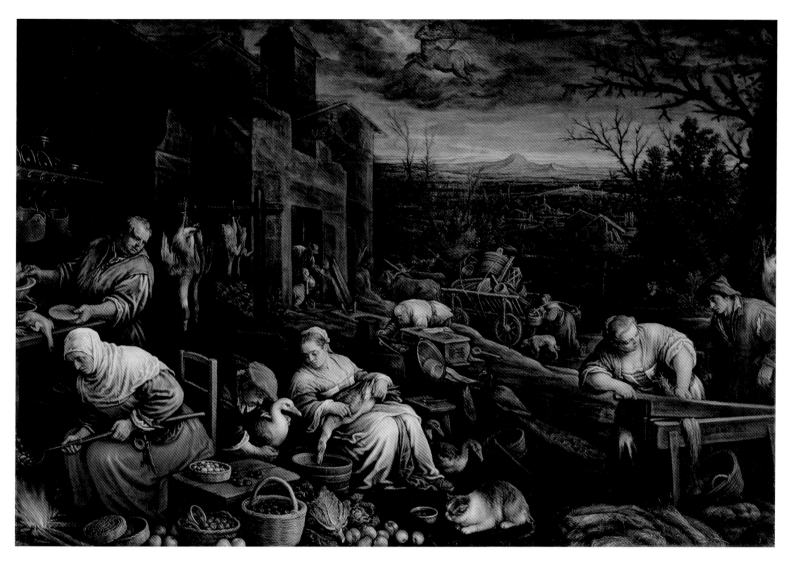

used bright pigments, and they aspired to achieve a chromatic harmony that would not detract from the intensity of individual hues.

Precious pigments were much sought after and, as a center of world trade, Venice could provide painters across Europe with the best materials, which would then be exported farther north, especially to Germany. If an artist used rare, imported minerals such as realgar and orpiment, for example, which were coveted for their rich, bright red and yellow tones, it further heightened the perceived value of the painting.

Eventually Venetian painting, with its brilliant color (*colore*), was competing against overall compositional balance (*disegno*) in the *paragone*, an aesthetic debate instigated by art theoreticians around the mid-sixteenth century. Vasari censured the Venetian works for their lack of *disegno*, while critics Paolo Pino and Ludovico Dolce noted the absence of intense *colore* in the works of Michelangelo and

other Florentine painters. *Disegno*, in determining form, was defined as the predominant intellectual element, and therefore masculine; *colore* was defined as the sensual element, and therefore feminine. This rather bizarre (from a present-day perspective) assessment and separation of painterly "elements" was effectively abolished by the sixteenth-century Venetian painters, who increasingly drew visible lines with their color-soaked brushes. These open, visible brushstrokes can be found in Titian's work of the 1540s and soon thereafter in Tintoretto's. Both Titian and Veronese attained the highest luminosity and intensity from their use of color, leaving *disegno* in the background and obtaining a force of expression that was liberated from the constraints of mere representation.

Artists also changed the method of preparation for their compositions, moving away from the neatly executed drawing on paper that they then transferred to the canvas or panel. Instead they used a more experimental form, in which the arrangement of the composition was revised and improved during the process of painting; today, the evolution of a composition can be revealed by x-radiography or infrared reflectography. While valuable information was gained through technical analyses of Giorgione's works, the most striking results were obtained from Titian's paintings: Titian's eagerness to experiment, the almost step-by-step development of his ideas, and his masterful control of the artwork-in-progress are much in evidence.

PAINTINGS FOR THE FAMILY PALAZZO

With a few exceptions, the works in this exhibition were commissioned directly from the artists by noblemen or distinguished citizens for private enjoyment, and indeed most of the works represent the power and the passions of Venetian nobility: religious works for reverence and spiritual edification, to offset the worldliness of secular endeavors; portraits of both men and women, to immortalize the individuals' official positions as well as their noble lineage; and historical, mythical, allegorical, or poetic works, for intellectual stimulation.

The Christian religion played a central role in the lives of the faithful, and there was a great demand for religious paintings during the Renaissance. During the fifteenth century, artists were called on to produce altarpieces for churches, great narrative cycles for the scuole, and private devotional paintings. Painters such as Giorgione, Titian, and Sebastiano del Piombo used novel approaches for these traditional religious subjects, varying the architecture or landscape in the background and experimenting with the forms of interaction that took place between the figures themselves or between the figures and the viewer. In his *Madonna of Ca' Pesaro* in the Basilica di Santa Maria Gloriosa dei Frari (fig. 17), realized between 1519 and 1526, Titian shifted the Virgin on her throne from the center to the right of the composition, while the figures relate to one another through animated gestures. The lighting and contrasting colors enhance the spiritual focus of the painting and intensify its effect on the

Fig. 17
Tiziano Vecellio, called Titian (ca. 1488–1576)
Madonna of Ca' Pesaro, 1519–1526
Oil on canvas
192⅛ x 105⅞ in. (488 x 269 cm)
Basilica di Santa Maria Gloriosa dei Frari, Venice

viewer. Titian's dynamic innovations in the composition of his altarpieces—from the *Assumption of the Virgin* (also in the Frari) to the *Madonna of Ca' Pesaro* to his *Death of Saint Peter Martyr* (for the Basilica dei Santi Giovanni e Paolo; the work was destroyed in 1867)—were embraced by painters of successive generations and constantly adapted and updated.

Patrons commissioned large-format religious works for a palazzo's reception hall or *portego*, the large, salonlike space connecting reception areas to the back of the house, and small-format works for the studiolo or the bedchamber. The small *Christ with the Cross* (pl. 28), attributed to Giovanni Antonio Sacchis (called Pordenone), for example, looks beyond the viewer. He does not express suffering, nor does he expect compassion; his gaze is almost haughty, as though challenging us. Pordenone's Christ acts as a temporal reminder of mankind's guilt and responsibility for his fate. In contrast, *Christ with the Globe* (pl. 17), from the workshop of Titian, falls within the tradition of Christ as the Salvator Mundi, or Savior of the World, and is a much more reassuring portrayal. Representations of individual saints such as Magdalene and Jerome were considered especially suitable subjects for the decoration of a study or library, although Tintoretto's large-format version of Jerome (pl. 42) may have been intended for a palazzo's spacious entrance hall or reception room. For private devotion, patrons preferred scenes from the Old and New Testaments and the lives of the saints, although artists now abandoned traditional, static arrangements in favor of more animated compositions set in secularized surroundings: Veronese's *Anointing of David* (pl. 46), for example, has all the trappings of a magnificent Venetian celebration, and Tintoretto's *Susanna*, enraptured by her naked reflection in the mirror, seems more appropriate for the genre of myth and allegory.

PORTRAITS

The wide range of activities accessible only to men, as well as the concept of the ideal man, found expression in the rich variety of male portraiture: from a Venetian civil servant to the doge himself, men were shown in romanticized depictions of the lover, the warrior, the scholar, and the elegant courtier.

A very small number of portraits can be unequivocally attributed to Giorgione. His paintings suggest that the artist preferred capturing abstract or ambiguous moods rather than creating realistic portraiture. Through his depictions of a pensive *Warrior* (pl. 5) and a sensitive and poetic *Youth with an Arrow* (pl. 8), Giorgione wanted to rise to Leonardo's challenge that artists should capture the soul of man in their paintings. At the same time, Giorgione and his peers were confronted with a more practical technical challenge: depicting men in armor, which included reproducing the effects of reflected light on shiny metal. In the first decade of the cinquecento, Venice was under attack from enemies on both land and sea; defending the republic was a serious matter for every Venetian, and the theme of the warrior had become very relevant. Great commanders and captains preferred having their

portraits painted while wearing armor, which was not only the most splendid fashion for men of the time but also accentuated their vitality and virility. A suit of armor was also extremely expensive, and it could cost as much as a private jet would today. In Tintoretto's two portraits of naval commanders, the men are resplendent in their glistening metal and stand proudly before views of the sea: Sebastiano Venier, victorious at the battle of Lepanto (pl. 41), seen in the background; and an unnamed thirty-year-old man (whose age is indicated on the column base), probably with the ship under his command, richly decked with flags (pl. 37).

The vast majority of portraits of men by Titian, Tintoretto, and other Venetian painters show the subjects wearing elegant black suits with white shirts, an ensemble that seems to have become the standard attire of the patrician. According to Baldassare Castiglione's *Il cortegiano* (*The Courtier*), printed in Venice in 1528, the qualities of the perfect courtier—nobility, talent, and a beautiful and graceful appearance—were shown to best advantage by black clothing, which expressed understated elegance. Titian's portraits of the nobility are not idealized or laden with allegory; instead, he depicted refined, confident, or philosophical individuals wearing modest yet sophisticated black attire. Tintoretto's men, when they are not in armor or robes of state, also wear black. While Tintoretto adopted Titian's graceful stances for his subjects, and likewise placed them before a dark or architectural backdrop, he progressively transformed his figures until they took on an almost otherworldly appearance, their seemingly overexposed faces set on bodies that are merely vague outlines. Unlike Titian's subjects, who have definite shape and presence and appear fully conscious of their historical significance, Tintoretto's reveal their fears and depths. Tintoretto, even in his biblical and historical narratives, depicted the world from the point of view of the "classless" man, and he generally saw people from a more God-willed, egalitarian perspective. Veronese, in contrast, could turn any occasion, including the biblical *Feast in the House of Levi* or *Feast in the House of Simon*, into a Venetian patrician gala.

This exhibition covers a surprisingly large spectrum of portraits of Venetian women, considering how few of these portraits were created by famous artists during the first half of the cinquecento, and how few have been preserved. Portraits of women were more commonly found on the mainland, such as that of an exquisite, melancholy young lady (pl. 30), which is informed by Lorenzo Lotto but awaits definitive proof of authorship. Tintoretto's relatively early *Portrait of a Young Woman* (pl. 36), who confronts the viewer in a surprisingly blunt and even aggressive fashion, represents a very original exception in Venetian portrait art. Veronese left behind a smaller group of portraits than did Tintoretto, but those images are profound and full of grace. In his *Portrait of a Venetian Woman (La Bella Nani)* (fig. 18), Veronese brilliantly captured his subject's shyness and timidity, enhancing the young woman's natural beauty into the realm of pure artistic enjoyment.

A purely Venetian invention of the early sixteenth century is the *bella donna veneziana*, the

idealized and eroticized half-length female portrait, originating from Giorgione's *Laura* (pl. 6) and represented in this exhibition by the outstanding paintings of Palma Vecchio (pls. 25–26) and Bordone (pls. 32–33). The women are shown in décolleté dresses and with disheveled hair, sometimes at their toilette and other times in the guise of a biblical or historical seductress such as Magdalene or Salome, or a heroine such as Judith (pl. 47) or Lucretia (pl. 48). Because there is such a sharp contrast between the realistic portrait and the eroticized idealization, researchers are still speculating whether the *belle donne* paintings were purely poetic inventions or if they were based on actual women. Some (predominantly female) art historians remain convinced that the paintings depict early sixteenth-century Venetian courtesans; they see the works as proof that the courtesans not only found their trade legitimized in art but also celebrated by the most brilliant artists. Other (predominantly male) art historians argue that these were bridal portraits, commissioned by the bridegrooms, and that the eroticized and idealized representations were to be seen as models, preparing the bride for her connubial duties. However, the fact that Judith and Salome, caressing the severed heads of Holofernes and John the Baptist, respectively, are also portrayed as erotic, half-length figures should instill caution against overly simplistic interpretations. As expressions of male desire as well as poetic allegories of femininity, these works were similar to the erotic nudes and mythological subjects destined to be viewed in private, in the intimacy of the bedchamber.

CLASSICAL THEMES AND THE *POESIE*

For paintings intended for private enjoyment, which were primarily commissioned by highly educated patrons, artists drew themes from the classic works of ancient authors, hoping to revive the ancient world, if only through imagery. Famous paintings such as Titian's *Pastoral Concert* (Musée du Louvre, Paris) and Giorgione's *Tempest* (Gallerie dell'Accademia, Venice) were intended for a nobleman's private chambers. There an aristocrat could abandon himself to the leisure and dreams of a bygone classical era, or the paintings could delight and entertain his guests, inspiring sophisticated and witty intellectual debate. Alongside the discourse on love, eroticism, and music, the refined Venetian patrician was deeply fond of philosophical and historical discussions.

Works such as Titian's *Bravo (The Assassin)* (pl. 21) and Giorgione's *Three Philosophers* (pl. 7) continue to provoke intelligent and thoughtful arguments, as they doubtless stimulated ethical and philosophical reflections during the cinquecento. Indeed, philosophy is the main theme of Giorgione's painting. According to Karin Zeleny's recent interpretation, it includes three men who represented the foundations of Western philosophical knowledge at that time: Thales of Miletus, Pherecydes of Syros, and his disciple Pythagoras. Because Giorgione's philosophers are in the countryside, the painting's atmosphere and lighting take on a deeper significance. This interest in the countryside was yet

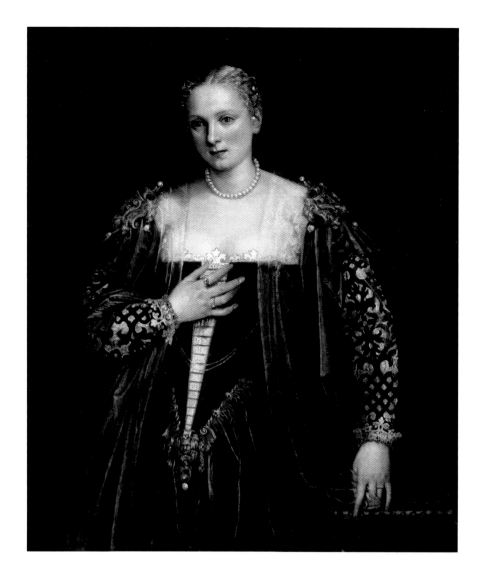

another hallmark of Venetian painting. Artists from the city of Venice are considered to have been the first to have highly valued rural settings, possibly inspired by ancient and contemporary pastorals such as Theokritos's poem about the shepherd Daphnis, Virgil's *Eclogues*, and Jacopo Sannazzaro's *Arcadia*, in which the narrator, a city dweller, sets out to learn about the life of the shepherds.

The countryside also became a backdrop for female nudes; shown in graceful union with nature, they express a proto-Romantic yearning for antiquity. Giorgione's *Sleeping Venus* (fig. 19) is considered the first perfect fusion of eroticism, sensuality, and a bucolic, romanticized landscape, creating an intense expression of deeply stimulating beauty. (Giorgione's pupil, Titian, is believed to have completed the landscape after his master's death.) In Palma Vecchio's *Bathing Nymphs* (pl. 27), which depicts thirteen female figures around a stream at the foot of a densely forested hill, the seemingly nonchalant stances of the women are in fact specific quotations of ancient sculptures and of famous postures

originated by Raphael or Michelangelo. This proves how intensely Palma had become involved with the *paragone*, the debate about the various merits of the disciplines of painting and sculpture so popular during the Renaissance. Here, Palma deliberately chose the poses with the intention of showing the beauty of the women from as many points of view as possible.

Leonardo was the first to proclaim the supremacy of painting because it was able to use sculpture as a model and its representations were more artful. Such considerations heavily influenced Titian's *poesie*, as Titian himself wrote in a letter, and indeed artworks such as *Danaë* (pl. 23) and *Nymph and Shepherd* (pl. 24) present ever-changing views of the beauty of the female body. No other school of painting dealt so intensely with the glorification of women, whether portrayed as Regina Caeli, as Venice, as Venus, as a saint, or as a courtesan. In 1533, in a document elevating Titian to the rank of Knight of the Golden Spur, the artist was dubbed the Apelles of Emperor Charles V. According to Pliny the Elder, Alexander the Great gave his beautiful lover to the painter Apelles because the artist better understood how to honor beauty than the ruler. Titian and his fellow masters of Venice took the naked, sensual figure of a woman, usually reclining in a luxuriant landscape, and made her a Venetian. In Venice, the beauty of woman was inseparably intertwined with the beauty of painting.

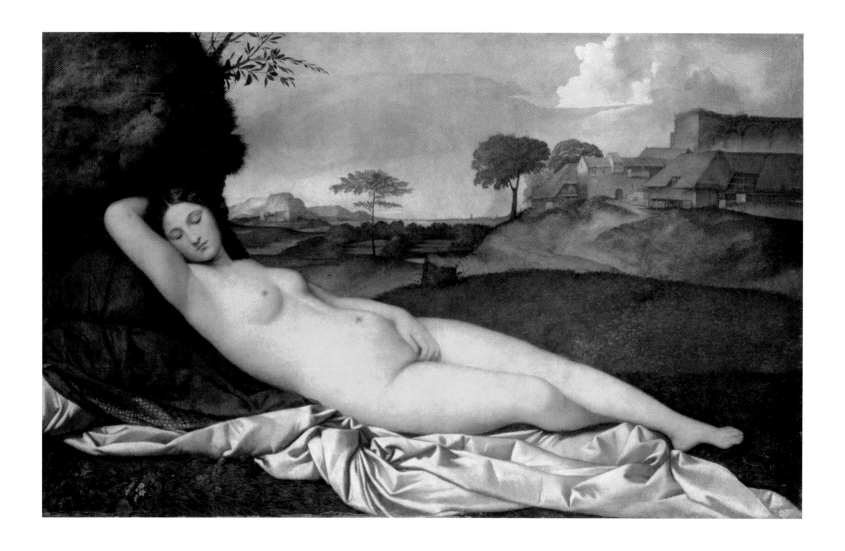

Fig. 19
Giorgio da Castelfranco, called Giorgione
(ca. 1477–1510)
Sleeping Venus, ca. 1508–1510
Oil on canvas
42⅞ x 68⅞ in. (109 x 175 cm)
Gemäldegalerie Alte Meister, Dresden

The Visible Media:
Methods and Materials of the Venetian Masters

ELKE OBERTHALER

Few subjects have been studied with such depth and passion as the methods and techniques of the great Venetian masters, which have fascinated historians, artists, and art connoisseurs since the sixteenth century. It is in fact quite challenging to summarize this complex topic when one considers the vast amount of literature that researchers have produced. This essay focuses on the Venetian paintings featured in *Masters of Venice* as a means to address some of the most important technical innovations of a period that represents the birth of modern European painting.

The distinctive manner of painting associated with Titian, Tintoretto, and Veronese is characterized by an increasingly bold application of paint, a vibrating use of color, and a singular treatment of atmospheric effects. All of these practices countered the traditional approach to highly finished paint surfaces, revolutionizing artists' working methods. Two developments were central: the use of (increasingly roughly textured) canvas, and the introduction of the oil-paint medium.

THE SHIFT TO CANVAS

The transition from panel to canvas as the predominant support for oil painting started early in Italy, especially north of the Apennines mountain range. Venice's damp environment was detrimental both to wall paintings and wooden panels, and artists had begun to use canvas extensively for large-scale works by the fifteenth century. These works were not painted in oil but rather in either a glue size medium (distemper) or tempera applied on a thin ground. They were not meant to be varnished, and their surfaces resembled frescoes rather than panel paintings.

The different surface properties of panel and canvas can be observed in the earliest works in the present exhibition, even though they hail from Mantua rather than Venice: Andrea Mantegna's *Saint Sebastian* of around 1457–1459 (pl. 1), painted on poplar wood, and the grisailles *David with the Head of Goliath* (pl. 2) and *Sacrifice of Isaac* (pl. 3), painted on canvas around 1490–1495. Mantegna exhibited a very early preference for canvas. He either used distemper on sized canvas with little or no gesso preparation (a type of painting not meant to be varnished, thus retaining a matte surface), or tempera with varnish (with surface effects that resemble panel paintings).

Saint Sebastian's poplar panel is covered with a smooth gesso ground that entirely disguises the wooden support, while the grisaille canvases have retained a rather "open" structure. Because the canvas is very finely woven, with approximately 27 horizontal by 26 vertical threads per square centimeter, and only thinly covered with a priming layer and pigment, it remains evident as the medium of support

Fig. 20
To create the yellow leather ribbons of the book in *Portrait of Benedetto Varchi* (pl. 11), Titian, using the texture of the canvas, dragged a brush loaded with a dry color over the darker paint of Varchi's coat.

Fig. 21
In this detail of Isaac's sleeve from Mantegna's
Sacrifice of Isaac (pl. 3), the fine canvas can still be
seen because the paint layer is so thin.

(fig. 21). The rough surface of a canvas also responds to light very differently than the smooth expanse
of a panel, reflecting it in many directions and creating a softer, more diffused, impression.

Due to the aqueous medium, the technique Mantegna used to create his grisailles is extremely
delicate, and the artworks very fragile. This is one reason why few such paintings still exist, and even
fewer have remained intact. Vienna's two Mantegna canvases were also erroneously varnished in the
past, giving them a much shinier, saturated surface than the artist originally intended. Even by the
time of Archduke Leopold Wilhelm's 1659 inventory, they were described as "oil on linen, gray on
gray," demonstrating that knowledge about Mantegna's technique was lost very early.

A 1477 letter from Mantegna to his patron Ludovico II Gonzaga hints at another pragmatic
explanation, in addition to the damp climate in Mantua, for the artist's preference for canvas: "If your
Lordship wishes to send [the portraits] far they can be done on fine canvas and wrapped around a
dowel." Sixteenth-century artists' biographer Giorgio Vasari also commented on the advantage of
canvases being rolled for transport.

The introduction of oil as a painting medium provided artists with a new range of aesthetic possibilities, as pigments bound in oil can be applied thickly to create heavy impasto or very thinly to produce translucent glazes. In Venice, Giovanni Bellini began to use oil paints around 1475. He still, however, worked predominantly on panel and used his fingertips to eliminate brushstrokes, resulting in very smooth, soft transitions. Giorgione's paintings of the early cinquecento were on canvases with a fairly fine, plain weave and an even texture. The canvas for *The Three Philosophers* (pl. 7), for example, is 21 by 17 threads, and the canvases of the smaller compositions are finer still: *Portrait of Francesco Maria I della Rovere* (pl. 4) is 22 by 20 threads, and *Portrait of a Young Woman (Laura)* (pl. 6) is approximately 21 by 25 threads. In the flesh areas in particular, with their soft modeling—such as the head of the old man on the right in *The Three Philosophers* (fig. 22) or the face of Laura—it is difficult to discern individual brushstrokes.

Such observations about brushstrokes and other surface effects must be made with care, however, because the surface properties of paintings on canvas are much more vulnerable to later interventions than those on panel. Over the centuries, the repeated reattachment of fabric to the

Fig. 22
The head of the elderly man in Giorgione's *Three Philosophers* (pl. 7) reveals soft modeling, and individual brush marks are not visible.

back of the picture (called lining)—a process that often involved hot irons, pressure, and moist glue—leads inevitably to a flattening of paint layers and, hence, an amplification of the texture of the canvas. Overly harsh cleanings can also cause damage by abrading the paint on raised areas where the canvas threads intersect. This can sometimes expose the canvas knots, thus emphasizing the canvas's texture more than the artist intended. The layers of paint in the flesh areas in Giorgione's *Laura*, for example, are quite abraded; however, because the finely woven canvas is glued to a fir panel, the surface texture may be less altered than if it had been on canvas alone. A faint inscription on the back from 1506, discovered in the late nineteenth century, indicates that this combined support is probably original.

Interestingly, Leopold Wilhelm's 1659 inventory describes thirty-six paintings as "canvas attached to wood," including Tintoretto's *Portrait of a Young Woman* (pl. 36) and Titian's *Christ and the Adulteress* (pl. 16). Both paintings were later removed from their panels and lined. Like Giorgione's *Laura*, only Palma Vecchio's *Bathing Nymphs* (pl. 27), also from Leopold Wilhelm's collection, remains mounted on panel. Dendrochronological analyses reveal that Palma's panel consists of four planks from different oak trees that originated in the Baltic region and were cut early in 1636. This type of wood was regularly used for seventeenth-century Dutch and Flemish panels, indicating that they were added during an early restoration, possibly performed in the Netherlands, where the painting was residing in the mid-seventeenth century. The pressure necessary to attach the canvas to the panel pushed the junctures of the canvas threads toward the front, exaggerating the "lumpy" texture of the already fairly rough canvas (15 by 14 threads) and giving it a surface appearance that was certainly not intended.

Giorgione's *Three Philosophers* was conserved in a less invasive manner: it was lined at least twice, and it is recorded as having been stored without a stretcher in the attic of Vienna's Hofburg palace during the eighteenth century. Paintings were frequently relined during the eighteenth century, and unlined canvases from that time are extremely rare.

A NEW MANNER OF PAINTING

Early sources, including the seventeenth-century artist and author Marco Boschini, mention that around 1507 Giorgione and Titian began using a new painting procedure: they abandoned the tradition of preparing their compositions through drawing and instead developed their works directly on canvas (or panel). Indeed, x-radiography and infrared reflectography have revealed that Giorgione made fundamental changes in composition while painting *The Three Philosophers* and *Laura*, as did Titian in many works. This more experimental approach may have the same roots as the development of the so-called visible brushstroke.

Canvas absorbs color unevenly. If the consistency of the color on the brush is very "dry" and the artist uses only slight pressure, color will be applied just on the raised junctions of the threads; the lower areas of the canvas, untouched by the pigment, remain visible, giving the paint layer a certain vibrancy. Even if paint is worked into the interstices of the canvas's weave, the layer will not be even unless it is exceptionally thick, which also contributes to a broken or blurred effect.

Titian was the first among the Venetians to develop a method of application that revealed the hand of the painter. The individual brushstroke, the influence of the canvas texture, and the building up of the paint to thicker, more impastoed layers became key features of Titian's surfaces, and these developments are closely connected to the artist's later preference for canvases of a more coarse and textured weave. Throughout his career, in fact, he used a thin gesso ground, which did not conceal the rough texture of the canvas. The "open" paint manner originated by Titian, however, was simultaneously practiced by the artist's younger colleagues, particularly Tintoretto and Veronese. In this highly individual manner of painting, each stroke may be considered a kind of signature. It is not necessarily a quick way to paint, however. Tintoretto had a reputation for painting rather rapidly, but it was recorded that Titian kept his canvases in the studio for a very long time, turning them to the wall and, eventually, coming back to revise the compositions.

A wide range of materials was available in Venice, where canvas was produced for the fabrication of sails and everyday goods. Plain, twill, herringbone, and diamond weaves were all used for painting supports. Titian's early canvases, from the 1510s and 1520s, have a finely textured weave: *The Bravo (The Assassin)* (pl. 21) is 22 by 18 threads; *Portrait of Physician Giacomo Bartolotti of Parma* (pl. 9) is 19–20 by 19 threads; and *Christ and the Adulteress* is 15 by 19–20 threads.

Whereas *Portrait of Isabella d'Este, Marchioness of Mantua* (pl. 10), from about 1534–1536, is on a very loose diamond weave canvas of 10 by 11 threads, Titian used plain weave canvases of various thread densities throughout his career. Later examples, from the 1530s through the 1560s, such as *Portrait of Benedetto Varchi* (pl. 11), *Portrait of Johann Friedrich, Elector of Saxony* (pl. 12), *Portrait of Fabrizio Salvaresio* (pl. 13), *Christ with the Globe* (pl. 17), and *The Entombment of Christ* (pl. 18), are on canvases with fewer than 17 by 21 threads. And the canvases for *Portrait of Titian's Daughter Lavinia as a Matron* (pl. 14), *Portrait of Jacopo Strada* (pl. 15), and *Danaë* (pl. 23) are all fewer than 12 by 12 threads.

It appears that Titian used twill weave to a lesser extent than Tintoretto and Veronese, and his very late *Nymph and Shepherd* (pl. 24), from around 1570–1575, is the only example on this type of canvas (at 13 by 17 threads) in the present exhibition. In general, this more sturdy canvas, with its distinctive texture, was preferred for relatively broadly painted works and larger formats. Tintoretto's *Saint Jerome* (pl. 42) and *Flagellation of Christ* (pl. 43), from the 1570s and 1580s, are also twill weave canvases. Examples of paintings on herringbone canvas are Tintoretto's *Portrait of Sebastiano Venier (and the Battle of*

Fig. 23
Using a few brushstrokes of a dry, brighter color on an orange middle tone, Veronese applied highlights to the drapery on the right of *Venus and Adonis* (pl. 50). These "broken" brushstrokes characterize reflected light and capture the texture of the shiny silk fabric.

Fig. 24
Individual brushstrokes suggesting the texture of the fur are evident in this detail of Titian's *Portrait of Fabrizio Salvaresio* (pl. 13).

Lepanto) (pl. 41), from about 1571, and *Saint Nicholas of Bari* (pl. 38) and Veronese's *Anointing of David* (pl. 46), the latter two of which both date to around 1555 and are on fairly coarse weaves of around 11 by 10 threads.

There is no simple explanation for an artist's use of certain canvas types. In addition to size, subject matter, and desired artistic effects, other factors might have influenced the artist's choice, such as the wishes of the patron and the price. Larger-format works, however, naturally required stronger materials. At 18 by 16 threads, the canvas of Tintoretto's *Susanna and the Elders* (pl. 39) is a relatively fine plain weave, considering the size of the composition, while the smaller *Flagellation of Christ* is on a slightly coarser twill, as is *Portrait of a Young Woman*, which was painted on a canvas of 11 by 10 threads.

Artists frequently emphasized a canvas's texture by dragging a brush loaded with "dry" and often bright color over a rough surface that had been toned in a darker color (see fig. 20). This technique could be used for a variety of purposes, such as smoothing transitions, breaking up contours, and characterizing the play of light over objects and materials. Titian and Veronese were especially skilled at suggesting, with a few strokes, the characteristic surface qualities of stiff or shimmering silks, downy velvets, and soft furs (figs. 23–24). Juxtaposing dissolving contours with sharp outlines helps to establish the spatial order of the depicted elements (fig. 25).

It has been argued that artists primarily used coarser canvases and a more open manner of painting for large artworks intended to be viewed from a distance. It is interesting to note, therefore,

Fig. 25
As can be seen in this detail of Susanna's left leg in *Susanna and the Elders* (pl. 39), Tintoretto used the canvas texture to avoid sharp outlines and create smooth transitions toward the dark background.

that two fairly small works—Veronese's *Hercules, Deianira, and the Centaur Nessus* (pl. 49) and *Venus and Adonis* (pl. 50), both on relatively coarse canvases of 14 by 15 and 15 by 13 threads—do not display a high degree of finish, indicating that the technique was also meant to be appreciated at close range.

Art historian Ernst Gombrich pointed out the communicative aspect of the open paint manner. A visible brushstroke, above all, reveals how the artist applied the paint to create an artwork. There is a great difference between what can be seen close-up and what is seen from far away, and this change in distance is necessary for the viewer to enjoy the visual play of deconstructing and constructing the image. The technique itself suggests not only novelty and ease but also virtuosity and artistic freedom, and these concepts of *sprezzatura* (nonchalance) and *facilità* (skill), which played a central role in art theory during the second half of the cinquecento, may be traced back to Baldassare Castiglione's influential book *Il cortegiano* (*The Courtier*), published in 1528.

LATE TITIAN

In his later years Titian developed a distinctive personal style. He dissolved the traditional highly finished paint surfaces into a kind of shorthand that seemed to consist only of patches of color. It appears that Titian brushed accents over the entire canvas almost simultaneously rather than painting individual areas in succession; thus, he always worked out his composition by considering the entire painting surface.

Titian's late style continues to polarize viewers, as it did during his lifetime: the final pictures are either held in the greatest esteem, or their free, painterly manner and seemingly reductive palette is attributed to defects stemming from the incomplete nature of the works or the infirmity of an elderly artist. For most of the nineteenth century, for example, his *Nymph and Shepherd*, then unappreciated, remained in storage. In the early 1890s it was moved back to the imperial gallery, despite being described in 1891 by the gallery's director, August Schäffer, as having "only sketchlike beginnings, or rather a ruinous appearance."

It is obvious that Titian used different styles in the painting. The landscape and the figure of the shepherd are handled loosely, while the brushwork for the nymph completely distinguishes it from the rest of the picture: the finely nuanced color tones seem to blend together almost invisibly, and the artist avoided obvious brushstrokes so as not to disturb the illusion of skin. This use of different styles may have been a conscious choice by the artist to increase the work's effectiveness; however, it also underscores the difficulty in tracing a linear, chronological development in the arrangement of the composition.

The idea of a painterly style is most relevant when viewing the background of *Nymph and Shepherd*: the distant landscape and especially the sky (fig. 26), where the open and vivid application of paint has led many to the opinion that the work is unfinished. Over the light gypsum ground are dark-brown or grayish layers of underpaint, onto which highlights, predominantly composed of lead white, were placed using wide brushes (up to three-quarters of an inch). Over these highlights are

additional layers of dark, glazing, or semi-opaque color in various brown to reddish tones, which were likewise applied unevenly. The toned-down, impastoed daubs of lead white function as a "body" to facilitate the building up of a thick, tactile paint surface composed of distinct patches of color, while the layering contributes to the restless mood of the composition. Clearly the artist expended much effort to produce and retain this agitated, uneven appearance throughout the work's creation. Boschini described Titian as pausing during his work, and surely these breaks were also necessary for drying: a too-rapid continuation of labor could have led to the blending of the distinct areas.

Equally complex is the construction of the red accent to the right of the goat. It is primarily composed of an impastoed underlayer made of multiple brushstrokes of lead white into which red paint was applied before the white had fully dried, creating the impression that the accent was built solely in reddish paint. The light yellow spots, presumably lead-tin yellow, were placed last. The visible brushstroke was far from accidental; it was a sophisticated working system intended to achieve a very specific artistic effect.

NOTE TO THE READER: All thread counts provided in this essay are horizontal by vertical, per square centimeter. The author wishes to acknowledge her debt to the scholarship published in Hans Dieter Huber, *Paolo Veronese: Kunst als soziales System* (Munich: Fink, 2005). English-language sources for the information in this essay appear in the list of suggested further reading on page 156, this volume.

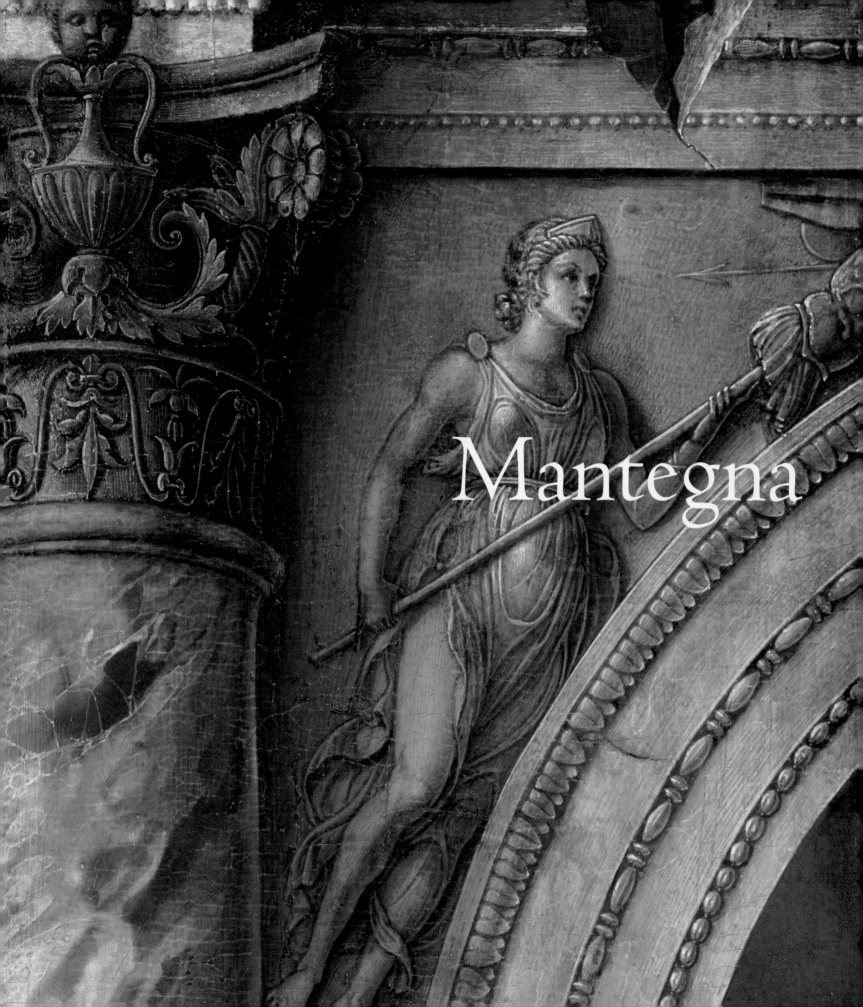

Mantegna

Among the most idiosyncratic artistic voices of the quattrocento, Andrea Mantegna (1430/1431–1506) crafted a signature aesthetic of great sophistication predicated on an early familiarity with classical antiquity. A gifted painter and a pioneering draftsman, Mantegna practiced a uniquely crisp and sculptural interpretation of Renaissance precepts, which distinguishes him from other Italian artists of the age. These attributes developed during Mantegna's formative years in Padua, a northern Italian center of humanist scholarship annexed by the Venetian state in 1405. Mantegna's Padua boasted both a classical Roman origin (Patavium) and Italy's most prestigious university, making it a conspicuously ancient and modern fifteenth-century city. This synthesis of antiquarianism and contemporary humanist scholarship fostered a dynamic and intellectually creative academic atmosphere that stimulated and informed Mantegna's distinct artistic identity.

Padua, as a center of learning and artistic patronage, offered Mantegna defining opportunities that shaped his artistic development. By 1442 Mantegna was apprenticed in the city's leading workshop—run by his adoptive father, Francesco Squarcione (ca. 1395–1468)—and there he learned the formal rules of painting and draftsmanship. This process involved copying his master's examples, including numerous drawings Squarcione had made during travels in Italy and Greece. Most significantly, Squarcione's apprentices could study his prized collection of casts and reliefs. This range of pictorial sources refined the young Mantegna's technical skills and fostered his understanding of sculptural form and fascination with antiquity.

Mantegna also profited from exposure to Padua's many artistic treasures, among the greatest of which is the early fourteenth-century fresco cycle in the Cappella degli Scrovegni (Arena Chapel) by the Florentine painter Giotto di Bondone (1266/1267–1337). Giotto broke new ground by abandoning the schematic flatness of Byzantine models to render solidly three-dimensional human forms set within convincingly illusionistic spaces, and his paintings initiated key principles that were valued by artists of the quattrocento. More specifically, Giotto understood the human body's expressive potential, which he further developed by depicting figures in believable spatial and emotional relationships.

Fifteenth-century Padua also attracted contemporary artists who brought with them new pictorial theories then percolating in other Italian centers of civic humanism. The example of Florence's leading sculptor, Donatello (ca. 1386–1466), who lived in Padua from 1443 to 1453, proved pivotal for Mantegna's stylistic development. Mantegna's own painted figures have a pronounced sculptural quality, and he even designed painted imitations of sculptural reliefs. Donatello's bronze reliefs for the high altar in Padua's Basilica di Sant'Antonio also exhibit an aggressive linear perspective, a formal device that Mantegna later employed with considerable expertise.

This stimulating atmosphere prepared Mantegna for his first major commission: frescoes for the Ovetari Chapel in Padua's church of the Eremitani. His early partnership with Nicolò Pizzolo

(ca. 1421–1453), Donatello's former assistant, contributed to the frescoes' Florentine-inspired realism. These frescoes (largely destroyed during World War II) unveiled Mantegna's aesthetic predilections in their references to classical antiquity, in the graphic precision of their figures and architectural elements, and in the use of dramatic perspectival devices. This exploration of illusionistic *all'antica* architectural settings foreshadowed Mantegna's later commissions at the Gonzaga court in Mantua, where he moved by 1460. Most spectacular are the frescoes in the Palazzo Ducale's Camera degli Sposi, also known as the Camera Picta, of 1465–1474, followed in the 1490s by nine murals rich in archaeological detail: the *Triumphs of Caesar* (Royal Collection, Hampton Court Palace, Surrey).

Most scholarship agrees that before leaving Padua, Mantegna painted the *Saint Sebastian* of 1457–1459 (pl. 1). According to Catholic tradition, Emperor Diocletian sentenced the third-century Roman officer to death for declaring his Christian faith. Sebastian miraculously survived being shot by arrows and was nursed back to health; when he confronted the emperor again, he was finally executed. As in the Kunsthistorisches painting, Saint Sebastian is traditionally depicted with arrows protruding from his punctured body. During the pestilence-ridden fifteenth century, Sebastian, the patron saint of plague victims, was a favored subject in art. His intercession was frequently invoked on behalf of the infected, whose symptoms resembled arrow wounds. Mantegna painted three versions of the subject: the present panel and two later versions now in the Musée du Louvre, Paris, and the Ca' d'Oro, Venice. Although a later date has been suggested for the Vienna painting, perhaps the artist's interest in the saint commemorates his own survival of the plague that ravaged Padua in 1456–1457.

Displayed before a crumbling triumphal arch, the martyred Sebastian expresses a somber resignation that suggests the forbearance of Christianity in the midst of pagan antiquity's wreckage. Beyond standard iconography, the painting hints at several of Mantegna's antiquarian interests, including lapidarian studies. The prominent Greek letters spelling "work of Andrea," seemingly carved below the saint's right elbow, highlight the artist's epigraphic interests. Mantegna also makes visual reference to the perennial *paragone* (or competition) between painting and sculpture by juxtaposing the fragment of a chiseled foot with the martyr's bloodied toes. Here Mantegna demonstrates painting's superior ability to achieve the convincing illusion of both stone and flesh.

Mantegna's natural stylistic temperament and vocabulary of *all'antica* motifs seem consciously to embody the theories of the fifteenth-century Italian architect and humanist Leon Battista Alberti, who wrote the quattrocento's seminal treatises on art and architecture. His *De pictura* (1435), devoted to painting, laid out the first systematic guide to linear perspective. This formal device, coupled with shading in the service of contour, precise architectural details, and sharply outlined forms, aided Mantegna in the noble quest of pictorial realism and overall compositional balance, or *disegno*. These

pictorial motifs and the underlying structural arrangement of *Saint Sebastian* suggest the artist's command of Alberti's guidelines for picture making.

Alberti also lauded references to antiquity's architectural remnants and extant literature. Even small details, such as the figure on horseback that appears in the clouds, seem to correlate with Alberti's precepts, here reiterating the classical theory that beautiful designs occur from natural elements. The figure's identity has challenged art historians: Is he one of the horsemen of the apocalypse, or the ancient King Theodoric? Regardless, Mantegna's successful combination of Christian tradition and classical motifs brings greater resonance to the image's conventional meaning while reflecting the artist's rich intellectual environment.

Coincidentally, in 1459 Mantegna and Alberti shared a wealthy patron and were most likely working on individual projects dedicated to Saint Sebastian. In this year, Ludovico II Gonzaga commissioned Alberti's design for Mantua's church of San Sebastiano. Mantegna had already committed to serve as the official court painter in Mantua, where he flourished under the patronage of three successive Gonzaga marchesi. The Gonzagas respected Mantegna's antiquarian expertise, seeking his advice on assembling their own collections in addition to purchasing works from him. In Ludovico II Gonzaga, his son Federico I, and grandson Francesco II, and also Francesco's wife, Isabella d'Este, Mantegna found patrons who shared his classical tastes and humanist interests.

At the Gonzaga court, Mantegna once again explored the relationship between painting and sculpture, this time in a series of small-scale grisailles produced during the 1490s (pls. 2–3). The term *grisaille* derives from a French word meaning "gray," and it succinctly describes these monochromatic studies, which emulate carved stone reliefs. The grisaille project took up as a challenge the trompe l'oeil achievements of ancient painters discussed in classical literature on art, including Pliny the Elder's *Naturalis historia* (*Natural History*). For Mantegna, this pictorial conceit had a more modern precedent in Giotto's Arena Chapel frescoes of the Virtues and Vices, which resemble relief sculpture. Mantegna and his workshop created numerous works using the grisaille technique; an extensive scholarly literature has debated their individual authorship, dating, and pairing.

The two Vienna paintings were first mentioned in the Habsburg collection of Archduke Leopold Wilhelm in 1659. Possibly previously belonging to Charles I of England, they most likely originated in the Gonzaga collection. Although their intended purpose is unknown, the grisailles were probably executed for a devotional chapel or a private study: marble reliefs decorated the doorframe of Isabella d'Este's studiolo, a private retreat in the Gonzagas' Palazzo Ducale. Mantegna's grisailles vary in subject, but known examples are limited to classical and religious motifs; the pair in Vienna's collection depicts scenes from the Old Testament. In *David with the Head of Goliath*, we see the hero David, who felled Goliath, the Philistine giant, with a stone shot from his sling. *Sacrifice of Isaac* is also

about proving the strength of one's religious conviction in the face of great challenge. The book of Genesis describes how God tested Abraham's faith by commanding him to sacrifice his only son, Isaac. Mantegna's grisaille depicts the hand of God reaching from heaven to stop Abraham. The sacrificial lamb, to be accepted in place of Isaac, appears on a carved stone altar. These grisailles synthesize Mantegna's signature fusion of traditional religious narratives with innovative representational techniques.

The honors bestowed upon Mantegna echo his distinctive assertion that the Renaissance was heir to classical antiquity's creative achievements. Contemporaries often compared Mantegna to the ancient Greek painter Apelles, who was celebrated in Pliny: both artists achieved fame in their lifetimes and earned the respect of peers and rivals. In his famous book on courtly responsibility, *Il cortegiano* (*The Courtier*) of 1528, Baldassare Castiglione named Mantegna one of the five greatest modern painters. Mantegna's illustrious reputation would have brought him to the attention of sixteenth-century Venetian masters even if he had not been the brother-in-law of Giovanni Bellini. The artists of the Venetian High Renaissance developed their own artistic vocabularies from the grammar of the previous generation. However, the example of Mantegna, a highly celebrated artist in his own time, offered technical lessons about aggressive perspective and an example of individual fame; both would have struck a resonant chord with the great Venetian artists of the cinquecento.

—*Melissa Buron*

1 Andrea Mantegna (1430/1431–1506)
 Saint Sebastian, ca. 1457–1459
 Tempera on panel
 26¾ x 11⅞ in. (68 x 30 cm)

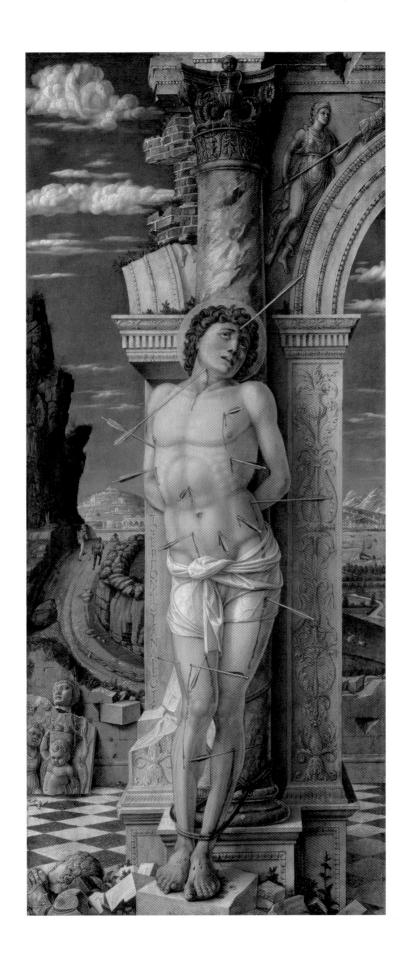

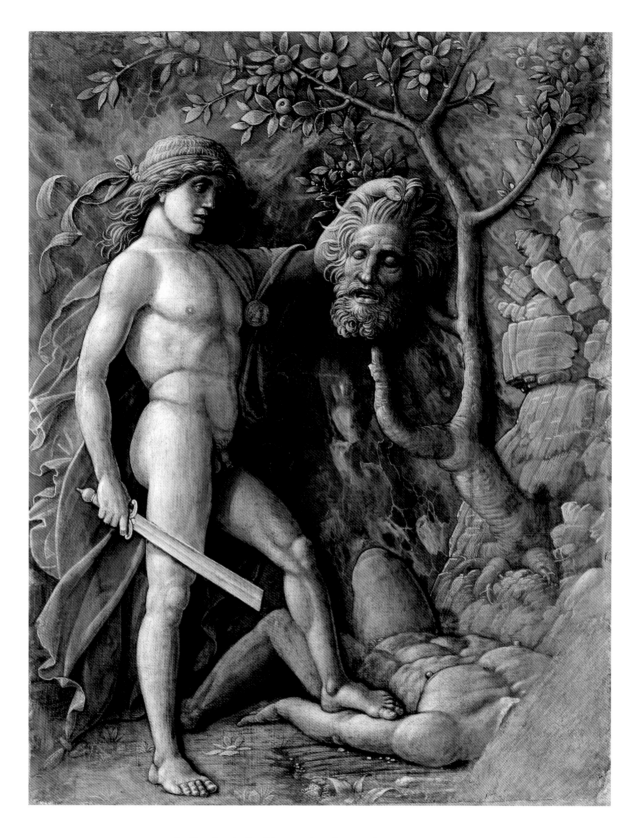

2 Attributed to Andrea Mantegna (1430/1431–1506)
David with the Head of Goliath, ca. 1490–1495
Distemper on canvas
19⅛ x 14⅛ in. (48.5 x 36 cm)

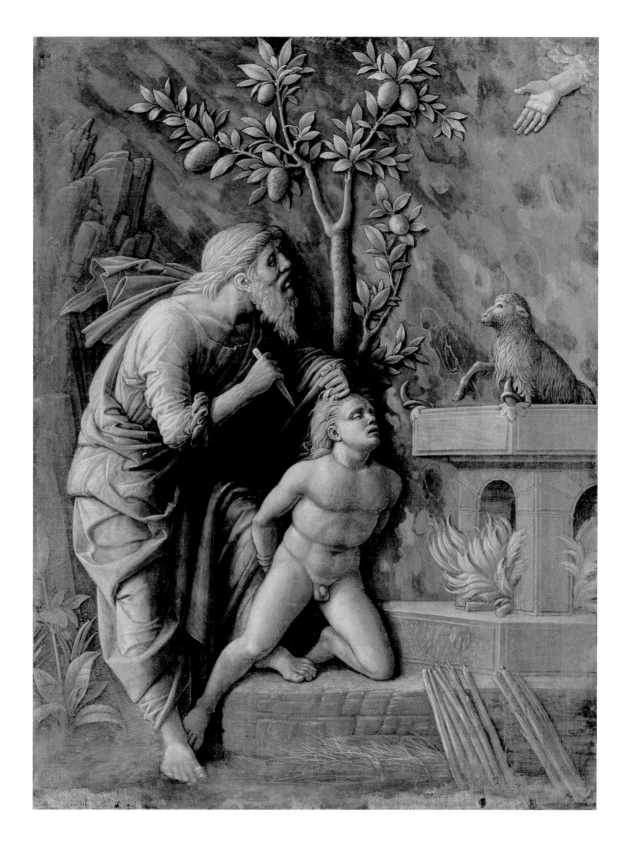

3 Attributed to Andrea Mantegna (1430/1431–1506)
 Sacrifice of Isaac, ca. 1490–1495
 Distemper on canvas
 19⅛ x 14⅛ in. (48.5 x 36 cm)

Giorgione

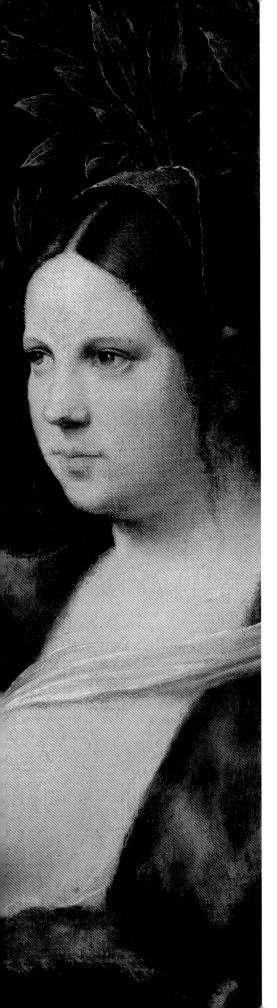

Few artists have experienced fame comparable to that of Giorgio da Castelfranco, known as Giorgione (ca. 1477–1510). He was the great innovator of Venetian painting, and his idyllic landscapes, portraits of men and women, allegories, religious subjects, and atmospheric scenes paved the way for the great paintings of the cinquecento.

Our understanding of Giorgione's personality and career is, however, encumbered by the aura of mystery that enshrouded him immediately after his death, made even more impenetrable by the lack of documentation and the inaccuracy of the available information. Tradition hands down the image of a great artist, a good-looking man, and a refined musician who participated in philosophical and humanistic circles and who, according to his biographer Giorgio Vasari, "continually entertained himself with the matters of love." While the meager catalogue of his works is fundamentally reconstructible on the grounds of stylistic considerations, there remains the undeniable difficulty of comprehending his subjects, over which looms a sense of ambiguity—a magical atmosphere that surrounds and animates the characters. His premature death from the plague (contracted from his lover, according to his biographers) further contributed to the romantic myth surrounding the artist.

Except for a few documentary clarifications, little had been added to the biography of Giorgione since the publication of Vasari's two editions (1550 and 1568) of *Le vite de' più eccellenti pittori, scultori, e architettori*, commonly known as *The Lives of the Artists*, and Carlo Ridolfi's *Le maraviglie dell'arte* (The marvels of art) of 1648. But thanks to a very recent archival discovery, we now have a family name for the artist: the son of Giovanni Gasparini, he was born in the small northern Italian town of Castelfranco Veneto, near Treviso. As Vasari claimed, Giorgione was indeed of humble origins. Based on information that the artist died of the plague in 1511, at the age of thirty-four, Vasari had given his birth year as 1477 (in the 1550 edition) and 1478 (1568). However, from the epistolary exchanges of Isabella d'Este, Marchioness of Mantua, and her agent Taddeo Albano between October and November 1510, it can be derived that the artist actually died in the fall of 1510. The noblewoman had asked Albano to see if the painting of a "Night" that she had heard of and wished to acquire was still in the studio of the recently deceased master. That the news of the painter's death was relayed so quickly, and that the marchioness and other art collectors responded so promptly, is ample evidence of Giorgione's fame during his lifetime.

According to Vasari and Ridolfi, the young Giorgione came to Venice in the early 1490s and apprenticed in the workshop of Giovanni Bellini (ca. 1431/1436–1516). He then dedicated himself to the painting of Madonnas and to the decoration of pieces of furniture. In the early 1500s he returned to Castelfranco, where he had been commissioned to paint the altarpiece for the Costanzo chapel in the town's cathedral as well as friezes for the Casa Marta Pellizzari. He subsequently returned to Venice, where he began the most prolific phase of his activity and created the works included here.

It is almost certain that the boy in the first painting (pl. 4), holding a helmet and posing before the receding colonnade, is Francesco Maria I della Rovere. The steel helmet, which is too large for the youth, is richly decorated with gold-plated bronze oak leaves and acorns, a sign that the young nobleman was a member of the house of della Rovere. Francesco Maria was the grandson of Federico da Montefeltro, Duke of Urbino, who later adopted the boy to continue the Montefeltro dynasty. The prominence of the della Rovere helmet speaks in favor of a commission from this family, perhaps to celebrate the young man's succession to the office of prefect of Rome in 1502. The painting may have been executed in Venice while Francesco Maria, fleeing Cesare Borgia's siege of Urbino that same year, headed toward France.

The refined reflections on the smooth surface of the helmet position both the artwork and its creator at the very center of the *paragone* debate. Since ancient times, painting and sculpture had competed for the title of supreme imitator of Nature. In the early modern period, after the contributions of Leonardo da Vinci (1452–1519), theorists and artists argued the issue with newfound enthusiasm. A painter's ability to portray the human body or an object from various points of view was demonstrated by introducing surfaces that could reflect areas not otherwise visible. The Venetian attribution of this fascinating portrait has always called attention to the painting's atmospheric qualities and to its subject's vitality and naturalism. And the sentimental characterization of the figure, which is in accordance with da Vincian principles, leads us back to Giorgione, the rising star of Venetian painting at the dawn of the new century.

A fascinating portrait of a warrior (pl. 5), heavily influenced by Leonardo, is perhaps Giorgione's most "classical" work for its strong references to antiquity. The Venetian nobleman Marcantonio Michiel observed this painting of a helmetless soldier during a 1525 visit to the home of the nobleman Zuanantonio Venier, a Venetian lawyer and politician. The figure wears the armor of an infantryman, a rank confirmed by his halberd. As a captain of the guards, he possibly received distinction for a deed and has been elevated by Giorgione to the status of hero; the crown of leaves gives the portrait a classical tone. The themes of triumph and Roman antiquity are important in reconstructing the cultural climate in which the painting came to light, when some patrician families of Venice, such as the Cornaros and the Marcellos, claimed Roman origins for their lineage.

A source of inspiration for this painting has been identified in a drawing by Leonardo that depicts the profile head of a laureate warrior, surrounded by four male faces in different poses and characterizations (Royal Collection, Windsor Castle). Leonardo's physiognomic studies remain his most incisive creations in the exploration of sentiment and personality. This influence is evident in Giorgione's compositions that include two or more figures conversing or standing opposite each other with contrasting expressions. Still to be fully explained is the role of the Leonardesque figure

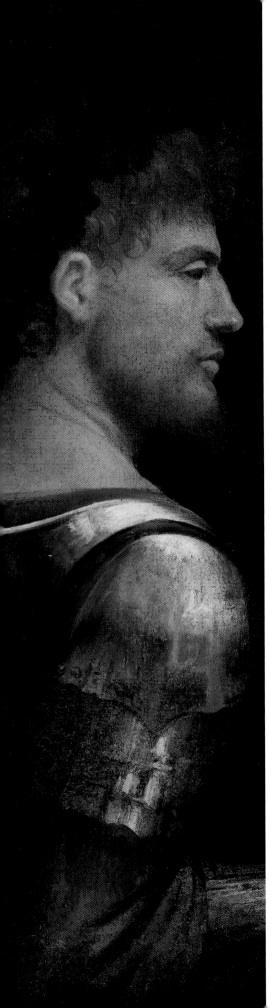

emerging from the shadows, which had been overpainted and was revealed during restoration in the mid-1950s.

Described as "Laura of Petrarch" in the seventeenth-century inventory of the Bartolomeo della Nave collection, *Portrait of a Young Woman (Laura)* (pl. 6) is a touchstone of Giorgione's oeuvre, representing the beginning of the artist's mature work. The subject of this painting has been a source of continued debate: What Venetian woman would have allowed herself to be portrayed with her breast exposed? Was she a specific individual, possibly a courtesan? Scholars have pointed out that there is no known genre of portraits of courtesans; furthermore, to emphasize her respectability, such a woman would likely have preferred to be shown in elegant dress. A more widely accepted hypothesis is that it is a romanticized portrait, representing an ideal rather than a particular person. There are three primary theories explaining the presence of the laurel branches: they allude to the name of the subject (Laura, from the Latin *laurus*), which is consistent with Leonardesque examples; they are symbolic of poetry, supporting the hypothesis that this is a portrait of a poet; or they are symbolic of a bride's chastity and purity.

An inscription on the reverse of the painting—almost illegible today—dates it to 1506; it also informs us that in that year Giorgione was a colleague of artist Vincenzo Catena (ca. 1470–1531) and that the painting was commissioned by "Maistro Giacomo." Did this man, about whom nothing else is known, hire the most modern painter in Venice to produce an extremely sensual and direct portrait of a woman close to him, very likely destined for private enjoyment in their home? It is certain that the extraordinary quality of this painting derives largely from the contrast between this "ordinary" female face and the intimacy of the gesture she uses either to conceal or reveal her breast. The subject is portrayed in a sheer blouse under a red jacket lined with fur, and the crimson coat contrasts with a dark background animated by the green of the laurel. She may be dressed in the type of garment that artist Cesare Vecellio (1521–1601) described as being worn at home during the winter months by some ladies or courtesans. The woman's physicality is manifest in the intent look in her eyes, so true they reflect the light; in the delicacy of the veil that covers the shiny chestnut hair tied at the nape of her neck; and in her natural presence. The work exemplifies the originality and beauty that is characteristic of Giorgione's paintings and was celebrated during his own lifetime.

Portrait of a Young Woman (Laura) holds great value as a document of the professional relationship between Giorgione and Catena, which most likely transcended the mere sharing of an atelier. Catena moved in elevated aristocratic and intellectual circles, and his social affiliations were of benefit to his colleague Giorgione. For example, Catena had connections with Doge Leonardo Loredan, and these may have been instrumental in Giorgione being awarded prestigious public commissions, including the decoration of the facade of the Fondaco dei Tedeschi in central Venice. Giorgione also

received a commission from the highest levels of the Venetian state to produce a large canvas for the hall of the Consiglio dei Dieci (Council of Ten).

With *The Tempest* (Gallerie dell'Accademia, Venice), *The Three Philosophers* (pl. 7) is one of the most difficult paintings to interpret in the history of Western art. The scene unfolds in a clearing, delimited on the left by a rock that is illuminated by a ray of light, and on the right by trees. A youth, dressed in white with a green cloak, sits in profile and looks toward the rock; he appears to hold a ruler and a compass. A turbaned figure, colorfully dressed in oriental fashion, stands in the foreground next to a white-bearded old man who holds a compass in his left hand and a tablet with inscriptions in his right. The sun either rises or sets behind the beautiful landscape. Once again, we are struck by the deep chromatic, compositional, and intellectual harmony that reigns among the figures, which are monumental in their solemnity, and by the sweet scenery of the Venetian hills.

Marcantonio Michiel was the first to describe the painting, in 1525, in the collection of Taddeo Contarini, a Venetian nobleman, collector, and humanist. According to Michiel: "The canvas picture in oil, representing three Philosophers in a landscape, two of them standing up and the other one seated, and looking up at the light, with the rock so wonderfully imitated, was commenced by Zorzo di Castelfranco and finished by Sebastiano." Scientific analyses, however, have proved that there was no substantial intervention by a different painter; if Sebastiano del Piombo (ca. 1485–1547) was indeed involved, his work was likely limited to a few touch-ups.

The mystery of the identity of the three figures has not been resolved. Some suggest a "scientific" reading of the subjects, which vary between astrologers and geometers in the Hamilton inventories. In 1782 Christian von Mechel put forth his interpretation that the men are the three magi awaiting the appearance of the Star of Bethlehem that would lead them to the Messiah. X-rays performed by Johannes Wilde in 1932 reinforced this interpretation, and studies undertaken for a 2004 exhibition found evidence of pentimenti showing that the old man had been wearing a rayed crown before it was replaced by a simple, hooded cloak. (The unusual form of the tablet in the man's hand has yet to be explained.) Various scholars have interpreted the figures as Aristotle, Plato, and Averroës; as personifications of the three major monotheistic religions; and, most recently, as the founding fathers of Western philosophy, Thales of Miletus, Pherecydes of Syros, and his disciple Pythagoras.

The theme of philosophy, particularly Renaissance humanism's quest for scientific knowledge, is common to all of Giorgione's paintings. Astronomers, mathematicians, and philosophers had appeared in the friezes of the Casa Marta Pellizzari in Castelfranco as a kind of summa of humanistic culture. Giorgione consciously returned to these subjects in *The Three Philosophers* and the Fondaco dei Tedeschi frescoes, in which one could discern the figures of geometers measuring the globe.

Leonardo's influence unmistakably reemerges in *Youth with an Arrow* (pl. 8), whose attribution

to Giorgione has been unanimously accepted by art historians since 1955. The painting is an undisputed masterpiece. The subject is a beautiful boy, his head slightly tilted to the right. His sweet and dreamy gaze never directly meets that of the viewer: it seems to go beyond, in absorbed contemplation. His face emerges from darkness, delicately shaped by golden light and shadow, giving it an expressive intensity similar to the effects achieved by the sculptor Tullio Lombardo (ca. 1455–1532). Indeed, the painting's genre and composition are closely linked to the sculptural tradition of the fifteenth century, which drew inspiration from late Roman portraiture. This work, too, has received numerous interpretations: religious (Saint Sebastian); mythological (Apollo or Eros); and more recent and complex readings that invoke the Neo-Platonic debate on the philosophy of love, a preoccupation of poets as well as most Renaissance artists and intellectuals. According to this theory, the intertwined beauty, love, and pain depicted in the painting represent the look (or arrow)—that is, the medium of love—that causes a wound that is simultaneously bitter and sweet.

We cannot know whether Giorgione's contemporaries and patrons saw in this painting a contribution to the debate on love. What is certain, however, is that the subject was successful. Michiel described two paintings of Saint Sebastian by the artist in the collections of two patrician Venetians. Around 1638, a "Saint Sebastian by Giorgione" could also be found in the Venetian del Gobbo collection. The cruel yet poetic portrayal of old age in *The Old Woman* (Gallerie dell'Accademia, Venice), realized just a short time after *Youth with an Arrow*, is the very counterpoint to this beautiful adolescent.

Giorgione contracted the plague in the first and most terrible of the many waves of the scourge that hit Venice and the mainland in the sixteenth century; he died in September or October 1510 on Lazzaretto Nuovo, a quarantine island northeast of the city. The inventory of his personal belongings confiscated by the authorities sketches the portrait of a man whose financial substance amounted to little more than eighty ducats. Containing no mention of the items kept in his studio, the document brings laconic closure to the enigmatic life of this great artist.

—*Francesca Del Torre Scheuch*

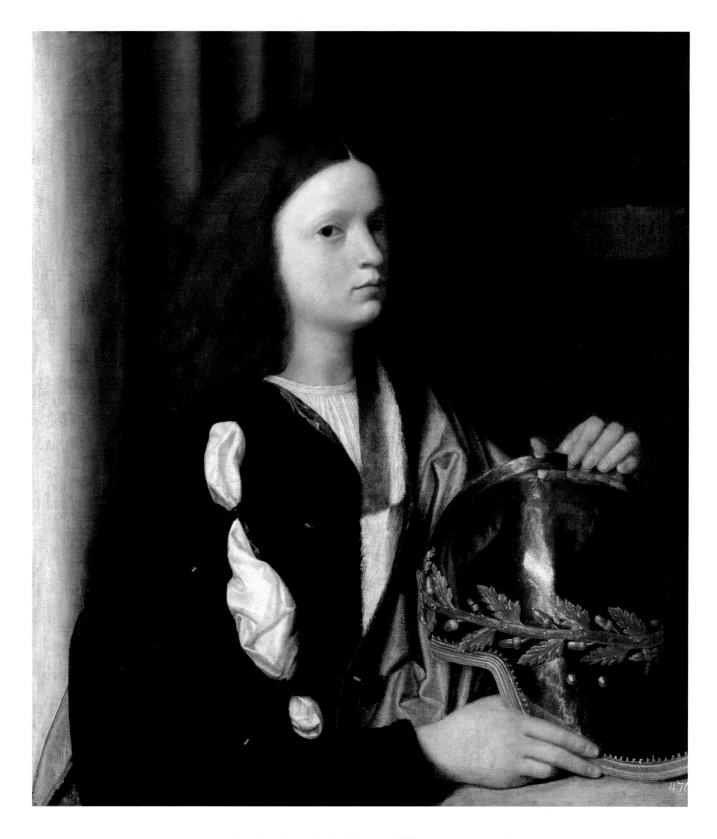

4　Attributed to Giorgio da Castelfranco, called Giorgione (ca. 1477–1510)
Portrait of Francesco Maria I della Rovere, ca. 1502
Oil on canvas
28¾ x 25¼ in. (73 x 64 cm)

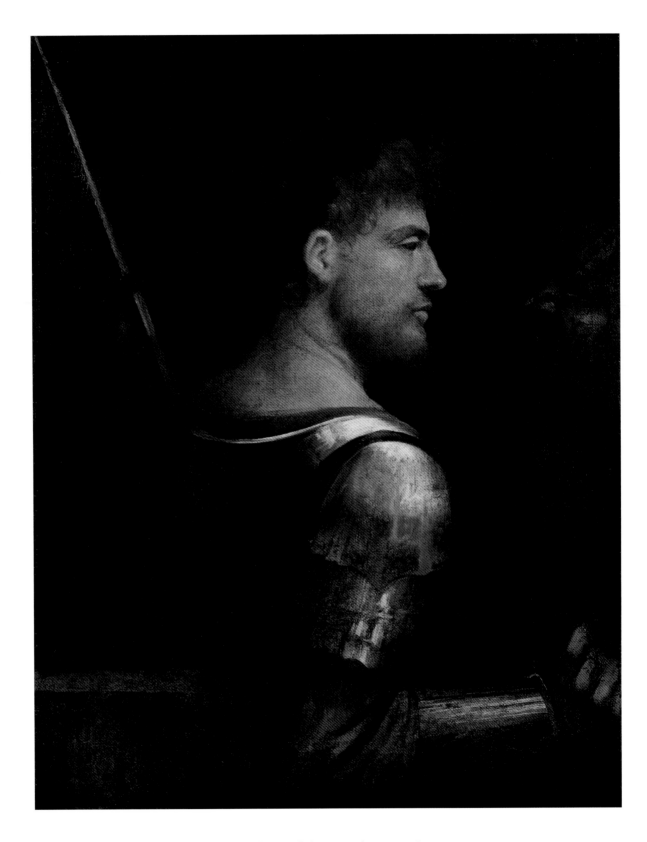

5 Giorgio da Castelfranco, called Giorgione (ca. 1477–1510)
 Warrior, ca. 1505–1510
 Oil on canvas
 28 x 22¼ in. (72 x 56.5 cm)

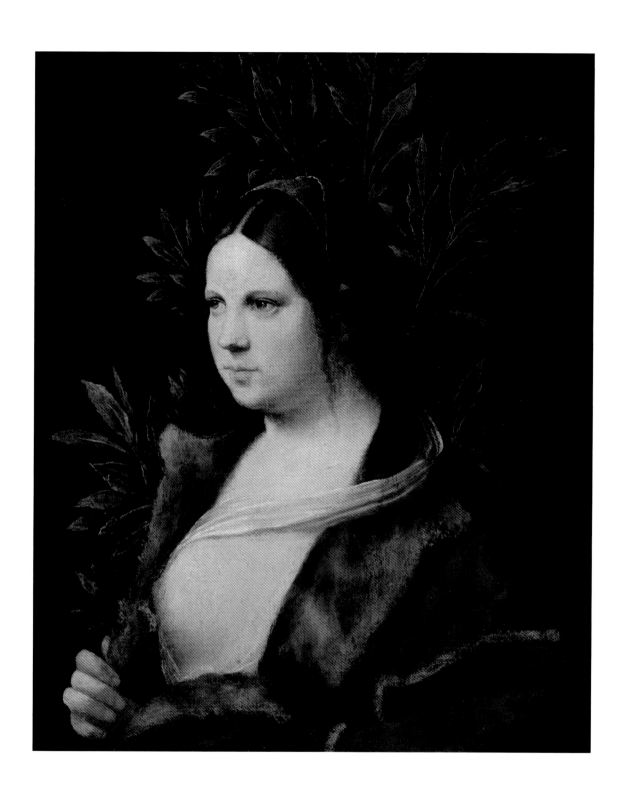

6 Giorgio da Castelfranco, called Giorgione (ca. 1477–1510)
 Portrait of a Young Woman (Laura), 1506
 Oil on canvas mounted on panel
 16⅛ x 13¼ in. (41 x 33.6 cm)

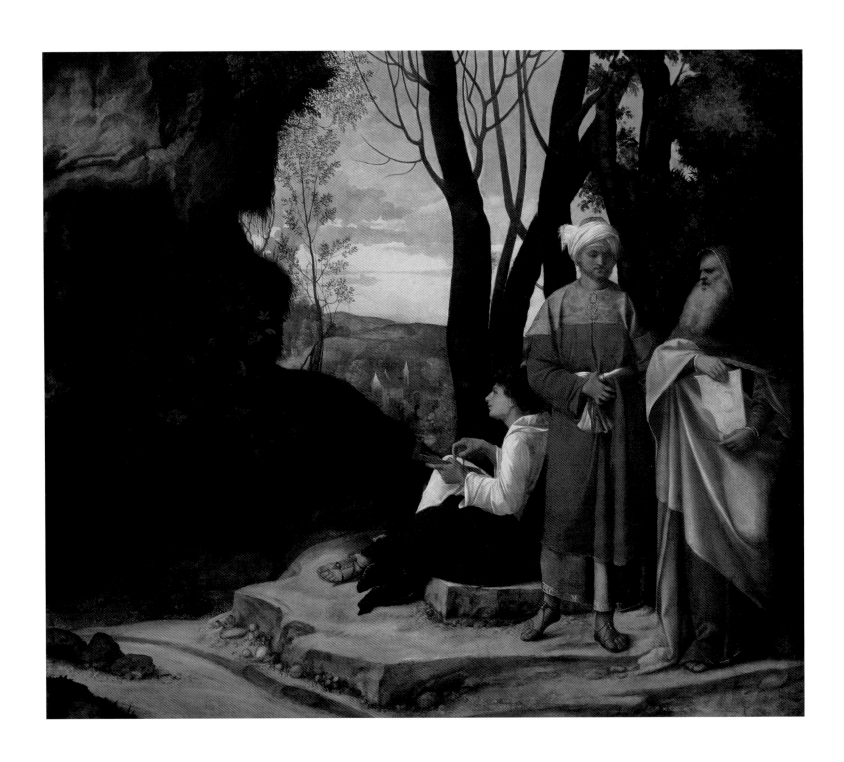

7 Giorgio da Castelfranco, called Giorgione (ca. 1477–1510)
The Three Philosophers, ca. 1508–1509
Oil on canvas
48¾ x 56⅞ in. (123.8 x 144.5 cm)

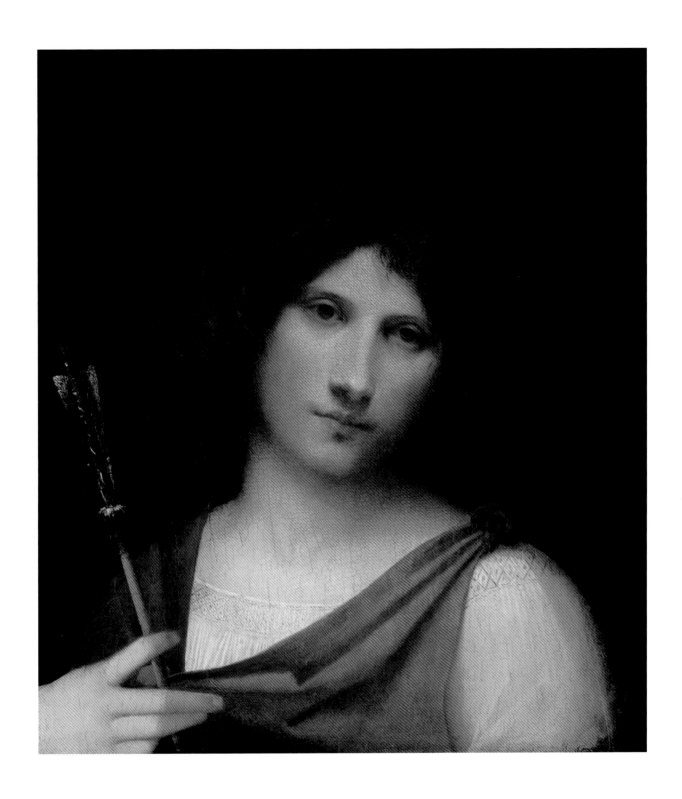

8 Giorgio da Castelfranco, called Giorgione (ca. 1477–1510)
 Youth with an Arrow, ca. 1508–1510
 Oil on panel
 18⅞ x 16½ in. (48 x 42 cm)

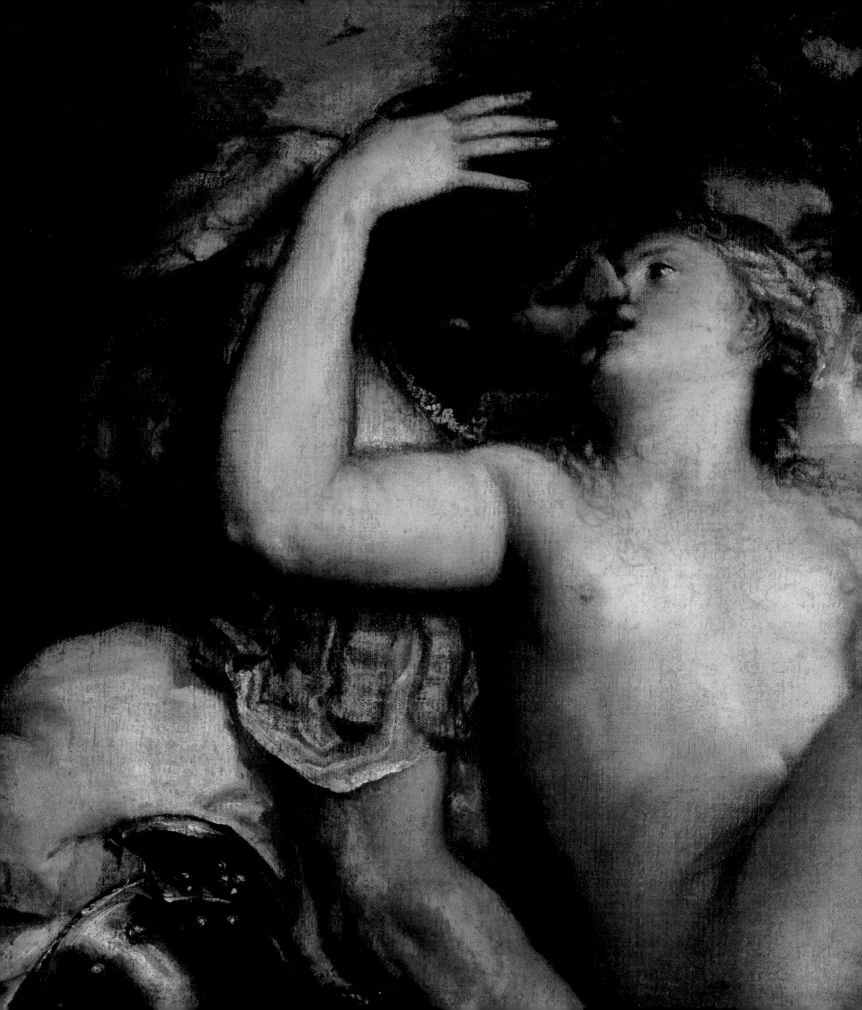

Titian

Born in the mountainous village of Pieve di Cadore in the Veneto, Tiziano Vecellio, known as Titian (ca. 1488–1576), dominated painting in sixteenth-century Venice; he also became one of the true giants of Western art, inspiring painters throughout the centuries. Titian was the youngest of the three painters who propagated a new artistic language in Venice during the first decade of the cinquecento. After Giorgione (ca. 1477–1510) died of the plague and Sebastiano del Piombo (ca. 1485–1547) went to Rome in 1511, Titian remained, eager to assume the mantle of *the* painter of La Serenissima, a distinction then enjoyed by the elderly Giovanni Bellini (ca. 1431/1436–1516).

From Bellini Titian inherited his sense of naturalism, his use of richly saturated colors, and his oil technique. For Bellini's enamel-like surfaces, however, Titian substituted a sensuous differentiation of textures and a diversified handling of the brush. From Giorgione he may have learned to manipulate impastoed pigments using visible brushstrokes and to exploit the blurred contours of sfumato, integrating figures into their surroundings and conveying the impression of atmospheric space. He developed a brilliant mastery of materials, freely experimenting with and mixing his pigments in his unconventional quest for new effects. The moistness of Titian's landscapes is almost tangible, and his figures have a vital, assertive presence that exudes self-confidence, responsibility, and other hallmarks of the Renaissance man. Titian seems to have embodied this ideal; he presented himself as a charming, shrewd, self-assured, and socially astute painter, and he enchanted his noble and royal patrons. He appears to have worked quickly and with great ease. He succeeded in all genres, from mythological, historical, and religious subjects to allegories and portraits, and in a variety of media, from frescoes to works on canvas or panel.

Titian's first public triumph—a large altarpiece, *The Assumption of the Virgin*, for Venice's church of Santa Maria Gloriosa dei Frari—was executed between 1516 and 1518. Situated on the high altar of the Gothic church, the painting was intended from its inception to present the Assumption of the Virgin as a dramatic and explosive vision of light and color never before seen in Venice. His famous bacchanal scenes for Alfonso d'Este, Duke of Ferrara, painted between 1516 and the early 1520s, marked his first successful commission for a powerful private patron. From the noble Este family he went on to work for Federico II Gonzaga, Emperor Charles V, and Pope Paul III. In the 1530s he created some of the touchstones of Western art for Francesco Maria I della Rovere, Duke of Urbino, and his family: the *Venus of Urbino* (Galleria degli Uffizi, Florence) and the portrait known as *La Bella* (Palazzo Pitti, Florence).

Titian continued to fulfill his role as the painter of La Serenissima, turning out altarpieces, large-scale religious paintings for the Palazzo Ducale, and devotional works for private citizens, although over the years he reduced such commitments to follow his grander patrons: the pope and his circle, the emperor and his entourage. He went twice to Augsburg, in 1548 and in 1550–1551, where he produced the famous equestrian portrait of Charles V as the glorious victor in the battle against the

Protestants at Mühlberg. When Titian met the son of the emperor, who was to succeed his father as King Philip II of Spain, he projected his concept of the ideal patron of painting onto the young prince. For Philip Titian created subjects of his own invention, including a series of paintings of heartbreaking beauty known as the *poesie*. To render these poetic myths Titian developed his technique still further, arriving at an open, expressive brushstroke capable of conveying the drama of his vision.

From the start of his career Titian maintained a large family workshop; it is not always clear what kind of work was assigned to his assistants. The artist left an enormous oeuvre, and today there is a general consensus on Titian's authorship of some three hundred artworks. Though most of the paintings in the present exhibition are considered to be by the artist's own hand, we have indicated where there are reasons to think that certain works were collaborations.

The portraits included here span about sixty-five years of Titian's career and demonstrate his changing modes of representation—not only over time but also in response to the various social standings of his subjects. According to the renowned biographer of the artists' lives, Giorgio Vasari, "there was almost no famous lord, nor prince, nor great woman, who was not painted by Titian." Of the approximately one hundred portraits produced by Titian, which enable us to trace the course of sixteenth-century Italian and European history, those presented here are a very significant group. What unites them all, and what made them so desirable to his patrons, was Titian's ability to highlight his subjects' most positive traits—their ideal personae.

With its rather stern pose and pronounced official quality, the portrait of Giacomo Bartolotti of Parma (pl. 9), who presided over Venice's College of Physicians from 1511 to 1512, may well have been commissioned to commemorate this office. Bartolotti is depicted as a powerfully intelligent dignitary, to whom one might safely trust one's health. His intense gaze has an ironic alertness that seems to convey more of his personality, beyond that of his official role as physician. Giorgione's portrait of a man (San Diego Museum of Art) may portray a younger Bartolotti.

Portrait of Isabella d'Este, Marchioness of Mantua (pl. 10) was painted approximately twenty years later and demonstrates the artist's skill in differentiating the textures of flesh, hair, velvet, and fur. Titian based this likeness on a portrait by Francesco Francia (ca. 1450–1517), itself a copy after the work of another painter, which explains Isabella's generalized features and absent expression. Isabella was in fact more than sixty years old at the time this work was executed. Titian had painted her from life about a decade earlier, in a red dress, and a copy of that portrait by Peter Paul Rubens (1577–1640), today also in the Kunsthistorisches, makes it clear that the earlier canvas was a far more realistic portrayal of her true age. So why would Titian paint such an idealized image?

Isabella was brought up in Naples by her mother, Eleanor, the wife of Ercole I d'Este, Duke of Ferrara, in a manner befitting the granddaughter of King Ferdinand of Aragon. She was educated

in literature and music, and her court was frequented by famous literary figures such as Pietro Bembo and Baldassare Castiglione. A connoisseur, she became the first female patron of the arts of international renown. Her remarkable collection of antiquities and of artworks in the classical style included a sleeping Cupid by Michelangelo (1475–1564). For the decoration of her studiolo she commissioned mythological and allegorical subjects from the most important artists of the quattrocento and cinquecento, and it became the prototype for other such ventures, most notably the Ferrara studiolo of her brother Alfonso d'Este, for whom Titian painted his famous bacchanals. The portrait of Isabella in blue can thus be seen as Titian's tribute to her illustrious political and social influence. Upon seeing the painting, she diplomatically remarked: "The portrait by Titian's hand is of such a pleasing type that we doubt that we were ever, at the age he represents, of such beauty that is contained in it."

Around the same time that Titian painted Isabella's portrait, the young Florentine humanist scholar Benedetto Varchi moved to Venice to serve as the tutor to Filippo Strozzi's children; he arrived in 1536 and departed in 1543. Titian's *Portrait of Benedetto Varchi* (pl. 11) bears the artist's signature on the column but is not dated. Although the subject's name was only proposed in the late eighteenth century, comparisons with known images of Varchi leave no doubt about the identification. Varchi was a distinguished historian who made important contributions to the Tuscan language; among art historians today he is known for his participation in the *paragone*, the famous Renaissance debate over the hierarchy of the fine arts. An inheritance enabled him to live like a nobleman and hire Titian to paint his portrait. He is depicted in an aristocratic, three-quarter-length pose, turned slightly to the left and leaning against the pediment of a column. Dressed in elegant black, with a small book in his right hand (perhaps a *petrarchino*?), he gazes, lost in contemplation, into the distance. Portraits such as this, expressing utmost refinement in dignified surroundings furnished with rich draperies and columns, were highly influential for later portraitists, including Rubens, Anthony van Dyck (1599–1641), and Pompeo Batoni (1708–1787).

Less elegant yet equally impressive is *Portrait of Johann Friedrich, Elector of Saxony* (pl. 12). As the most important exponent of the Protestant Schmalkaldic League, he had been taken prisoner by the Holy Roman emperor at the battle of Mühlberg in 1547. Titian portrayed him twice. One painting (Museo Nacional del Prado, Madrid), a work of lesser quality, shows the elector in armor, bleeding from a wound received in combat. The Vienna portrait, however, once again displays Titian's deep understanding of the human condition. Although the painting emphasizes the dignity of the sitter, it leaves no doubt of Johann Friedrich's precarious circumstances. Atop the heavy mass of the prisoner's body sits a rather small head, and on his face is a resigned expression. Most significantly, Titian applied an ostentatious technique—particularly noticeable in the fine modeling of the face and the painstaking indication of each curl in the beard—recalling the work of Johann Friedrich's court

painter, Lucas Cranach the Elder (1472–1553). The canvas was prepared with oil-based lead white, an unusual medium typically employed, according to Vasari, for works destined to travel. From this one might argue that Titian executed the work in Venice and sent it back to Augsburg.

A cenotaph-like plaque at the upper left of Titian's portrait of a man with a black boy in attendance (pl. 13) bears the inscription *MDLVIII / FABRICIUS SALVARESIUS / ANNU[M] AGENS L. / TITIANI OPUS* (1558, Fabrizio Salvaresio, age fifty, made by Titian). Salvaresio was a powerful merchant who made his fortune importing grain. Leaving no doubt about his success, he is shown wearing a fur-lined coat with a rich silk sash around the waist, posing before a pedestal bearing a domed clock. The timepiece may have been a studio prop; Titian likely became interested in them while he was in Augsburg, where the most famous table clocks were then produced for export. The figure in profile offering flowers is similar to the little boy visible in Titian's earlier portrait of Laura Dianti (private collection, Switzerland). African slaves were by then common in Sicily and Venice, and the boy's fancy dress and flowers may be intended to suggest that he was well treated and happy, even though Salvaresio's family was also involved in the slave trade.

According to scholar Charles Hope, Titian married at least twice, and he had two sons, Pomponio and Orazio, and two daughters, Lavinia and Emilia. The artist was especially fond of the girls and painted them both. Lavinia, the presumed subject of the portrait included here (pl. 14), married a Venetian nobleman in 1555; her date of birth is assumed to be between 1535 and 1540. She bore six children and died between 1574 and 1577. Her name appears in an inscription on a portrait in Dresden that bears a resemblance to the Vienna painting, particularly in the green-gold coloring of the gown. A recent X-ray of the Vienna portrait revealed an earlier composition with a dress identical to that worn by the Dresden lady—confirmation that the Dresden and Vienna portraits may depict the same individual at different times.

The most celebrated masterpiece of Titian's late portraiture (pl. 15) represents Jacopo Strada, an art dealer and antiquarian from Mantua who served Albrecht V, Duke of Bavaria, and three Habsburg emperors: Ferdinand I, Maximilian II, and Rudolf II. Strada's identity is confirmed by the inscription on the cartouche at upper right: *JACOBUS DE STRADA. / CIVIS ROMANUS. CAESS. / ANTIQUARIUS ET COM / BELLIC. AN. AETAT. LI ETC M.D.LXVI* (Jacopo de Strada, Roman citizen, imperial antiquarian and minister of war, age fifty-one, in the year 1566). A letter on the table in the foreground is addressed to "il Signor Ttiano Vecellio . . . Venezia." Titian's depiction flatters the sitter, showing him in elegant attire as he proudly displays his prized possessions. One of Strada's primary interests was numismatics, and he published a number of books on the subject, to which the volumes visible above his head might allude. The coins on the table, bearing the profiles of Roman emperors (the precursors of the Habsburg empire), refer to Strada's occupation as an antiquarian, as do the

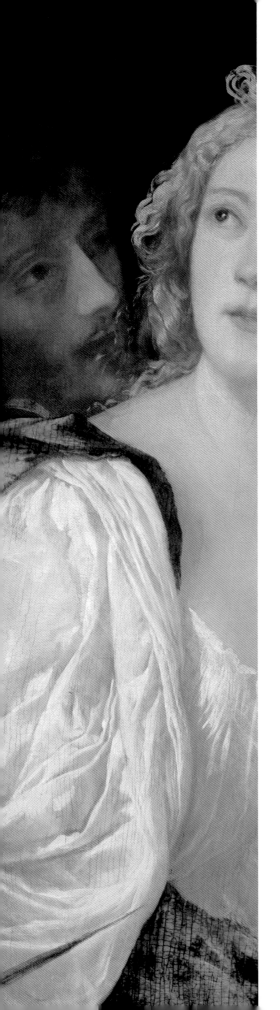

classical torso fragment and the figure of Venus. In his subject's fleeting glance to the right, Titian captured a sense of anxiety, perhaps an awareness of the art dealer's distress at having to part with a beloved object. The work is also noteworthy for the artist's economy of technique: the background is painted very thinly, leaving bare the structure of the canvas. Titian used a smoothing ground coat for objects in the foreground to provide a more even surface.

Despite intense interest in artistic developments among Renaissance humanists and antiquarians, the Catholic Church remained the most important patron of the arts. Religious subjects are primary in Titian's artistic production, and many of his large-scale altarpieces remain in situ in churches in Venice, Ancona, Brescia, and other Italian cities. Some religious works—particularly those made on a smaller scale for private devotion, such as Vienna's *Gypsy Madonna* (ca. 1510) and *Madonna of the Cherries* (1516/1518), are extremely fragile. Even though the paintings included here cannot represent the full spectrum of Titian's religious art, they tell us much about this aspect of his oeuvre. For example, in *Christ and the Adulteress* (pl. 16), the juxtaposition of the protagonists immediately signals the artist's intent to dramatize the story. The frieze-like arrangement of half-figures in the near foreground draws the viewer into the event. Christ turns toward the guilty woman, who is presented by a group of men demanding that she be judged and stoned. He absolves her, saying: "He that is without sin among you, let him first cast a stone at her" (John 8:7). From the surface condition and the general lack of color, it appears that the painting was probably never finished, and that it may have suffered from past restoration campaigns. Its composition is akin to the dramatic close-ups Titian developed in the 1510s and used less frequently after the early 1520s. X-ray, infrared, and chemical investigations have revealed a very complex work in progress beneath the final composition, dismissing the theory that the painting could be the work of a Titian imitator of the seventeenth century or later.

The little-known *Christ with the Globe* (pl. 17) was intended for private devotion. The iconography, deriving from Byzantine art showing Christ as pantocrator, was especially popular in fifteenth-century Netherlandish painting, and the duke of Urbino sent one such work as a prototype when, in the early 1530s, he requested a portrayal for his wife. Titian had developed this type of youthful, handsome Christ early and returned to it throughout his career. The Vienna painting is of such considerable quality that it is tempting to consider it to be by Titian himself: the facial features and hand are delicately modeled and the transparency of the glass globe is beautifully rendered. Nonetheless, the work lacks the lush surface treatment so typical of Titian's work of the 1510s and 1520s, notably his comparable depictions of Christ at the Palazzo Pitti, Florence, or in *The Tribute Money* (Gemäldegalerie Alte Meister, Dresden).

The Entombment of Christ (pl. 18) is most likely informed by a work Titian sent to Spain in 1557 but which was lost in transit. From documents we know that the earlier version was smaller and that it

had the same half-length figures. Titian replaced the lost work with a grander Entombment in which the figures are shown full length; later, in the 1570s, he sent yet another version to Spain (both now in the Prado). In the Vienna painting the drama is at closer range than in the later versions, but the figures' gestures are less dramatic and pathetic and there is more restraint in their mourning. The realism in the facial types and other details suggests that an artist from Germany or the Netherlands may have laid hands on the painting in Titian's workshop.

Titian seems to have been drawn to stories, myths, and allegories for their drama and their deeply poignant reflection of the foibles of humankind, and some of his most novel and successful canvases were inspired by these subjects. One such work, *The Tambourine Player* (pl. 19), is a perfect illustration of the theme of vanitas. The little boy is seated on stone steps in a landscape, holding a tambourine; however, rather than pounding away happily or at least childishly at his instrument, he looks melancholy. The work was listed as a painting by Giorgione in the Bartolomeo della Nave inventories, but it was identified as a Titian in all of Archduke Leopold Wilhelm's documentary materials. In modern times the painting lost its appeal and was relegated to Lorenzo Lotto (ca. 1480–1556); to Titian's brother Francesco (1475–1559/1560), who had used the motif in his altarpieces; and to Titian's early workshop. Only if we accept early Titian's capacity for twilight moods, in which a not-so-innocent babe might play to the sound of the music of vanitas, can we appreciate the wonderfully painterly brushwork he had developed when he painted the altarpiece of *The Virgin and Child with Saints Anthony of Padua and Roch* (Prado).

Titian was particularly interested in historical events that were emblematic of great political change, such as the violation of Lucretia by the Etruscan prince Sextus Tarquinius, which was recounted by Livy in his *Ab urbe condita* (*The History of Rome*) and by Ovid in his *Fasti*. Lucretia's beauty and purity were publicly praised by her husband, which aroused the desire of the prince. He stole into her bedchamber and threatened to expose her adultery with a slave if she would not yield. She surrendered to him, deciding that she would tell the family about her rape, call for vengeance, and then commit suicide. This led to the overthrow of the prince's father, the Etruscan king, and the end of the Etruscan dynasty in Rome. Though Lucretia's historical importance has enjoyed little attention, her rape and suicide proved popular themes in the arts.

In Vienna's dramatic depiction (pl. 20), Titian focused on Lucretia on the verge of suicide. He invoked radiant beauty and purity through her upward glance, reminiscent of Christian martyrs illuminated by the desire to unite with God. The pale countenance of her husband in the background only emphasizes her great spirit, which prompted art historians to suggest that the subject of this painting was actually Arria, the wife of Caecina Paetus. After participating in a failed plot against the emperor, Paetus had to commit suicide but was afraid. Arria took the dagger, saying, "Paete, non dolet" ("Paetus, it does not hurt"), and plunged it into her heart. If we identify the cowardly man

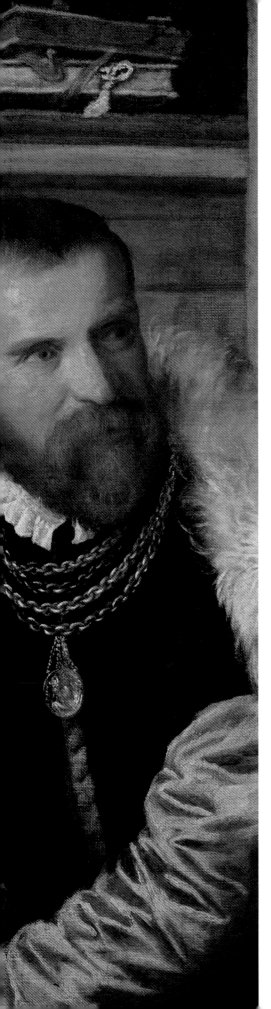

behind her as Paetus, this story, told in Pliny and Cassius Dio, does seem to fit our composition perfectly. However, X-rays suggest that in an earlier version the man was Tarquinius, holding the dagger, while Lucretia's right arm was bent upward in defense. This is merely one of many instances in which Titian changed not only the formal solution of a composition while working on canvas but also the dramatic moment of the story itself. Titian would return to the subject of Lucretia in a stunning late painting for Philip II (Fitzwilliam Museum, Cambridge).

The Bravo (The Assassin) (pl. 21) implicates the viewer as the witness of an impending attack. The violence is announced by the dagger in the hand of the aggressor in the lower right corner and travels through the brilliant red of his sleeve to his shaded face and then on to the coolly lit face of the intended victim, a blond man in bright blue attire who wears a wreath of vines. "The two figures who attack each other were by Titian" is how Marcantonio Michiel, a contemporary aristocrat, described the painting in 1528 when he saw it in the house of the Venetian nobleman Zuanantonio Venier. It may also be dated to around 1520, when Titian was still working on the famous bacchanals for Alfonso d'Este, Duke of Ferrara. Since the seventeenth century, the painting has borne the title *Bravo*, an idiomatic Italian word for a mercenary. Its subject has been identified as Claudius assaulting Caelius Plotius, as reported by the ancient Roman historian Valerius Maximus in his *Factorum et dictorum memorabilium (Memorable Deeds and Sayings)*, who had referenced Plutarch's *Life of Marius*. According to Plutarch, however, the aggressor is Caius Lusius, the nephew of the emperor, and the intended victim, Trebonius, actually killed his attacker. Another interpretation, which attempts to link Plutarch's story with the violent end of an unfortunate fourteenth-century ancestor of the house of Venier, remains as unsatisfying as the suggestion that the figures are creations of Titian's imagination and represent no identifiable personages from mythology or history.

While the threatened youth's longish blond hair, wreath of vines, and blue garb do not seem to correspond to any military figure in Roman accounts, they do correspond with other figures of Bacchus in Titian's oeuvre, and scholar Bruce Sutherland's interpretation of *The Bravo* that references the myth of Bacchus and his entourage seems the most promising. In Euripides's play *The Bacchae* and later in Ovid's *Metamorphoses*, we find the story of Pentheus, the king of Thebes, who wants to prevent the spread of Bacchus's orgiastic cult by having the god arrested. The arrogance in the victim's expression—as if to say "How dare you?!"—would be appropriate for a god at the moment of his arrest. Unusual for such representations is the sword visible in the Bacchus figure's right hand. Perhaps he had taken the sword of the soldier, who would have worn it on his right side. According to myth, Bacchus's revenge for the attempted arrest was terrible: Pentheus was torn to pieces by his own mother, who had become a maenad, a follower of Bacchus.

At the center of Titian's mythological inventions and *poesie* were erotic female nudes disguised

as Venus, Diana, Andromeda, Europa, and Danaë. As art historian David Rosand suggests, he had staked a claim to this genre with his *Sacred and Profane Love* of 1514 (Galleria Borghese, Rome) before arriving at his first true masterpiece, the *Venus of Urbino*. Completed by 1538, it set a new standard of desirability among Titian's highest-ranking male clients. When the artist's first painting of Danaë was well under way, it was reported among high clergy that she would make the *Venus of Urbino* look like a nun.

From the early 1550s on, Titian sent his beautiful *poesie* to King Philip II of Spain, with whom he might have discussed the importance of Ovid's *Metamorphoses* when they met in Milan or Augsburg in 1548 or 1550. From the detailed correspondence between the artist and king, we are aware of Titian's progress in the execution of the Ovidian myths. Of the six original compositions known today, two are still in Spain, three are in Great Britain, and one is in Boston. Titian sent additional mythological creations to the king, including many paintings of Venus with a musician, and still others, such as *Lucretia*, which he called an *inventione di pittura* (painting invention).

The three *poesie* in Vienna—*Mars, Venus, and Cupid* (pl. 22), *Danaë* (pl. 23), and *Nymph and Shepherd* (pl. 24)—feature the nude from the front, the side, and the back. The shifting point of view played a very important role in Titian's vision of the *poesie*, and he drew attention to this feature in one of his letters. Although we do not know who commissioned *Mars, Venus, and Cupid*, there is no doubt that it is charged with erotic intensity and features a remarkably inventive composition. We know of no other representation by Titian of this, the most popular theme of godly adultery in Italian Renaissance painting. Mars approaches from behind, clearly demonstrating his desire. Although the amorous encounter takes place in nature, the setting is comfortably furnished with satin cushions and a carpet. Cupid, hovering over the couple with his bow, seems quite content with his work.

As always with Titian, it is difficult to establish if he invented the story in this picture or if there were precedents. X-rays of a painting of a nymph and a satyr with the same compositional structure (private collection, Great Britain) revealed figures of Mars and Venus much as we find them here. The complex composition and the suave handling of paint, as well as the summary description of the distant landscape, suggest a date in the mid-1550s. It is not to be dismissed that Titian may have been helped by a very gifted assistant.

According to Ovid, Danaë was imprisoned in a tower by her father, Acrisius, the king of Argos, after an oracle foretold great disaster should his daughter give birth to a son. But the god Jupiter saw her in the tower and came down to her in the form of a shower of gold. She bore a son, Perseus, and the prophecy was eventually fulfilled. Titian's first *Danaë* (Museo di Capodimonte, Naples) was destined for Cardinal Alessandro Farnese, the nephew of Pope Paul III, around 1545. Titian took it to Rome, where Vasari and Michelangelo came to admire it, though Vasari has Michelangelo say that Titian lacked in *disegno*. This work enjoyed such fame that other collectors

must have desired one of their own. The artist made the subject even more titillating for patrons by portraying their mistresses in the guise of Danaë, allowing them to identify themselves with the splendid god Jupiter. Another version, for Philip II (Prado), is so sumptuous in its handling of paint that it has prompted much recent discussion about its date of execution. The Vienna painting, yet another version, was sent in 1600 by Cardinal Montalto in Rome to Emperor Rudolf II in Prague. A comparison of the three works reveals little difference in Danaë's splendid repose, but the figures accompanying her vary greatly. In the Naples painting, Cupid proudly walks out of the scene, congratulating himself on his accomplishments. In Madrid we find an ugly old woman collecting coins (the shower of gold) into her apron; it has been suggested that she was inserted to heighten the beauty of Danaë. In the Vienna composition, which is more vertical in format, we find the old woman catching the coins in a golden platter. Whereas Jupiter appeared merely as a cloud in the earlier versions, in the Vienna picture (as well as in a version at the Art Institute of Chicago) we clearly see his face in the heavens.

If the execution of *Danaë*, while perfectly harmonious and of high quality, lacks the accentuated sensuality so typical of Titian's brushstroke, it is immediately recognizable in *Nymph and Shepherd*. A woman reclines on an animal fur in a wild landscape under a tempestuous sky. Her back is to us, but she turns her head to return the viewers' gaze. On the left sits a young man wearing a wreath and holding a flute; he turns toward her. One of Titian's most monochromatic paintings, *Nymph and Shepherd* was executed using very open, extravagant brushwork. This once linked it with a group of paintings that were considered to be unfinished and dated to varying periods. However, evidence uncovered during the course of restoration pointed in a different direction. What appears to be monochrome is in fact the result of building up multiple layers of vivid color—bright reds, yellows, and greens— that were subsequently subdued. We must therefore assume that the painter worked very carefully to achieve this restrained palette. In the face of such technique, the idea of complete or incomplete becomes irrelevant; in most cases, "completion" was left to the whim of the artist, who may have regarded a work as finished at one point but then decided to continue on it later. His pupil Palma Giovane (ca. 1548–1628) in fact described this as Titian's working method.

But it is not just the question of finish, commission, and date of the painting that are mysterious. Its subject, a reclining nude seen from the rear, may have been inspired by an early print of Venus by Giulio Campagnola (ca. 1482–after 1515): in the X-ray we find the woman reclining on a cloth, similar to Giorgione's *Sleeping Venus* (fig. 19). The prototype for the young shepherd may be Sebastiano del Piombo's *Polyphemus* (Villa Farnesina, Rome). The enigmatic theme has inspired art historians to interpret it variously as Endymion and Diana, Venus and Anchises, Daphnis and Chloe, Paris and Oenone, and many more. Among the more likely identifications are Bacchus and Ariadne, strongly favored by Augusto Gentili. The melancholic mood and the reference to the pastoral—the shepherd and his flock

in the background at right—suggest, according to Hans Belting, the poet Jacopo Sannazzaro's *Arcadia*, in which the shepherd Galicio praises a beautiful nymph viewed from behind. It has been observed that the elderly Titian often returned to subjects that had preoccupied him in his youth, and Sannazzaro's pastoral poetry was very much in vogue at the beginning of the 1500s. But how differently Titian interprets the pastoral now! The languid woman turns toward us and, with a philosophical, all-knowing gaze, draws us into her mysterious world—a place where a man, whether a shepherd or a god, can only pay reverence to the all-encompassing feminine power of nature.

— *Sylvia Ferino-Pagden*

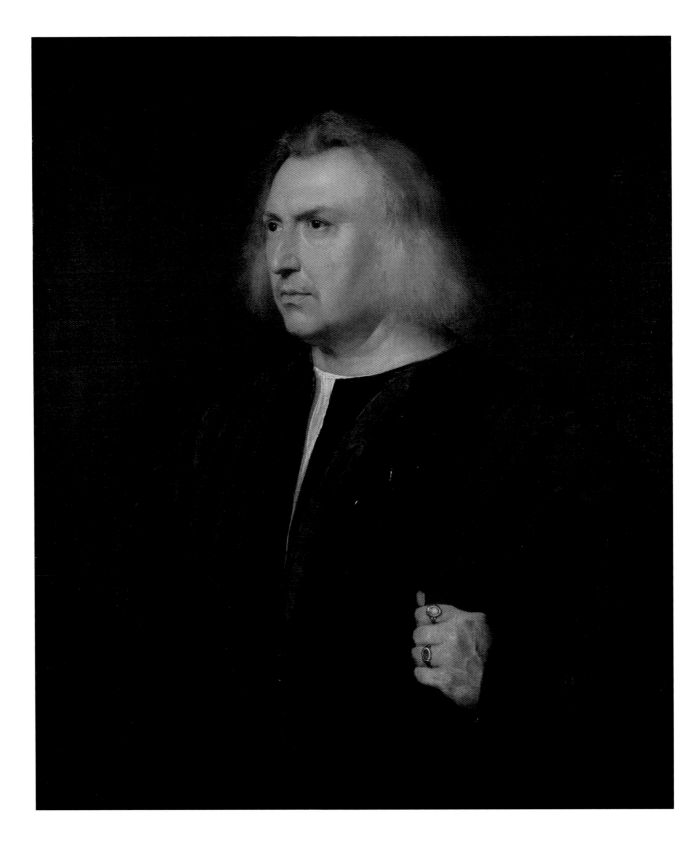

9 Tiziano Vecellio, called Titian (ca. 1488–1576)
Portrait of Physician Giacomo Bartolotti of Parma, ca. 1512–1515
Oil on canvas
34⅝ x 29½ in. (88 x 75 cm)

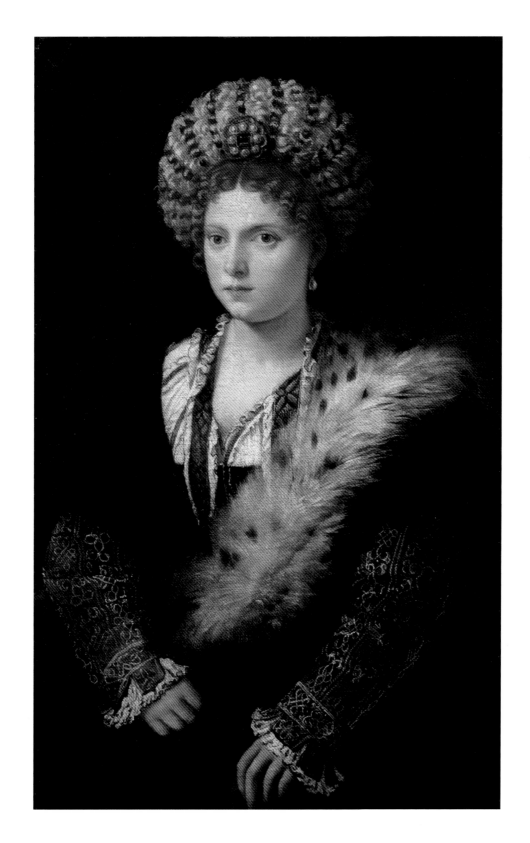

10 Tiziano Vecellio, called Titian (ca. 1488–1576)
Portrait of Isabella d'Este, Marchioness of Mantua, ca. 1534–1536
Oil on canvas
40⅛ x 25¼ in. (102 x 64 cm)

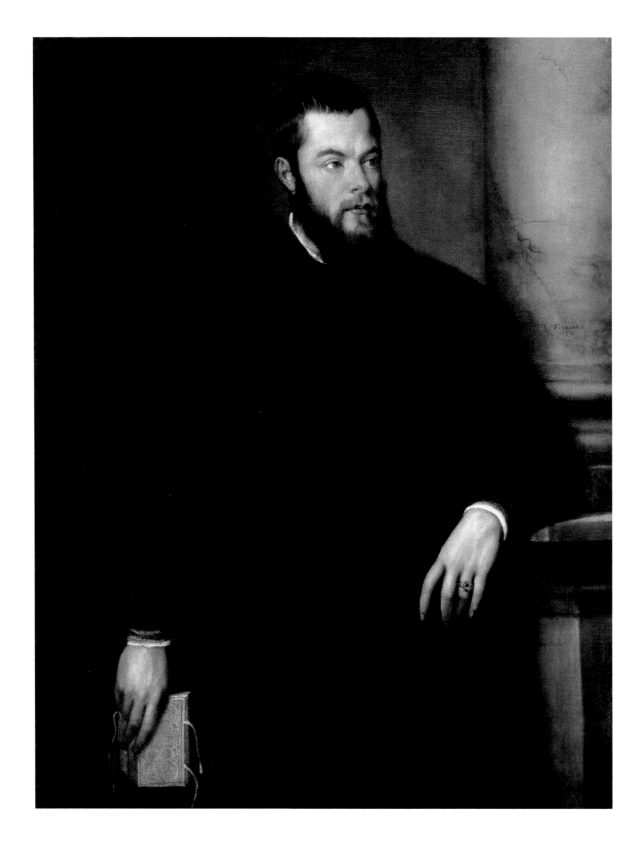

11　Tiziano Vecellio, called Titian (ca. 1488–1576)
Portrait of Benedetto Varchi, ca. 1540
Oil on canvas
46 x 35⅞ in. (117 x 91 cm)

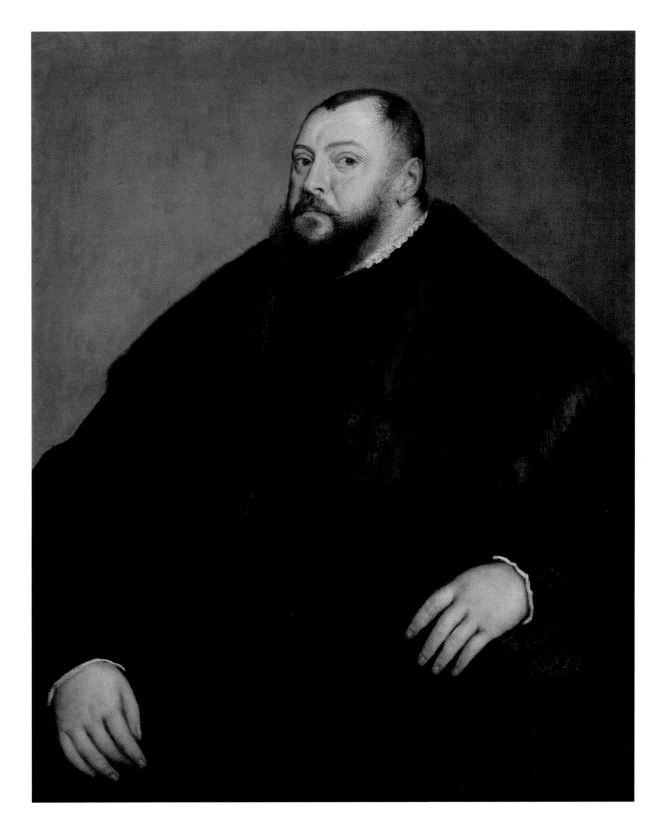

12 Tiziano Vecellio, called Titian (ca. 1488–1576)
Portrait of Johann Friedrich, Elector of Saxony, ca. 1548–1551
Oil on canvas
40¾ x 32⅝ in. (103.5 x 83 cm)

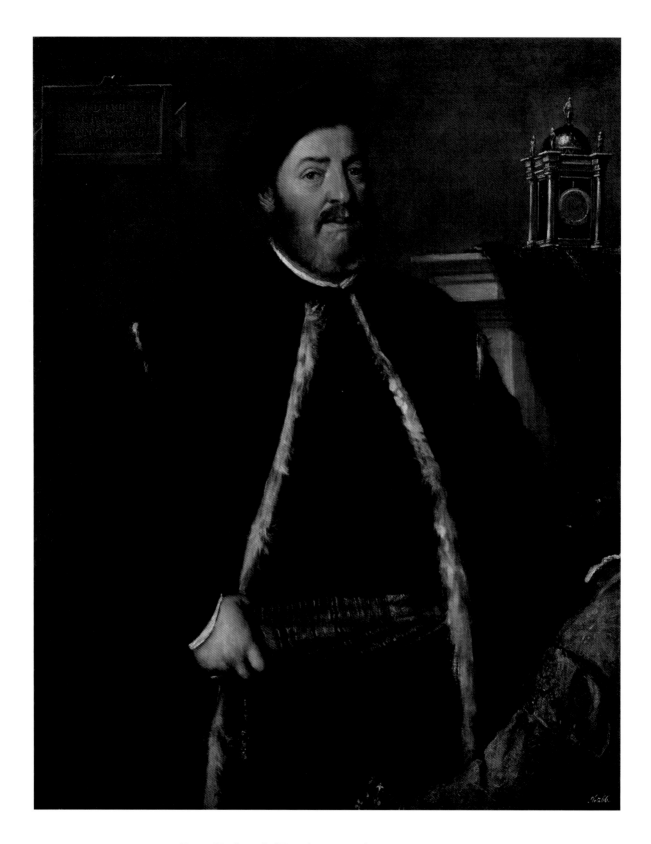

13 Tiziano Vecellio, called Titian (ca. 1488–1576)
Portrait of Fabrizio Salvaresio, 1558
Oil on canvas
44⅛ x 34⅝ in. (112 x 88 cm)

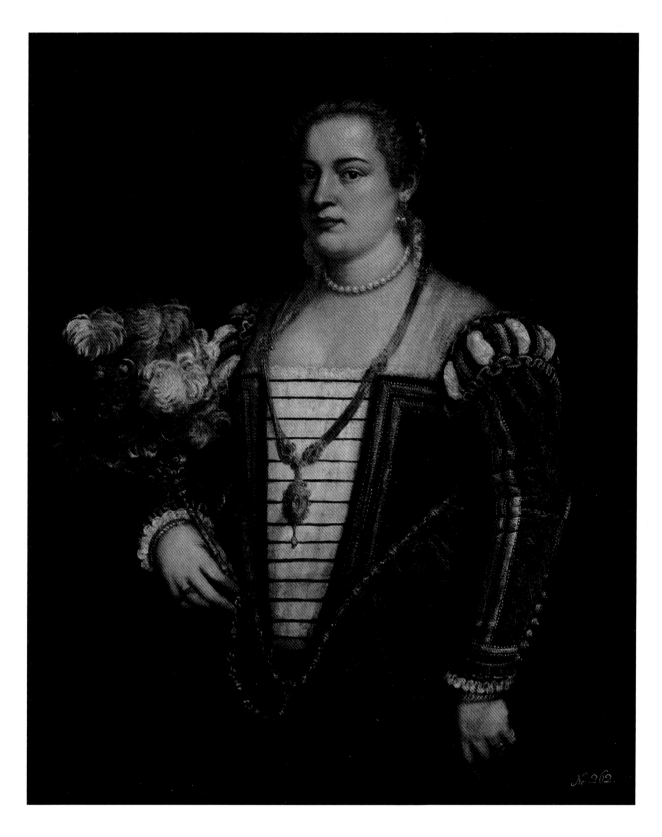

14 Tiziano Vecellio, called Titian (ca. 1488–1576)
Portrait of Titian's Daughter Lavinia as a Matron, ca. 1565
Oil on canvas
43¾ x 35⅝ in. (111 x 90.5 cm)

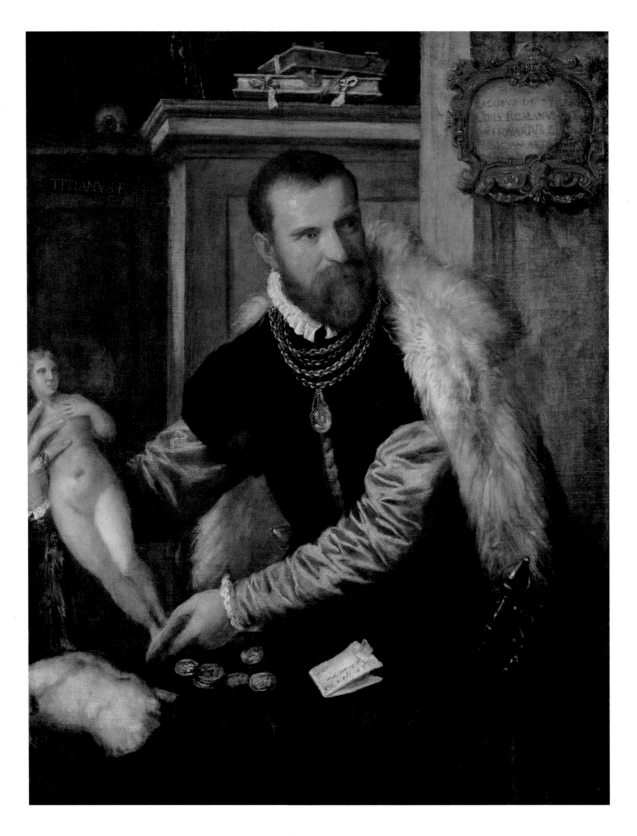

15 Tiziano Vecellio, called Titian (ca. 1488–1576)
Portrait of Jacopo Strada, ca. 1567–1568
Oil on canvas
49¼ x 37⅜ in. (125 x 95 cm)

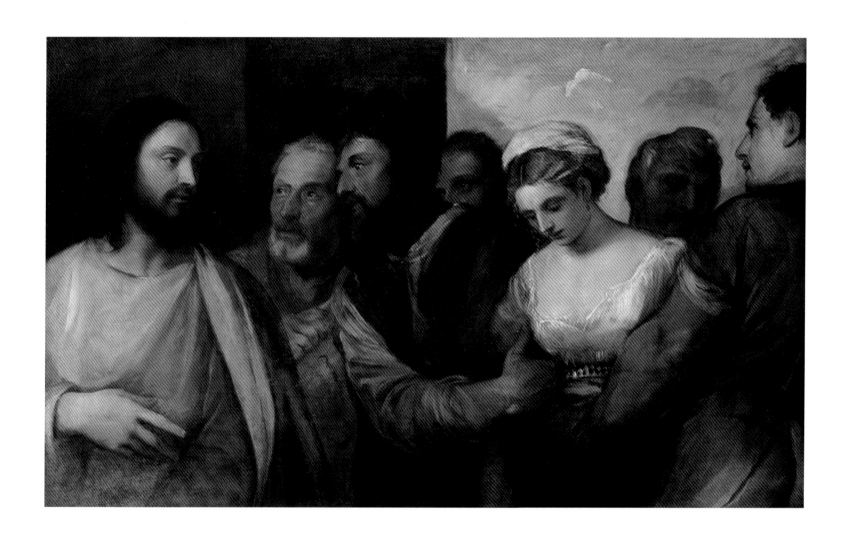

16 Tiziano Vecellio, called Titian (ca. 1488–1576)
Christ and the Adulteress, ca. 1520
Oil on canvas
32½ x 53¾ in. (82.5 x 136.5 cm)

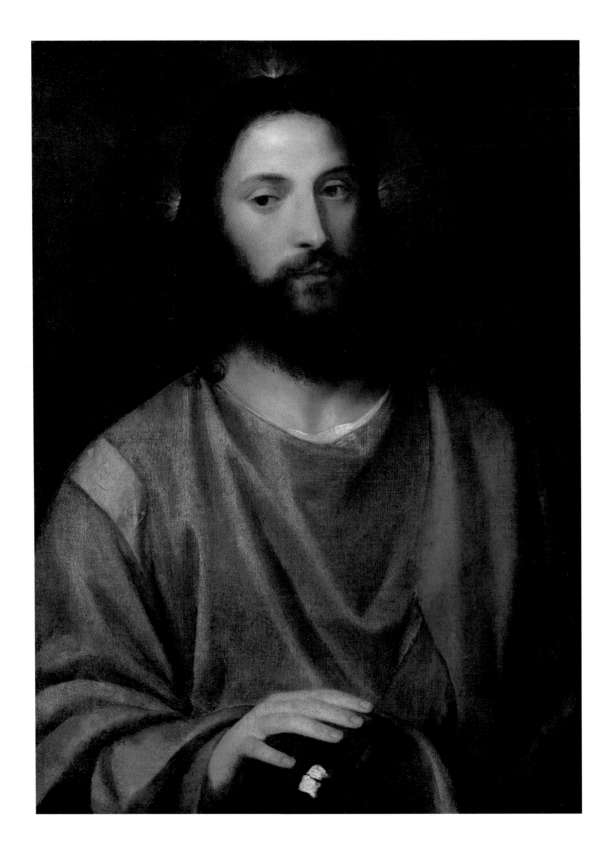

17 Workshop of Tiziano Vecellio, called Titian (ca. 1488–1576)
 Christ with the Globe, ca. 1530
 Oil on canvas
 32½ x 23⅞ in. (82.5 x 60.5 cm)

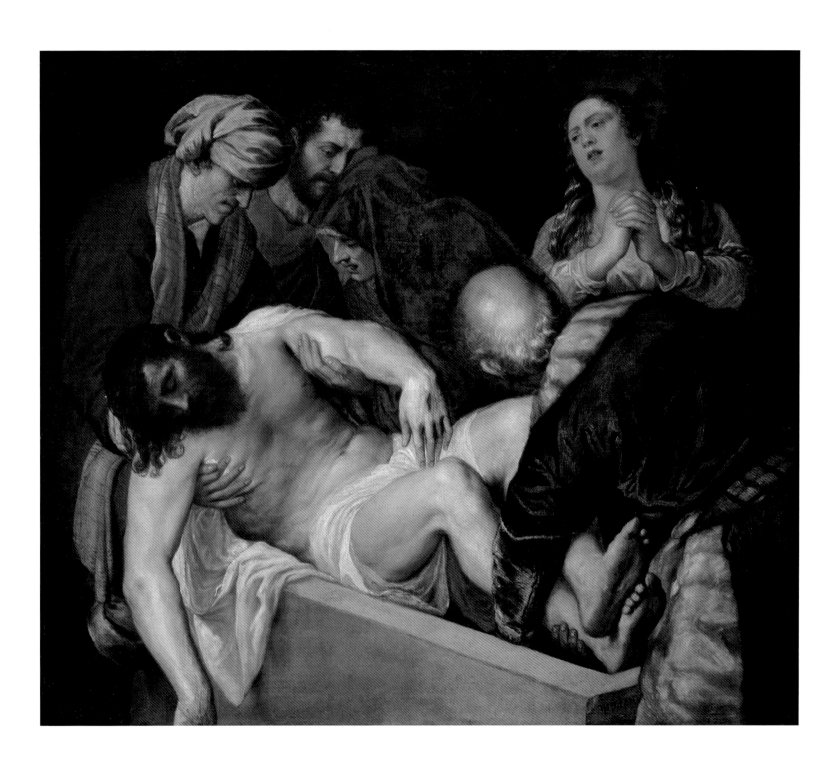

18 Workshop of Tiziano Vecellio, called Titian (ca. 1488–1576)
The Entombment of Christ, after 1557
Oil on canvas
39⅛ x 45½ in. (99.5 x 115.5 cm)

19 Attributed to Tiziano Vecellio, called Titian (ca. 1488–1576)
 The Tambourine Player, ca. 1510
 Oil on canvas
 22⅝ x 20½ in. (57.5 x 52 cm)

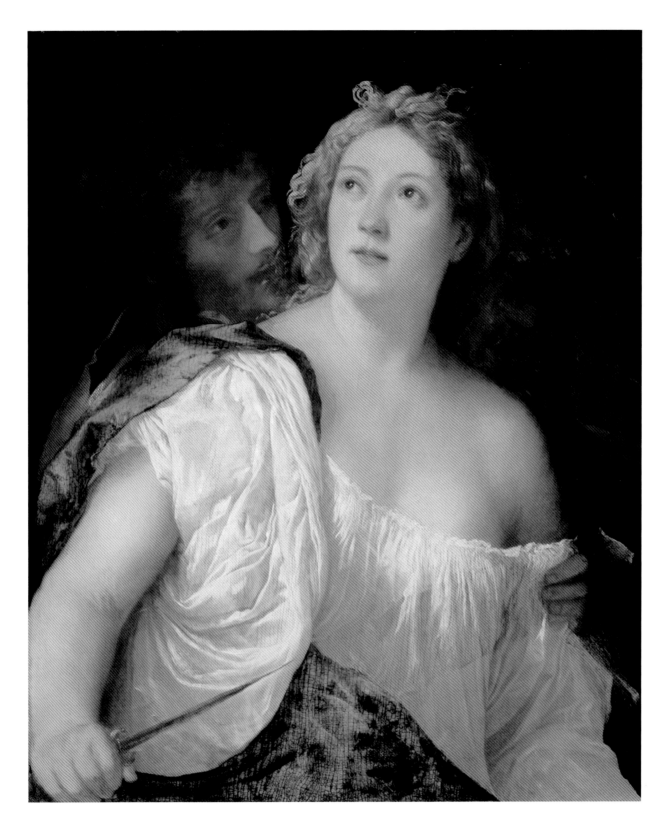

20 Tiziano Vecellio, called Titian (ca. 1488–1576)
Lucretia and Her Husband, Lucius Tarquinius Collatinus, ca. 1512–1515
Oil on panel
32½ x 27 in. (82.5 x 68.5 cm)

93

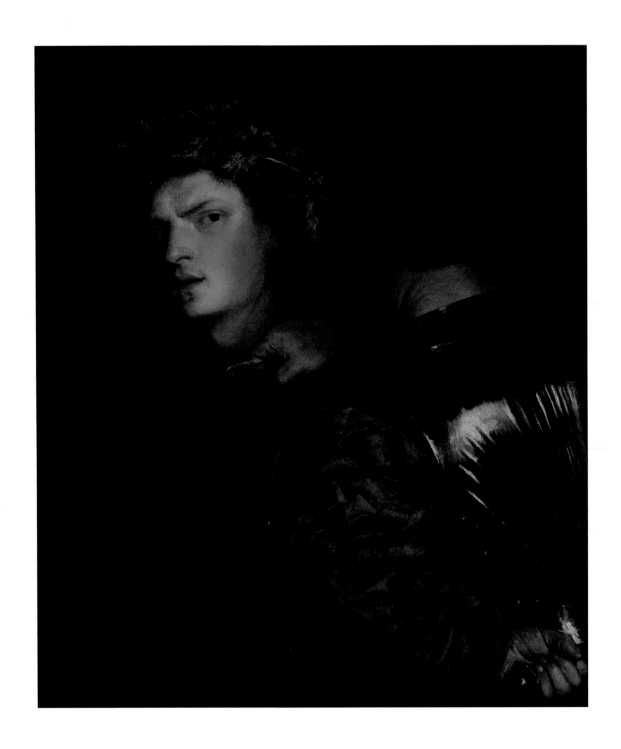

21 Tiziano Vecellio, called Titian (ca. 1488–1576)
The Bravo (The Assassin), ca. 1515–1520
Oil on canvas
11⅞ x 10¼ in. (30.3 x 26.2 cm)

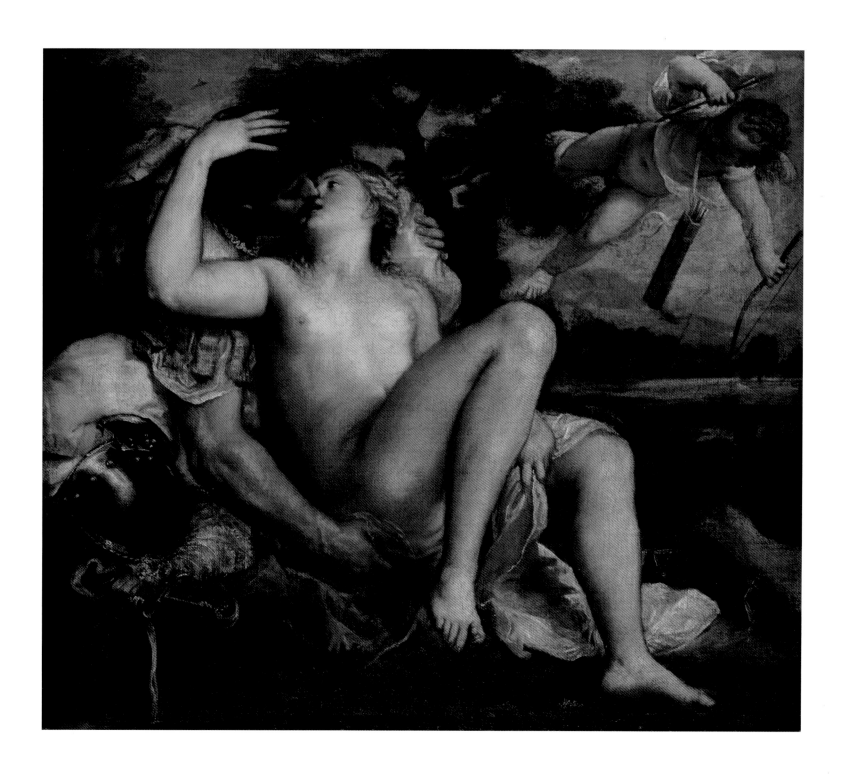

22 Tiziano Vecellio, called Titian (ca. 1488–1576)
Mars, Venus, and Cupid, 1550s
Oil on canvas
38¼ x 42⅞ in. (97 x 109 cm)

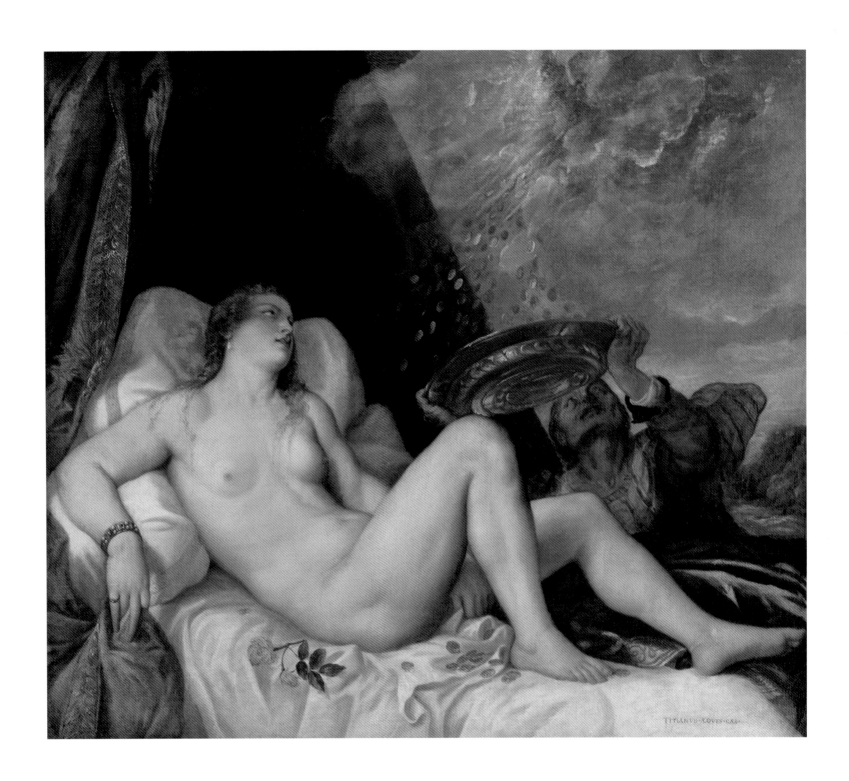

23 Tiziano Vecellio, called Titian (ca. 1488–1576)
Danaë, 1560s
Oil on canvas
53⅛ x 59⅞ in. (135 x 152 cm)

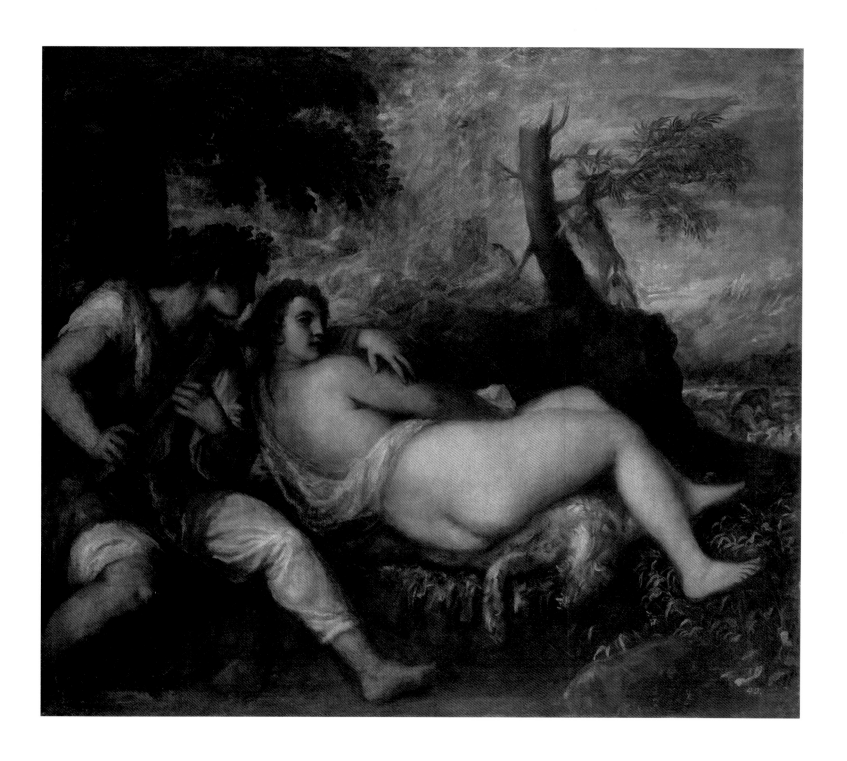

24 Tiziano Vecellio, called Titian (ca. 1488–1576)
Nymph and Shepherd, ca. 1570–1575
Oil on canvas
58⅞ x 73⅝ in. (149.6 x 187 cm)

97

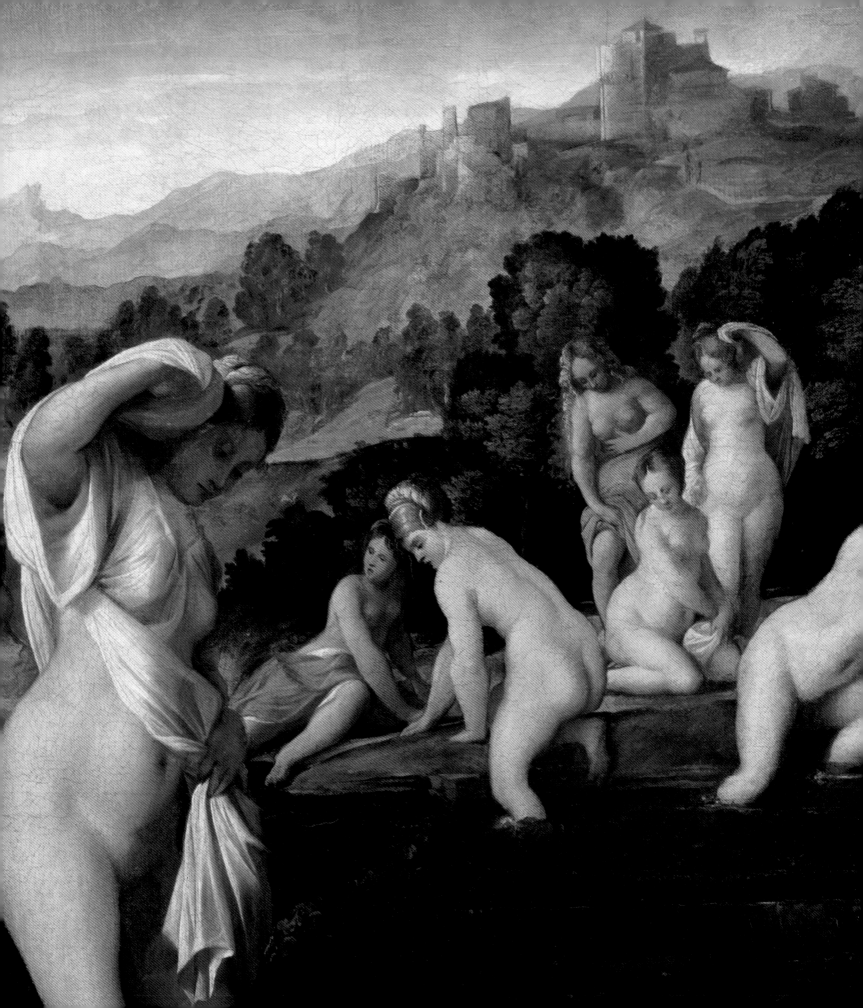

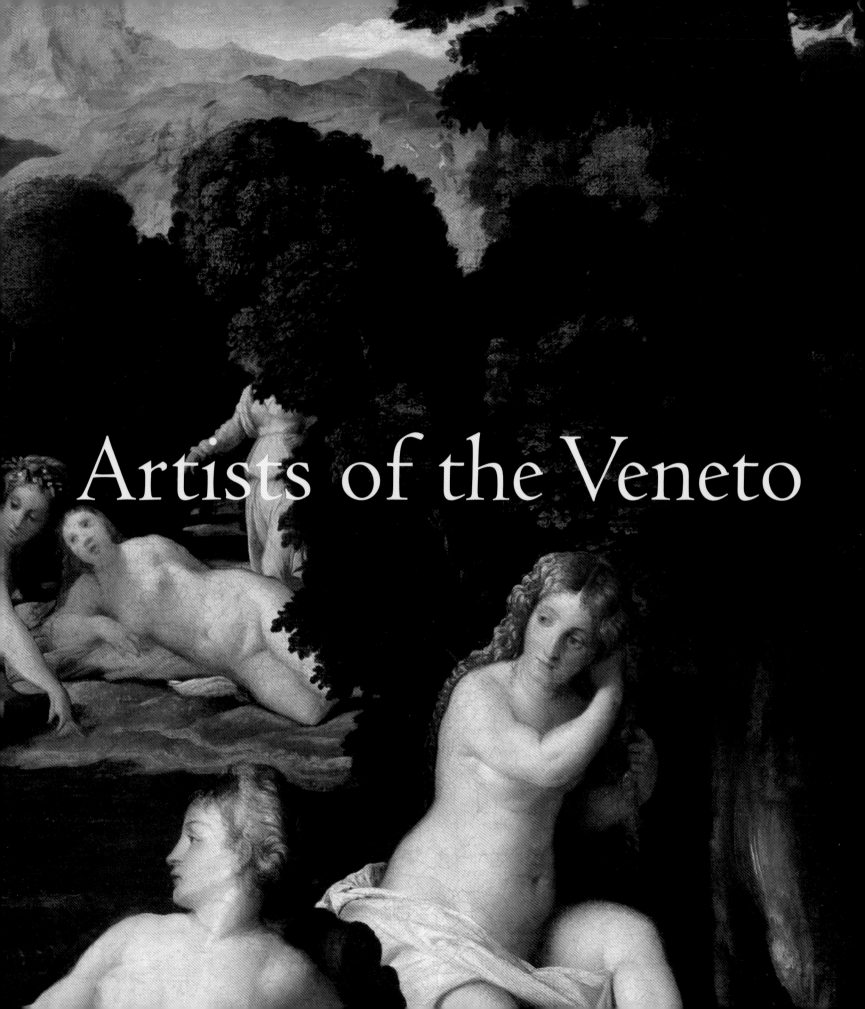

Artists of the Veneto

During the sixteenth century, the conflicting and overlapping territorial claims of the pope, the Habsburg Holy Roman emperor, France, England, Spain, various Italian city-states, and the Venetian Republic were challenged, defended, and won or lost by ever-shifting alliances. Venice's political and territorial reach fluctuated with the military gains and reversals that marked an unsettled century for northern Italy and indeed most of western Europe. The desire for a buffer zone between the vulnerable island city and her enemies dovetailed with commercial necessity and, by the end of the fifteenth century, Venice had consolidated control over extensive tracts of the Italian mainland. The city's control of northern Italian routes across the Alps into northern and central Europe partially mitigated Venice's weakening monopoly over Mediterranean seaborne trade (lost to Genoa and Portugal) and the disruption of Venice's role as an intermediary between Far Eastern and European markets.

In 1405 Venice conquered the nearby mainland cities of the Veneto plain, including Padua, Vicenza, and Verona (all less than seventy miles west of Venice). The more distant Lombard cities of Brescia, Cremona, and Bergamo (all more than a hundred miles west of Venice) were annexed in 1428; they were important strategically for their close proximity to the contentious boundary with Milan. The penetration of Venetian artistic influence within her new dominions varied greatly. While most of these centers already had and retained their own local artistic traditions, many were socially and artistically conservative in contrast to the sophistication of secular Venice. Artists in provincial towns emphasized the narrative and illustrative role of painting, and both they and their patrons were less interested in the purely aesthetic potential of the oil-on-canvas medium being exploited so poetically by the generation of Giorgione (ca. 1477–1510) and Titian (ca. 1488–1576). Thus the artistic character of metropolitan Venice did not necessarily predominate in all her territories; rather, ideas were exchanged between Venice and Italy's central and northern regional schools, and these influences varied based on the experiences of individual painters and their encounters with artists or artworks of Venetian origin.

While most regional artists remained just that, several masters of distinct and distinguished personality emerged and succeeded in the competitive atmosphere of Venice itself. During the first decades of the sixteenth century, among the most significant was Palma Vecchio. Born Jacopo Negretti (ca. 1480–1528) in the alpine village of Serina north of Bergamo in Lombardy, Palma belonged to the community of Lombard artists then resident in Venice, many of whom had been lured by the promise of patronage and, more pragmatically, of an escape from recurrent war on the mainland. Documents place Palma in Venice by 1510. His works from that time demonstrate the influence of Andrea Previtali (ca. 1480–1528), a fellow artist from Bergamo, and Lorenzo Lotto (ca. 1480–1556), a Venetian-trained artist active primarily in Bergamo and other provincial centers. Both Previtali and Lotto had in turn been influenced by the Venetian master Giovanni Bellini (ca. 1431/1436–1516). As Palma matured

artistically, his style and subject preferences aligned closely with Bellini, Giorgione, and the young Titian. While Palma painted a number of different subjects—including a *Sea Storm* (Gallerie dell'Accademia, Venice) much praised by his biographer, Giorgio Vasari, for its unique evocation of a terrifying tempest—he is famous for his treatment of two particular subjects: the *sacra conversazione* (sacred conversation) and half-length portraits of beautiful but unidentified blond women.

Palma's refinement of the *sacra conversazione* theme of the Virgin and Child informally accompanied by saints within a unified landscape, now organized in a horizontal format, brought him deserved renown. Palma also excelled at a new type of female portrait that ultimately derives from innovative works by Leonardo da Vinci (1452–1519) and was later adapted by Titian in, for example, his famous *Flora* (Galleria degli Uffizi, Florence). Titian's interpretation of feminine beauty resonates in Palma's work of the second decade of the cinquecento. Given the charm of Palma's female subjects, it is not surprising that several superior examples entered the Habsburg holdings. Indeed, four Palmas, all sharing a provenance from the Bartolomeo della Nave and duke of Hamilton collections, are depicted as prize acquisitions in David Teniers the Younger's "portrait" of Archduke Leopold Wilhelm's Italian paintings gallery around 1651 (fig. 4).

In the present exhibition Palma is represented by three paintings, including two early works (pls. 25–26) that depict fashionable, alluring, and anonymous young women. Art historian Sydney Freedberg characterized this quintessentially Venetian genre—explored contemporaneously by Palma, Giorgione, Titian, and others—as lying on the "verge of portraiture," presenting female types of "conspicuous handsomeness." Palma himself repeated a specific compositional formula: a half-length figure that pushes against the confines of its pictorial space; a charming feminine face, shown in three-quarter view, with a small mouth and sharp features; blond hair (often with dark roots) parted in the middle, as was then the fashion in Venice; great expanses of décolletage and bare, sloping shoulders; a dress of thick folds often loosened at the bodice to reveal a thin chemise; and elegant yet fleshy hands that might play with a piece of clothing, emphasizing rather than masking the figure's dishabille. Palma smoothed skin passages to a finish of high perfection, and his brushwork is relatively discreet. The ample but always graceful figural forms and voluminous draperies are enriched by a palette that is distinctive for its sharp brilliance of localized color.

There has been much speculation about the meaning of these "portraits" of blond women, of which more than twenty examples by Palma survive today—many seemingly of the same model. In the cinquecento, relatively few portraits were painted of Venetian women. Portraiture developed in Venice as a vehicle to define and promote distinctions of class, status, and privilege among leading members of its patrilineal society; thus, it was reserved almost exclusively for the male sitter. It is unlikely that Palma's paintings were conceived as portraits of specific upper-class women, or even of

celebrated courtesans, who emulated the fashions of patrician ladies; rather, they are personifications of an idealized but objectified feminine beauty. Such cabinet pictures were intended for a male audience, and it is impossible not to respond to their frank, contradictory appeal: generalized in the description of facial features but tactilely specific in the rendering of the garments and jewelry. In their pleasant sensuality, these beauties embody the Venetian fascination with surface and appearance rather than psychological insight.

Before his early death in 1528, Palma's growing reputation challenged Titian's supremacy among patrons in Venice to the extent that Palma won several important commissions for Venetian churches in the 1520s. The commanding polyptych dedicated to Saint Barbara, ordered by the Scuola dei Bombardieri for their altar in Santa Maria Formosa (in situ), was admired by Vasari as one of Palma's best works. Here, motifs adapted both from Titian and from printmaker Marcantonio Raimondi's etchings after Raphael (1483–1520) suggest the competing influences that shaped Palma's artistic personality. Impulses that were more characteristic of central Italian painting strengthened in his subsequent work.

Palma's *Bathing Nymphs* (pl. 27) is among the many paintings in Vienna that can be traced back to the della Nave and Hamilton collections of the seventeenth century; it made its first Habsburg appearance in 1660, in Teniers's catalogue of Archduke Leopold Wilhelm's collection, the *Theatrum pictorium* (Theater of painting, fig. 6). The provocative canvas presents a variety of fulsome Mannerist nudes arranged across the pictorial surface and within the idyllic pictorial space. Many of the figures strike poses that are either reminiscent of ancient sculpture or that reference more contemporary central Italian artworks known through print reproductions. The contours of Palma's idealized and elongated female figures exhibit a linear artifice that betrays these origins. Seeking new models for inspiration in the 1520s, Palma attempted to update his artistic vocabulary through a synthesis of Venetian and non-Venetian stylistic elements, including novel approaches to the human form then found in the works of northern Italian masters Lorenzo Lotto and Dosso Dossi (ca. 1486–1542). At his best, as in *Bathing Nymphs*, Palma demonstrates his uniquely personal accommodation of somewhat cooled Venetian color and genteel Mannerist form that resulted in an immensely appealing hybrid figural type of refined grace.

Contemporaneous with Palma's Venetian beauties is a striking, half-length *Christ with the Cross* (pl. 28), which entered the Habsburg collections in 1785. The painting has been credited to various masters, including Palma, over the years; the attribution to Giovanni Antonio Sacchis, called Pordenone (1483/1484–1539), was proposed in 1975 and has gained some currency. A native of Friuli, an area northeast of Venice then under Venetian control, Pordenone was the region's most important Renaissance artist. He excelled at fresco painting and, once established in Venice in 1535, became

Titian's primary rival. Scholarly debate about the attribution aside, *Christ with the Cross* is remarkable for its immediacy and for the viewer's direct confrontation with the Christ figure, who looks anxiously over his shoulder.

This innovative pose ultimately relates to a haunting silverpoint drawing by Leonardo (Gallerie dell'Accademia, Venice). A painting also by Leonardo, now lost and known only through a copy (Liechtenstein collection, Vienna), and a painting from the circle of Giovanni Bellini (Isabella Stewart Gardner Museum, Boston), further developed the device of isolating Christ from the larger narrative of his journey to Calvary. The motif of Christ carrying the cross is also incorporated into an altarpiece (Scuola Grande di San Rocco, Venice), alternately attributed to Giorgione and Titian, commissioned for a small chapel in the church of San Rocco. The San Rocco painting became famous for the miracles ascribed to it, and the image was widely circulated in the sixteenth century through prints. It is to these pictorial sources that the Vienna *Christ with the Cross* is closely related. However, the artist of this composition constructed a foreboding architectural backdrop for the very human and individualized Christ, who, with barely masked apprehension, turns as if in response to a character beyond the frame. The mood is unprecedented and chillingly modern. Before the onset of Mannerism, much of Italian religious painting maintained an emotional reserve. In contrast, religious subjects depicted by northern Italian artists often explore poignant emotional depths to intensify a devotional response. Obviously, this *Christ with the Cross* was created within the orbit of early cinquecento Venetian style; however, the artist's insistence on narrative specificity reflects the heightened religious piety typical of art from Lombardy and Friuli. This sentiment imbues the image with a more realistic and thus more provincial flavor.

This underlying realism links several outstanding cinquecento portraits in the Habsburg collection. These works demonstrate the mastery achieved by individual provincial artists, some of whom are perhaps no longer identifiable, who worked occasionally in Venice or served patrons in the Venetian dominions. Although unsigned, the three-quarter-view *Portrait of a Man in a Beret* (pl. 29), dated 1538, speaks to developments in portraiture in Brescia, and the most accomplished and original Brescian portraitist at that time was Alessandro Bonvicino, called Moretto da Brescia (ca. 1498–1554). Moretto's portraits take a straightforward approach that suggests the artist was interested in portraying aspects of the sitter's character in addition to simple details of physiognomy, costume, and surface texture. Regardless of authorship, this portrait conveys the sober and thoughtful dignity of an intelligent man.

Among the most ravishing sixteenth-century portraits is Vienna's *Portrait of a Young Woman* (pl. 30). Attributed to various artists, including Moretto and his more artistically flamboyant contemporary Giovanni Girolamo Savoldo (active ca. 1480–after 1548), the painting glows with scintillating lighting effects. Textural differentiation is handled with consummate perfection, from the radiant satin to the sable pelt (or *zibellino*) that was then the height of fashion, despite contemporary sumptuary

laws. A masterpiece of quiet opulence and flawless beauty, the portrait invites prolonged study that is rewarded with visual—if not to say sensual—delight.

Bernardino Licinio (ca. 1485/1489–ca. 1550), also of Bergamasque descent, was born and worked in Venice. Vienna possesses an outstanding example of Licinio's talents: *Portrait of Ottavio Grimani, Procurator of San Marco* (pl. 31), dated 1541. Here, as with other Venetian portraits of the time, the emphasis is not on psychology or personality but on the trappings of class and status. As a procurator (roughly equivalent to a United States senator or cabinet member), Grimani belonged to Venice's power elite, and his patrician family produced two doges during the cinquecento. Staged here in a dynamic pose, Grimani projects a self-confident magnificence that dominates the pictorial space. Diagonal formal devices—the angled position of the arms, the silhouetted slope of the shoulders, and his directed gaze—utilize the entire surface of the canvas. But the glory of Licinio's portrait is not the subject's face, handsome though Grimani appears, but the watermelon-red fabric, which is slashed, embroidered, pleated, and gathered to create a costume of sartorial splendor. Licinio's brilliant portrayal brings to mind portraiture as it developed on the mainland, particularly as it was refined in works by masters such as Moretto and his pupil Giovanni Battista Moroni (ca. 1520/1524–1578). Interestingly, in the city of Venice, elaborate and magnificent costumes, as well as portraits documenting them, contradicted the rationale for the city's extensive sumptuary laws. City leaders understood that wearing lavish clothes of vivid colors and luxurious materials in public could lead to envy and resentment, and that resentment could flare into civil unrest. Consequently, sumptuary laws penalizing conspicuous consumption were created to downplay the real social and economic differences between the patrician and the lower classes.

The shifting balance between provincial realism and poetic idealization that characterized painting in Venice's mainland territories reached an idiosyncratic pitch in the works of the Trevisian painter Paris Paschalinus Bordone (1500–1571). Having trained briefly (according to Vasari) with Titian, Bordone drew inspiration from disparate artistic sources, specifically Raphael, Giorgione, and Tullio Lombardo (ca. 1455–1532), among others. A Lombard sculptor active in Venice, Tullio looked to ancient sculptural forms to create a modern ideal of beauty that was appealing and placid. In his turn, Bordone crafted a distinctive and recognizable figural style that attracted a wide clientele, mostly beyond Venice itself. He secured commissions for religious paintings, portraits, and secular cabinet pictures from European noble families, including an invitation to the court of French king François I at Fontainebleau. There Bordone joined other Italian specialists in the *maniera*, including Francesco Primaticcio (1504–1570) and Rosso Fiorentino (1494–1540).

In Vienna's *Portrait of a Young Woman at Her Dressing Table* (pl. 32) and *Portrait of a Woman in a Green Cloak* (pl. 33) it is evident that, at mid-century, Bordone reverted to imagery that had been refined by

Palma Vecchio early in the cinquecento: the half-length Venetian beauty. Although closely related through subject matter, the hands of the artists are easily distinguished. Repeating a uniquely idealized female type, Bordone's paintings are characterized by a signature crispness of form, an almost shrill brilliance of color, and a certain awkwardness of anatomy and figural choreography. Nonetheless, Bordone's *Allegory of Mars, Venus, and Cupid* (pl. 34) demonstrates that such shortcomings could be turned into delightful Mannerist rhythms. This is one of a pair of mythological paintings in Vienna that date to Bordone's stay in Bavaria, most likely between 1553 and 1560. Bordone relies on his singular interpretation of beauty for his voluptuous Venus, here joined by her lover Mars. The meaning of the allegory remains elusive. While Venus's red garment and the myrtle wreaths bestowed by Victory allude to matrimonial love, Venus was of course already married—to the god Vulcan. Stylistically, the compositional rhythms established by the dance of inclined heads and elegant limbs are echoed in the nervous shimmer of icy highlights, reflections, and crinkled fabric. With such strikingly decorative effects, Bordone's cabinet pictures found a ready, moneyed audience.

Palma Vecchio, Moretto, Licinio, and Bordone represent a wider group of skilled artists active in the smaller cities of northern Italy. Each, according to his own artistic temperament, adopted or adapted progressive elements developed in the studios of Venice. Some painters introduced Venetian motifs or stylistic inflections into works executed for provincial patrons, while others brought a provincial accent to works produced in Venice itself. Sixteenth- and seventeenth-century collectors avidly sought high-quality works by these artists, as attested to by the stunning paintings presented here. And while the supreme mastery of Giorgione, Titian, Tintoretto, and Veronese must be acknowledged, numerous regional painters of great originality stepped forward to challenge and at times equal their artistry. The mixture of provincial realism and Venetian sophistication was highly individualized among the artists of the Veneto, leading to some of the most unique artistic personalities of the sixteenth century. And although the unrelieved verisimilitude typical of northern Italy's provincial centers might have seemed old-fashioned at the time, it was in fact this careful realism and heightened emotional intensity that provided the visual and spiritual framework that would produce Michelangelo Merisi da Caravaggio (1571–1610) and the great innovations of the Baroque era to come.

—*Lynn Federle Orr*

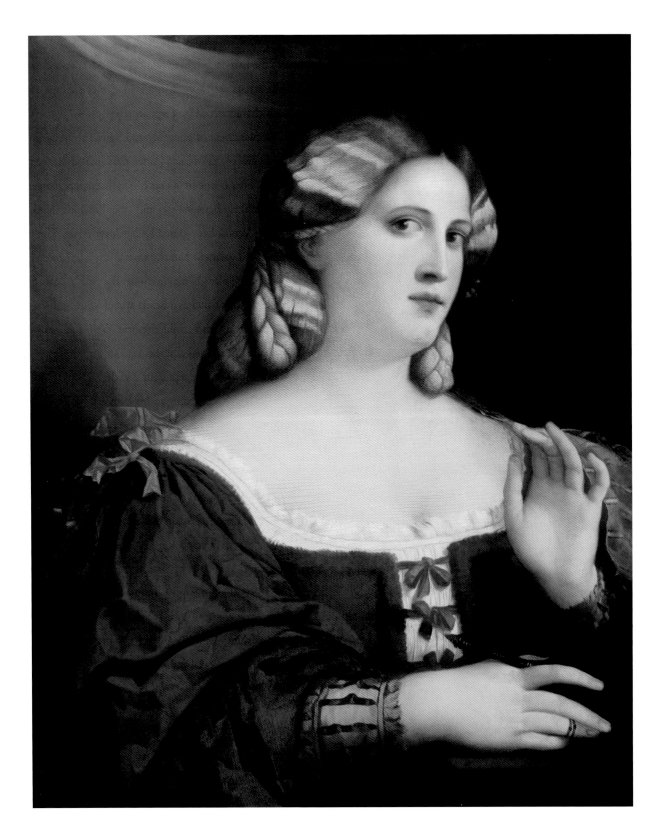

25　Jacopo Negretti, called Palma Vecchio (ca. 1480–1528)
Young Woman in a Blue Dress Holding a Fan, ca. 1512–1514
Oil on panel
25 x 20⅛ in. (63.5 x 51 cm)

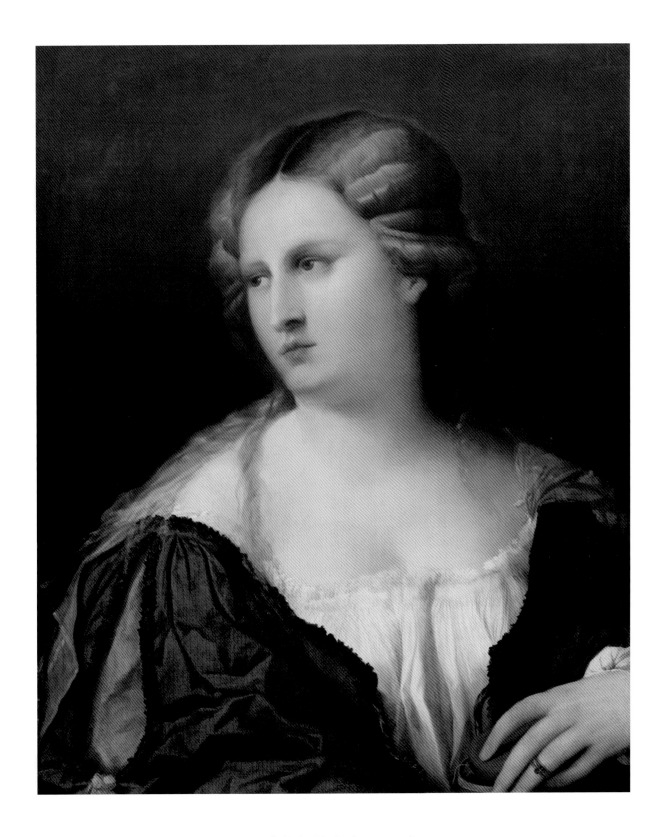

26 Jacopo Negretti, called Palma Vecchio (ca. 1480–1528)
 Young Woman in a Green Dress, ca. 1512–1514
 Oil on panel
 19¾ x 16 in. (50 x 40.5 cm)

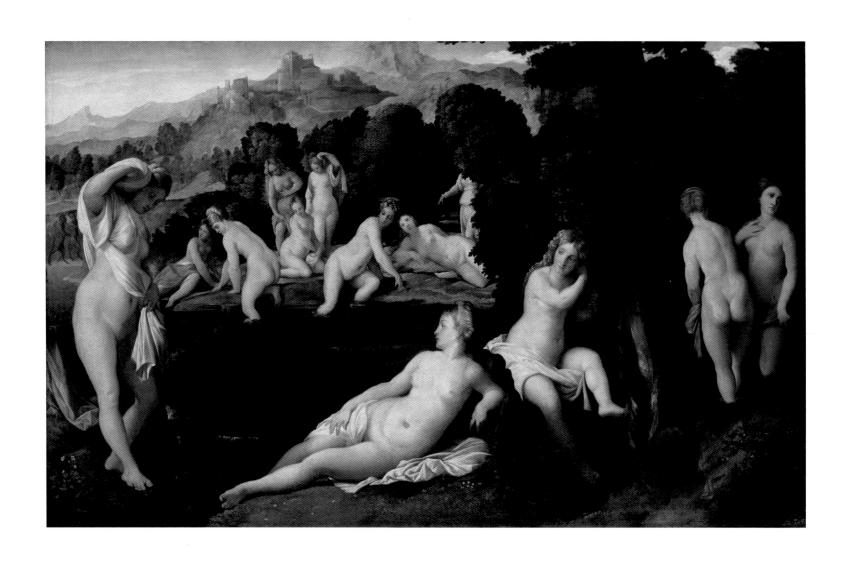

27 Jacopo Negretti, called Palma Vecchio (ca. 1480–1528)
 Bathing Nymphs, ca. 1525–1528
 Oil on canvas mounted on panel
 30½ x 48⅞ in. (77.5 x 124 cm)

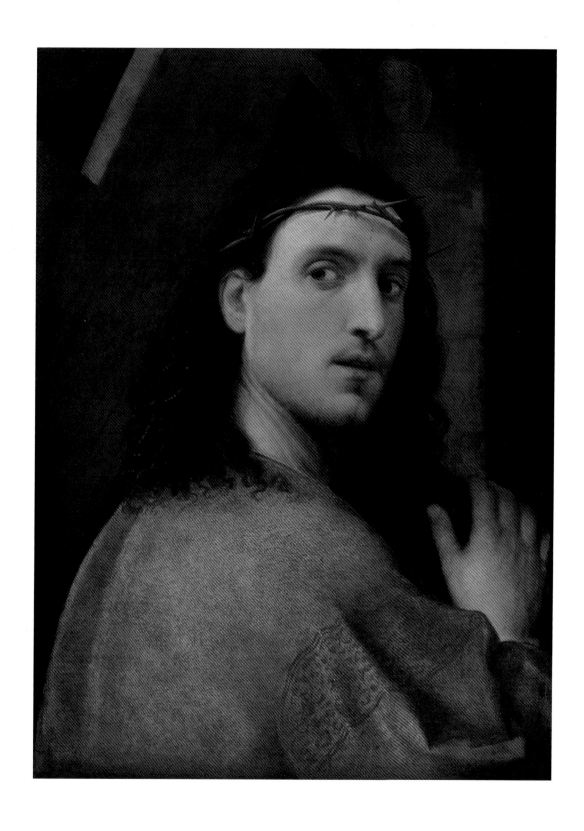

28　Attributed to Giovanni Antonio Sacchis, called Pordenone (1483/1484–1539)
Christ with the Cross, ca. 1515
Oil on panel
24¾ x 18⅛ in. (63 x 46 cm)

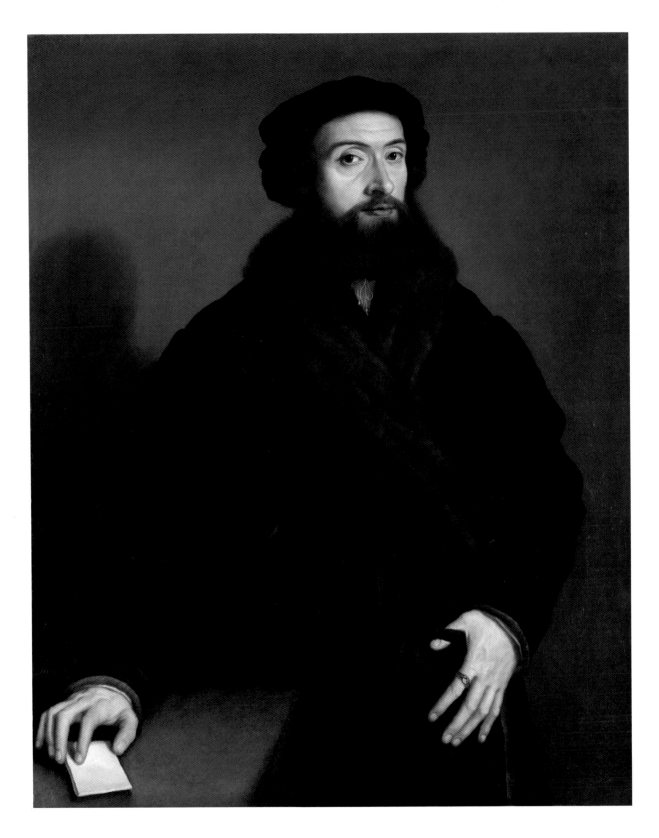

29 Unidentified Brescian artist
Portrait of a Man in a Beret, 1538
Oil on canvas
40½ x 32¼ in. (103 x 82 cm)

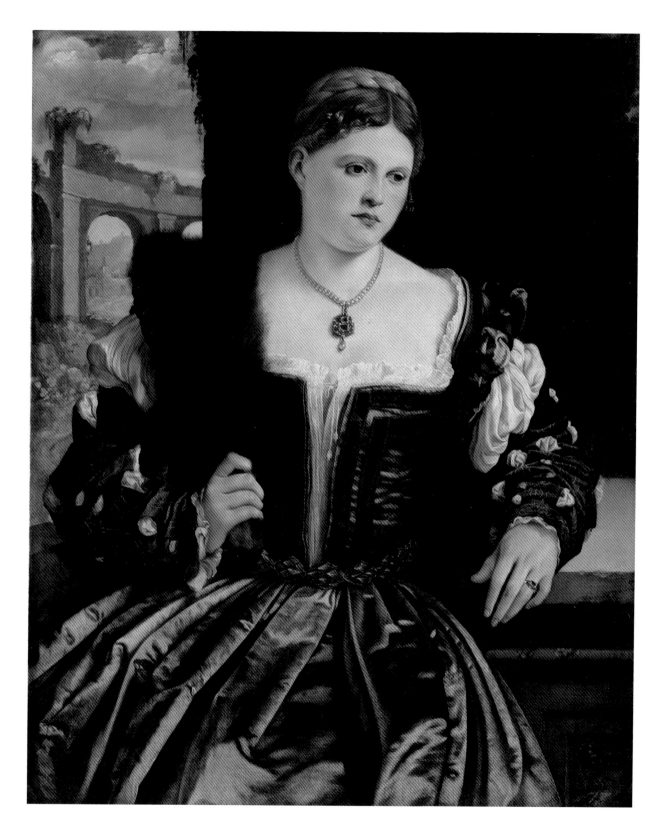

30　Unidentified Brescian artist
Portrait of a Young Woman, ca. 1540
Oil on canvas
39¾ x 32¼ in. (101 x 82 cm)

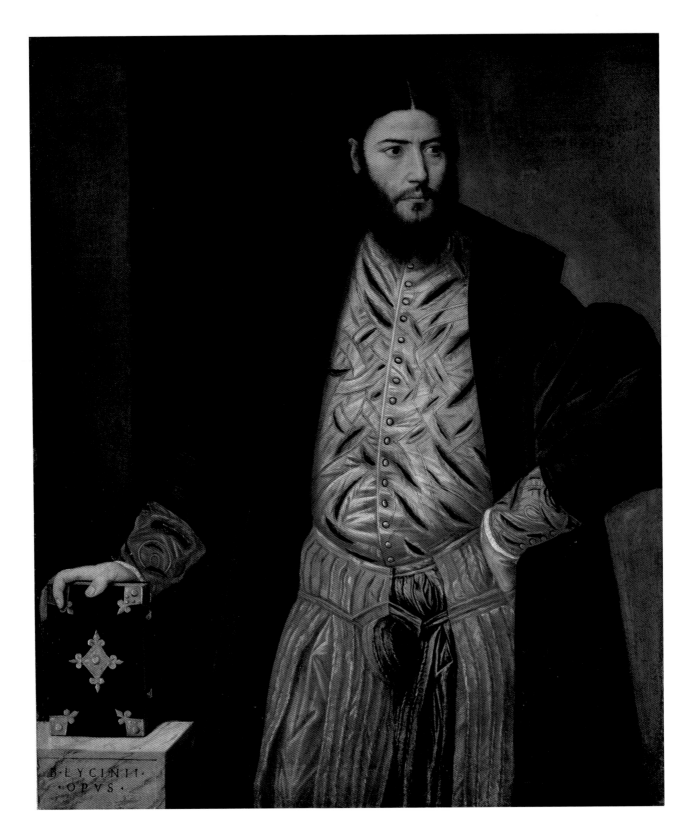

31 Bernardino Licinio (ca. 1485/1489–ca. 1550)
Portrait of Ottavio Grimani, Procurator of San Marco, 1541
Oil on canvas
45⅛ x 37½ in. (114.5 x 95.2 cm)

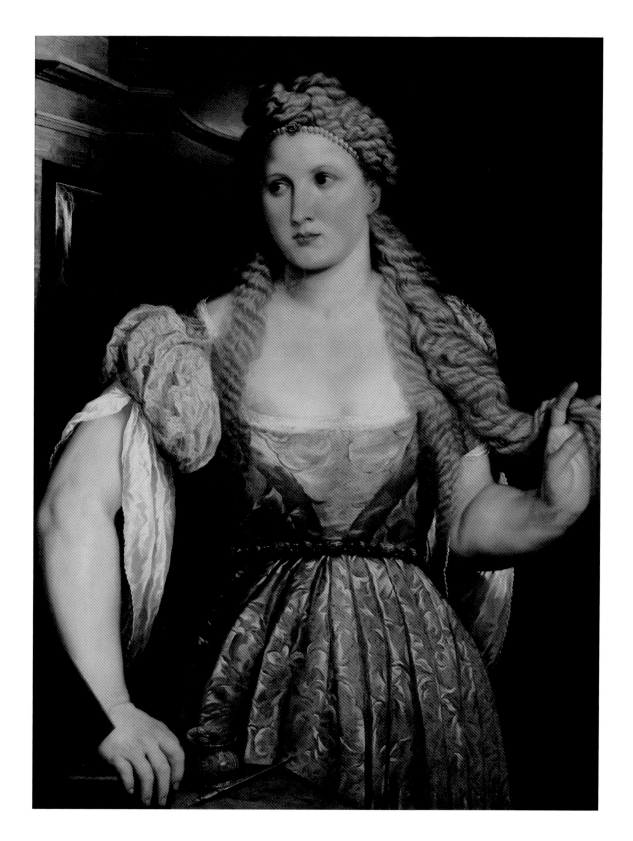

32 Paris Paschalinus Bordone (1500–1571)
 Portrait of a Young Woman at Her Dressing Table, ca. 1550
 Oil on canvas
 40⅛ x 31⅞ in. (102 x 81 cm)

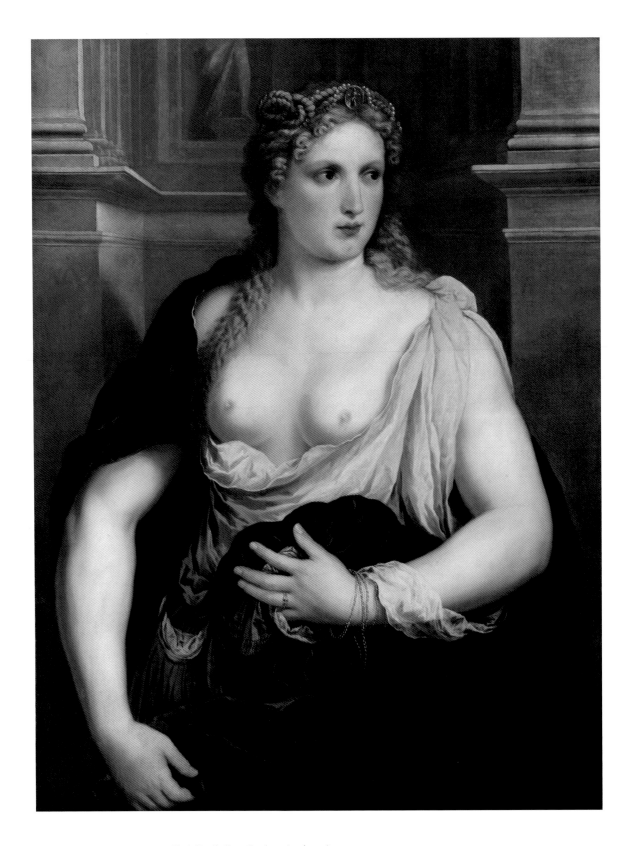

33 Paris Paschalinus Bordone (1500–1571)
Portrait of a Woman in a Green Cloak, ca. 1550
Oil on canvas
40⅛ x 30½ in. (102 x 77.5 cm)

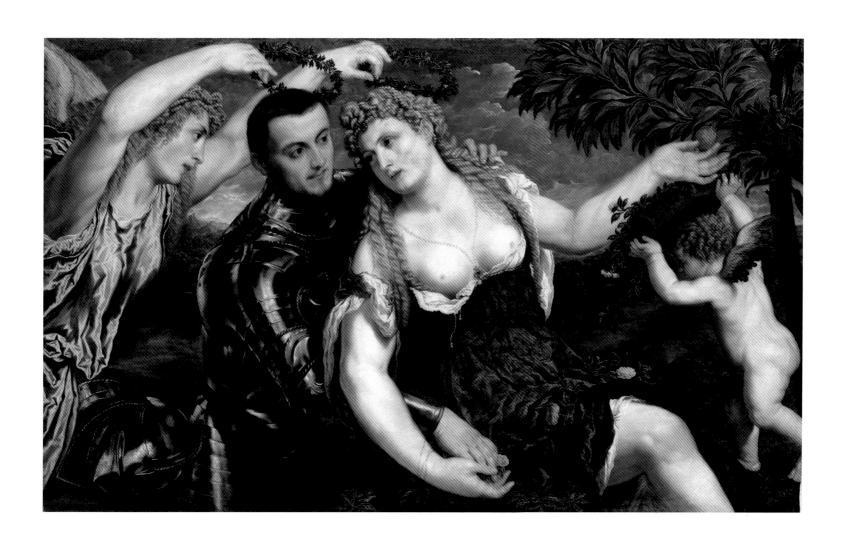

34 Paris Paschalinus Bordone (1500–1571)
Allegory of Mars, Venus, and Cupid, ca. 1560
Oil on canvas
43⅞ x 68¾ in. (111.5 x 174.5 cm)

Tintoretto

Jacopo Robusti, called Tintoretto (1519–1594), was, together with Titian (ca. 1488–1576) and Veronese (1528–1588), one of the most important painters of the Venetian cinquecento. His name is intimately connected with the city of Venice, where he was born, lived, and worked, but he asserted his talent throughout Europe. Like Titian and Veronese, he produced a vast body of work, mainly portraits and paintings destined for churches and the fraternities known as scuole, or "schools." Accounts by his earliest biographers were plentiful and diverse, and his way of painting, fast and vigorous, aroused debate within the Italian art world. Even so, Tintoretto's late style broke away from Venetian painting tradition, preparing fertile ground for the leading lights of the European seicento.

The present exhibition includes nine paintings by Tintoretto. Ranging from the 1550s to the 1580s, they demonstrate the evolution of his art while reflecting the artistic and cultural transformations that took place in the latter half of the sixteenth century. The Venice of Giorgione (ca. 1477–1510), of young Titian, and of Palma Vecchio (ca. 1480–1528) was markedly different from that in which Tintoretto operated, and the spirit of change left deep impressions in his artistic production. Religious discord and economic decline in the later cinquecento cast an aura of anxiety over Venetian society that supplanted the reassuring *sacre conversazioni* (sacred conversations) of the early 1500s, set in joyful, pleasant gardens where everything is regulated by an unquestionable divine will. Monumental canvases crowded with figures replaced the small paintings of Giorgione and Palma. The individual viewer, no longer the center of the world, is thrown into a realm of disorienting line, swirling light, and undefined shadow.

Jacopo Robusti was born in Venice in 1519. His father, Giovanni Battista Robusti, whose real name was Comin, was a dyer by trade (hence Tintoretto, or "little dyer"). According to the artist and writer Carlo Ridolfi, who published a life of Tintoretto in 1642, the painter's father sent the young artist to be apprenticed to Titian. His tenure in the master's workshop did not last long, however: Titian turned the boy out, having recognized the signs of his future mastery. In a document of 1539 Tintoretto referred to himself as *maestro*, suggesting that he had already started a career as an independent painter. Works executed around 1540 prove his familiarity with contemporary Venetian art, augmented through the study of paintings by Giulio Romano (1499–1546) and Andrea Schiavone (ca. 1500–1563) and the sculpture of the Florentine masters. Ridolfi recounted Tintoretto's quest to obtain plaster casts of ancient marble figures as well as the sculptures of Michelangelo (1475–1564) in the Sagrestia Nuova (New Sacristy) of San Lorenzo in Florence. Nor did the artist ignore Titian's paintings. Indeed, combining Titian's use of color with Michelangelo's plasticism would become his trademark.

The decisive years for Tintoretto came toward the end of the 1540s. One work in particular—a 1548 painting depicting Saint Mark freeing a slave, commissioned by the Scuola Grande di San Marco— granted him access to the circuit of official commissions. The Venetian scuole were religious associations governed by lay officials; they had developed in the Middle Ages with the aim of offering assistance, both spiritual and material, to their members. They spread widely, especially in the mid-sixteenth

century, when the Catholic Church convened the Council of Trent (1545–1563), a body charged with defining reform of the Church and its position toward Lutheranism and Calvinism. More or less directly, these brotherhoods, whose members came from all social classes, fought against Protestant heresy, according to which justification (in God's eyes) by faith alone negated the value of charitable acts.

Tintoretto painted other works for the Scuola Grande di San Marco and later for the Scuola Grande di San Rocco. In the scuole he found a large audience for his art as well as interlocutors in religious matters. The vast halls owned by the scuole were congenial spaces for the presentation of his large canvases, whose figures were meant both to reassure and intimidate the viewer. To this end he appropriated the monumentality of Michelangelo as well as the dialectic of Titian.

It is the portraits of Titian that the first Vienna painting invokes. *Portrait of Lorenzo Soranzo* (pl. 35) is one of the most remarkable examples of Venetian portraiture of the mid-cinquecento. Completed in 1553, according to the inscription on the pedestal at lower left, the picture shows a man in his mid-thirties, recognized as Lorenzo Soranzo, a member of the Venetian Soranzo family (of the San Polo branch). A nephew of the procurator Jacopo Soranzo, who was portrayed by Tintoretto on various occasions, Lorenzo held numerous public offices during his career. Tintoretto's painting may commemorate his 1553 nomination to the position of *camerlengo di comun*, the treasurer in charge of collecting and reallocating all revenues; his brother Benedetto would hire Tintoretto to do the same some years later. For the 1553 work, Tintoretto adopted Titian's portraiture style of the 1540s, in which the subjects are portrayed against a dark backdrop, sometimes with architectural elements. The gaze of Titian's subjects rarely meets the viewer's eye, and he conveys their intensity, giving them a distinct and commanding presence. Although Tintoretto has shown Soranzo against a dark background, the equally dark robes partially blend into the surroundings, and the subject's gaze seems wistful.

Portrait of a Young Woman (pl. 36) was also executed in the mid-1550s. Attributed to Titian until the end of the nineteenth century, it depicts a young woman in a fully frontal pose, her gaze meeting the viewer's. The subject was once thought to be the painter's firstborn daughter, Marietta (ca. 1554–1590), who was also an excellent portraitist; however, the chronology makes this impossible. The lady is unusually expressive, immediate, and aware for Venetian female portrait subjects of the time. Leaning on a parapet covered by an intricately designed carpet, she holds in one hand a pair of gloves and in the other a marten stole with a gilded head. Her brocade dress, attached in front by a gold chain adorned with precious stones, corresponds to the fashion of the 1550s as described by Titian's cousin, Cesare Vecellio, in his *Degli habiti antichi et moderni di diverse parti del mondo* (The clothing, ancient and modern, of various parts of the world) of 1590. She obviously wished to display her wealth: she wears large pearls and gold jewelry. Her fair hair was possibly lightened by the sun. Vecellio points out that women of the mid-sixteenth century, to enhance their beauty, tried many techniques to turn their hair to the color of gold.

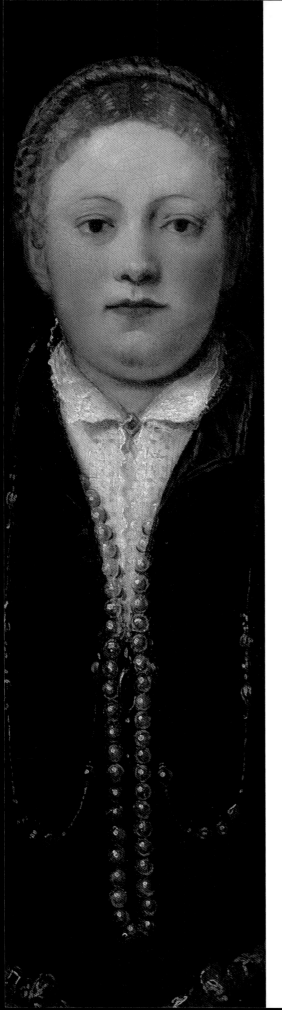

Portrait of a Man in Gold-Trimmed Armor (pl. 37) clearly references a series of portraits of Roman emperors that Titian produced for Federico II Gonzaga, Duke of Mantua, in the 1530s. Although Titian's paintings were lost in a fire in Madrid in 1734, we know from engravings that they depicted figures in three-quarters stance, often in armor, before backgrounds of drapery or architectural columns. The young man painted by Tintoretto wears armor and rests his right hand on his helmet. Behind him are three columns; a window opens to his left, revealing a red galley heading out to sea. Much as effigies of Roman emperors symbolized Rome's political might, Venetian paintings of soldiers expressed Venice's military pride and the strength of her navy.

The fate of Venice had always been inextricably linked to seamanship. In the thirteenth century the city established a permanent military fleet to control the Adriatic Sea. But even before that, around the year 1000, the republic had introduced a special ceremony to propitiate the sea and affirm its maritime supremacy: the *sposalizio del mare* (marriage of the sea), held during the Catholic celebration of the Ascension. During the ceremony, a procession of boats, led by the doge's ship, sailed to the Lido, where it stopped in the waters before the church of San Nicolò. Here, at the church dedicated to the patron saint of sailors, a prayer was offered, followed by the casting into the sea of a gold ring.

Since the twelfth century San Nicolò has housed relics of Saint Nicholas of Bari, bishop of Myra, taken by the Venetians during the First Crusade. Nicholas, one of Christendom's most popular saints, was the protagonist of many stories of miracles that benefited the poor. Around 1555 Tintoretto realized a small canvas depicting Saint Nicholas (pl. 38), which came to Vienna, along with *Portrait of a Young Woman*, as part of Archduke Leopold Wilhelm's collection. According to tradition, the saint is shown wearing a bishop's vestment and miter and carrying a crosier. In his right hand he holds a book upon which are balanced three gold balls, a reference to a story of the saint's compassion and generosity. It is said that Nicholas heard of a poor man who had three daughters. Because the man could not afford proper dowries for them, they would remain unmarried and probably, in the absence of other employment, become prostitutes. Nicholas decided to help. Being too modest to assist the man publicly (or perhaps to save the man the humiliation of accepting charity), Nicholas went to his house at night and tossed three purses filled with gold coins through a window, thus providing them with their dowries. Here Tintoretto changed the three purses to gold balls and included a ship riding a stormy sea in the background. It has been argued that the canvas was once part of a larger composition; however, a recent hypothesis, pointing out the work's narrative congruence and completeness, as well as the saint's status as the protector of sailors, suggests that it may either be a study for a work not yet found or an ex-voto offering for a safe voyage at sea.

As Tintoretto painted his portraits of the gentlemen and gentlewomen of Venice, his brush became ever more fluid and sensual, although he did not fail to linger over descriptive details. He insinuated himself deeper into the circuit of commissions for churches and also into the graces of

Venetian patrons, who hired him to produce paintings for their palaces. The nobility preferred mytho-logical compositions, offering Tintoretto an opportunity to paint erotic scenes for private consumption. One example, *Susanna and the Elders* (pl. 39), executed around 1555–1556, is among the artist's most celebrated canvases. It represents a story from the biblical book of Daniel that was a popular subject in Italian paintings of the cinquecento and seicento. Susanna and her husband lived in a palace surrounded by a beautiful garden, to which he often invited visitors. Among the guests were two elderly magistrates who secretly lusted for Susanna. One day she undressed to bathe in a pond in the garden, unaware that she was being spied upon. The two old men revealed themselves, telling her that if she refused to submit to them sexually, they would say they saw her with another man under a tree in the garden. Although according to ancient Jewish law a woman guilty of adultery was punished with death, Susanna nonetheless refused them, preferring that fate to the sin they proposed. Daniel, convinced of Susanna's innocence, exposed the elders' lies. Interrogating them separately, he asked under which tree Susanna had committed adultery. Each man named a different tree. The elders were executed for the crime of false witness, and Susanna's honor and life were saved.

In Tintoretto's painting, Susanna has shed her elegant clothes to refresh herself by the water. One of the elders is watching her, hidden by a rosebush, while the second appears to be approaching. The roses might represent the boundary between vice and virtue, but they are also a symbol of the erotic power of women: the rose was known as the flower of Venus. A magpie, a symbol of eloquence as well as a warning of spiteful tongues, sits on a branch above.

The story of Susanna was especially appreciated by Italian painters and patrons in the second half of the sixteenth century. It gave artists the opportunity to depict scenes that were simultaneously erotic and morally edifying. For their clientele, chastity, honor, and faithfulness were the virtues expected of a wife. Men often displayed paintings of this kind in bedrooms, to remind their wives about proper married behavior.

Around the same time that Tintoretto realized *Susanna and the Elders*, the younger artist Veronese, a recent arrival to Venice, painted *The Anointing of David* (pl. 46). A comparison of the works demonstrates the substantial difference between the two artists: Veronese, proving himself a talented designer, seems to be chiseling forms like a sculptor, while Tintoretto softly models bodies and draperies in a virtuosic play of light and shadow. These stylistic tendencies, however, would be reversed over the course of the following decades. As Veronese was being seduced by the softer forms of Tintoretto, the latter was experimenting with faster and finer brushstrokes that made the folds of his draperies look as sharp as razor blades.

Thus began the dialogue between the two champions of the Venetian art world, along with their rivalry for commissions. In 1555 Veronese started the decoration of the church of San Sebastiano, and around 1560 he painted the philosophers Plato and Aristotle for the Libreria Marciana (Library

of San Marco)—thanks to the mediation of Titian, who had excluded Tintoretto from the commission. In the early 1560s Veronese realized *The Wedding Feast at Cana* for the Benedictine refectory in San Giorgio Maggiore (it is now in the Musée du Louvre, Paris), even as Tintoretto painted the entrance hall ceiling of the Palazzo Ducale and continued producing canvases for the Scuola Grande di San Marco. The greatest opportunity of Tintoretto's career came in the mid-1560s: the decoration of the Sala dell'Albergo, the smaller hall on the upper floor of the Scuola Grande di San Rocco. The hall was completed around 1550, and in 1564, after having rented paintings and rejected works by artists unknown to us today, the school held a competition to select the artist to paint the ceiling. According to Ridolfi, Tintoretto won the competition, which Veronese had also entered, by submitting a finished canvas rather than the requested sketch and placing it in the hall (see fig. 11). After that, Tintoretto enjoyed an undisputed reign over commissions from the school.

Yet he never stopped producing portraits, immortalizing doges, senators, procurators, and nobility. The exquisite *Portrait of a Man with a White Beard* (pl. 40), created around 1570, depicts an old man whose gaze meets, almost by chance, that of the viewer. Tintoretto had been making this type of three-quarter-view portrait since the late 1540s, but here his technique is more refined, tending toward the *pittura di macchia* (painting with splotches) that Titian had introduced around the 1560s. The quickly drawn brushstrokes rely on the close juxtaposition of thick patches of dark and light color. They give a sense of vigor and motion to the old man's hand, which seems about to disappear into the sleeve of his fur-lined coat.

Tintoretto painted *Portrait of Sebastiano Venier (and the Battle of Lepanto)* (pl. 41) during the same period. Sebastiano Venier held numerous public offices throughout his life: he was a government administrator for Venice as well as governor of Candia (Crete), which had been apportioned to Venice in 1204, after the Fourth Crusade. In December 1570 he was named chief admiral of the Venetian fleet and, in October 1571, led Venice's contingent of ships in the Holy League navy to Lepanto to battle the Turks. The Holy League (which included the Spanish fleet, among others) roundly defeated the Turkish fleet. The battle of Lepanto was a decisive event for all Christendom because it halted the expansion of the Ottoman Empire into Europe, and Venier returned to Venice a war hero. In 1577 he was elected doge; he died the following year. The Vienna picture commemorates the military valor of its subject, who holds the staff of his office in his right hand. The composition recalls that of *Portrait of a Man in Gold-Trimmed Armor*, harking back to Titian's series of Roman emperors for the duke of Mantua. In the background, through the window, we see the battle of Lepanto, where Venier made his name as a commander.

In the early 1570s Tintoretto was finally able to paint a series of philosophers for the Library of San Marco, the project from which he had been excluded by Titian in favor of Veronese and

other artists from the Venetian mainland. The sixteenth-century sources are imprecise, but modern art historians have attributed six figures to Tintoretto. Tintoretto scholars point to one in particular, a representation of Diogenes, for the sensuality of its color and the intensity of the chiaroscuro. Closely related is the Vienna *Saint Jerome* (pl. 42). The figure of the saint, smaller than that of Diogenes, is otherwise its perfect mirror image. The painting displays the same exaggerated chiaroscuro—also characteristic of his contemporaneous canvases for the Scuola Grande di San Rocco—and the strong and sensual use of color, leading us to date the Vienna picture around the same time as the San Marco philosophers.

Jerome was a priest and scholar in the Catholic Church who lived between the fourth and fifth centuries. He devoted himself to the study of Greek, Hebrew, and Latin, and his Latin translation of the Bible later became known as the Vulgate. Two iconographic models exist for the portrayal of the saint: the first depicts him wearing the red cassock of a cardinal, in a study reading the Holy Scriptures; the second shows him as a hermit in the desert, where he retired to complete his translation of the Bible and live the life of an ascetic. He is unclothed, with his broad-brimmed cardinal's *galero* cast to the ground to symbolize the renunciation of all honors. He is often shown with a lion, based on a story that he had removed a thorn from a lion's paw; alternatively, to symbolize penitence, he may be shown with a crucifix, a skull, or a rock. The two typologies correspond to the two faces of the Church: on the one hand, the speculative and normative; on the other, the institution imitating the life of Christ. Tintoretto clearly made use of the second iconographic model. He depicted the saint in a cave, reading the Holy Scriptures, apparently unclothed but for his red cloak. In his left hand he holds a crucifix; the cardinal's hat lies on the ground. At lower left can be seen the faithful lion.

The Flagellation of Christ (pl. 43) is a small painting, perhaps a study for a larger work, and it was executed in the early 1580s, following a series of important commissions in the previous decade. Between 1575 and 1581 Tintoretto completed the decoration of the Sala Grande Superiore of the Scuola Grande di San Rocco, and between 1577 and 1578 he decorated rooms of the Palazzo Ducale, which was being rebuilt after a fire. During the 1570s his style underwent considerable changes: having previously abandoned his soft brushstroke and bright colors, the artist now almost completely renounced color, relying somewhat exclusively on the contrast of light and shadow. The flashes of pigment are functional, giving a certain prominence to figures and objects, whose barely outlined forms almost seem to merge. His works had achieved the appearance of high-relief sculptures: the figures standing out against the backdrop are carved with the brush, and the dresses and draperies are sketched out with full force. Even small-scale works such as this *Flagellation* have a sense of monumentality, through which Tintoretto sought to captivate and astonish his patrons and viewers.

—*Davide Dossi*

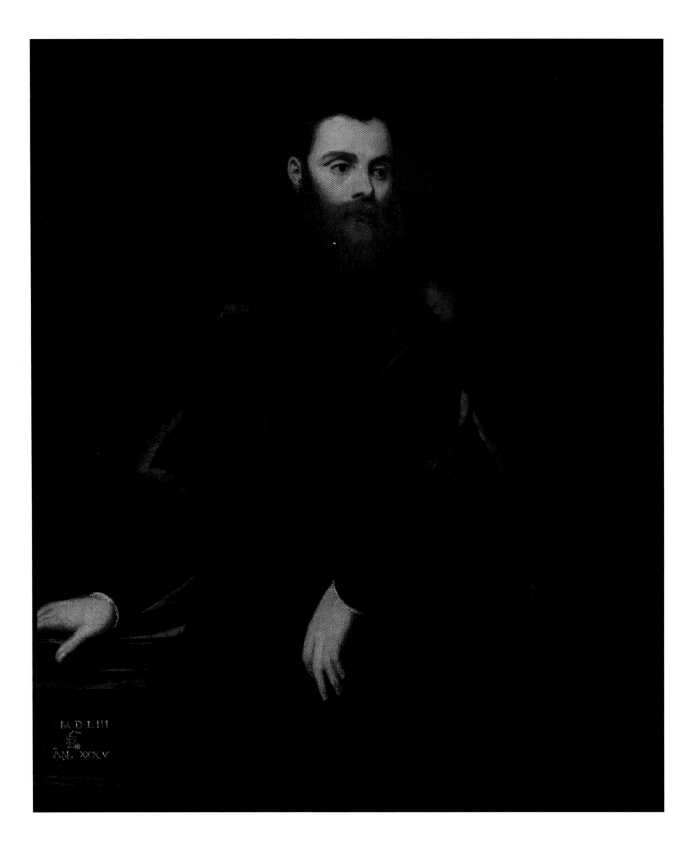

35 Jacopo Robusti, called Tintoretto (1519–1594)
 Portrait of Lorenzo Soranzo, 1553
 Oil on canvas
 45⅝ x 39⅜ in. (116 x 100 cm)

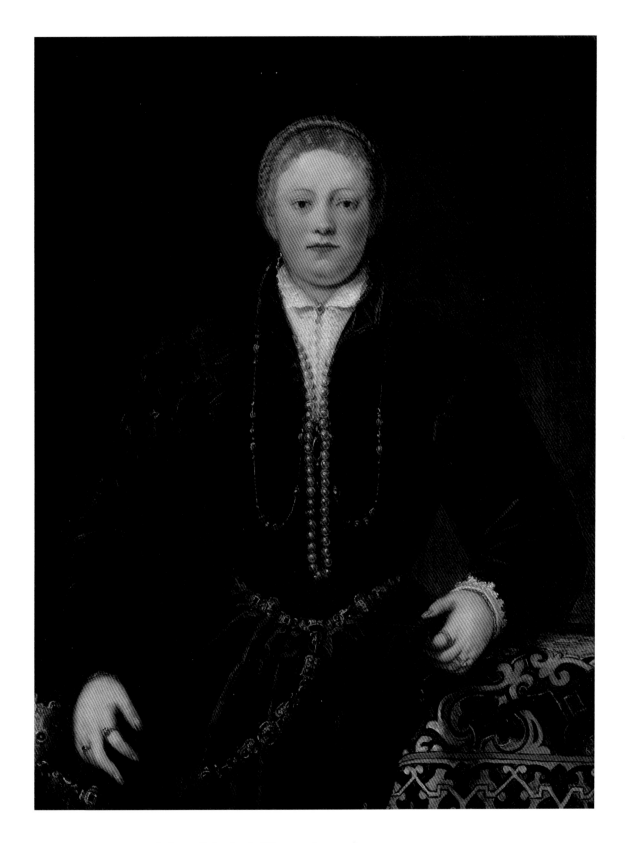

36 Jacopo Robusti, called Tintoretto (1519–1594)
Portrait of a Young Woman, ca. 1555
Oil on canvas
38⅝ x 29¾ in. (98 x 75.5 cm)

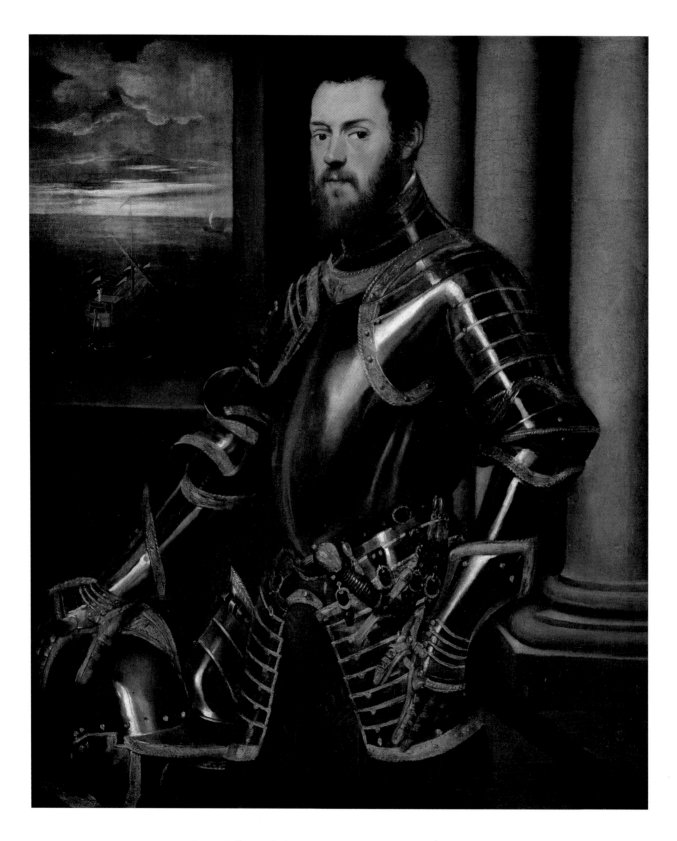

37 Jacopo Robusti, called Tintoretto (1519–1594)
 Portrait of a Man in Gold-Trimmed Armor, ca. 1560
 Oil on canvas
 45¼ x 39 in. (115 x 99 cm)

38 Jacopo Robusti, called Tintoretto (1519–1594)
 Saint Nicholas of Bari, ca. 1555
 Oil on canvas
 44⅞ x 22 in. (114 x 56 cm)

39 Jacopo Robusti, called Tintoretto (1519–1594)
 Susanna and the Elders, ca. 1555–1556
 Oil on canvas
 57½ x 76¼ in. (146 x 193.6 cm)

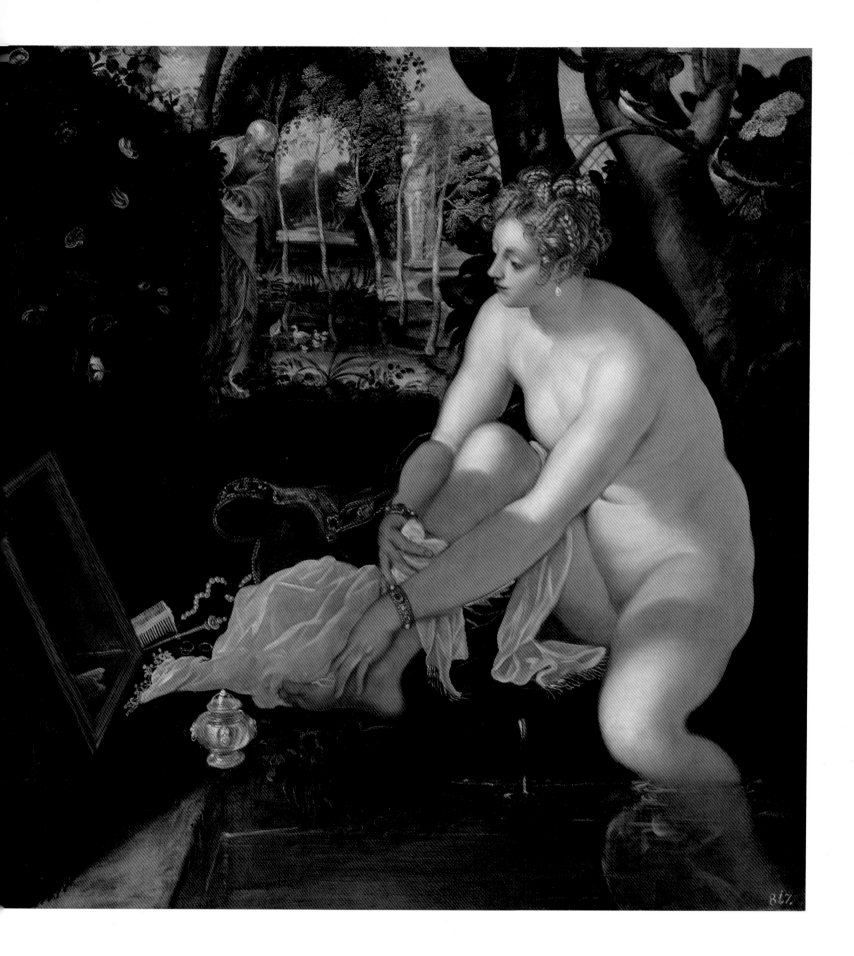

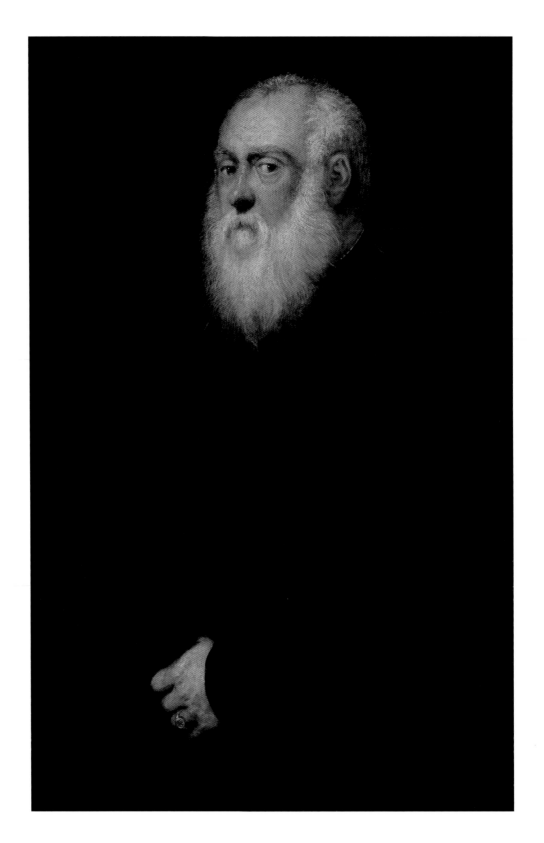

40 Jacopo Robusti, called Tintoretto (1519–1594)
Portrait of a Man with a White Beard, ca. 1570
Oil on canvas
36⅜ x 23⅜ in. (92.4 x 59.5 cm)

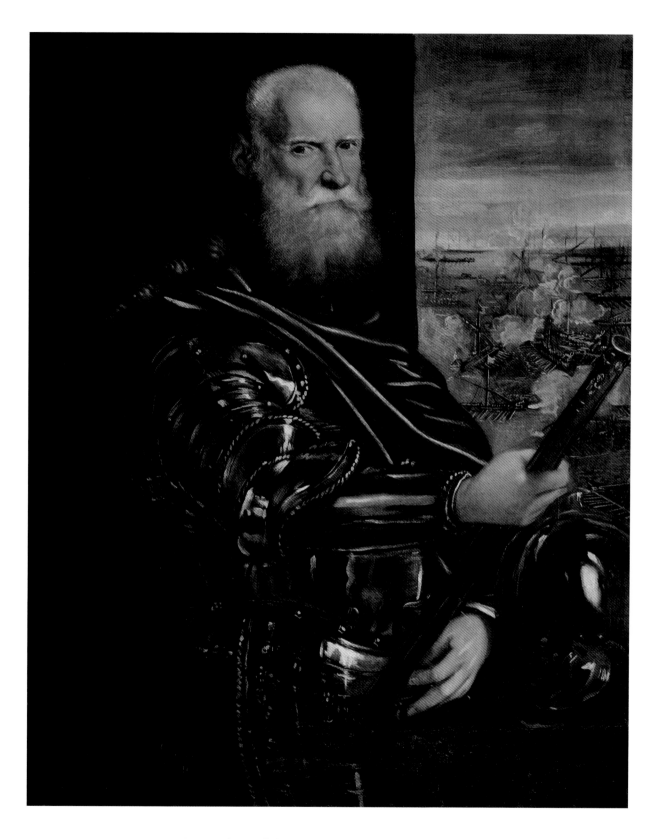

41 Jacopo Robusti, called Tintoretto (1519–1594)
Portrait of Sebastiano Venier (and the Battle of Lepanto), ca. 1571
Oil on canvas
41⅛ x 32⅞ in. (104.5 x 83.5 cm)

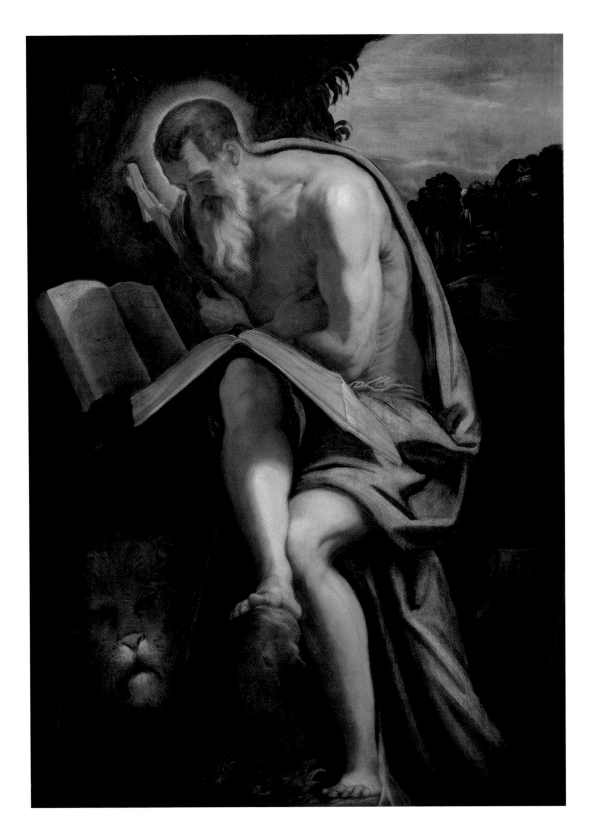

42 Jacopo Robusti, called Tintoretto (1519–1594)
Saint Jerome, early 1570s
Oil on canvas
56¼ x 40½ in. (143 x 103 cm)

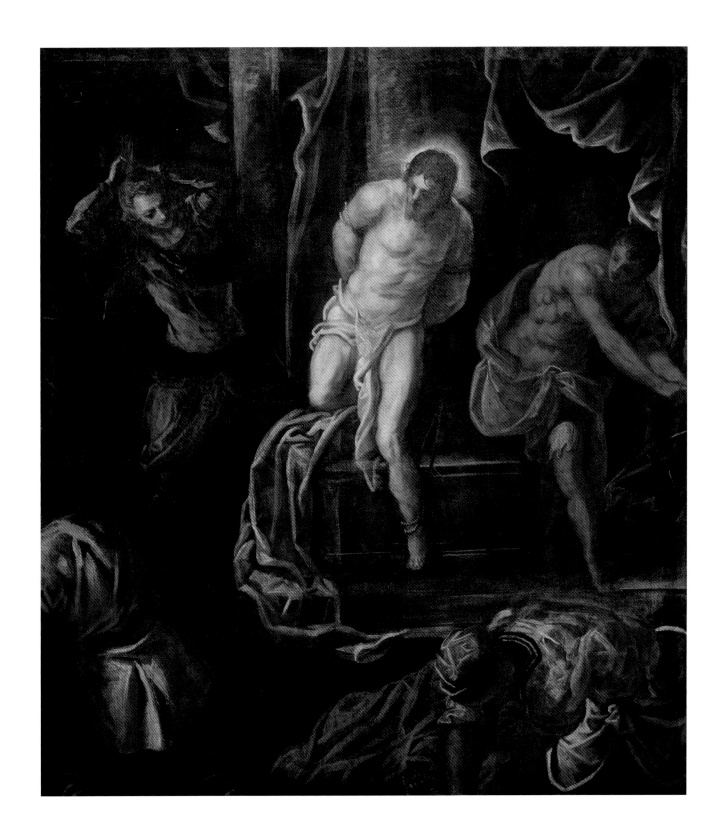

43 Jacopo Robusti, called Tintoretto (1519–1594)
The Flagellation of Christ, early 1580s
Oil on canvas
46⅝ x 41¾ in. (118.3 x 106 cm)

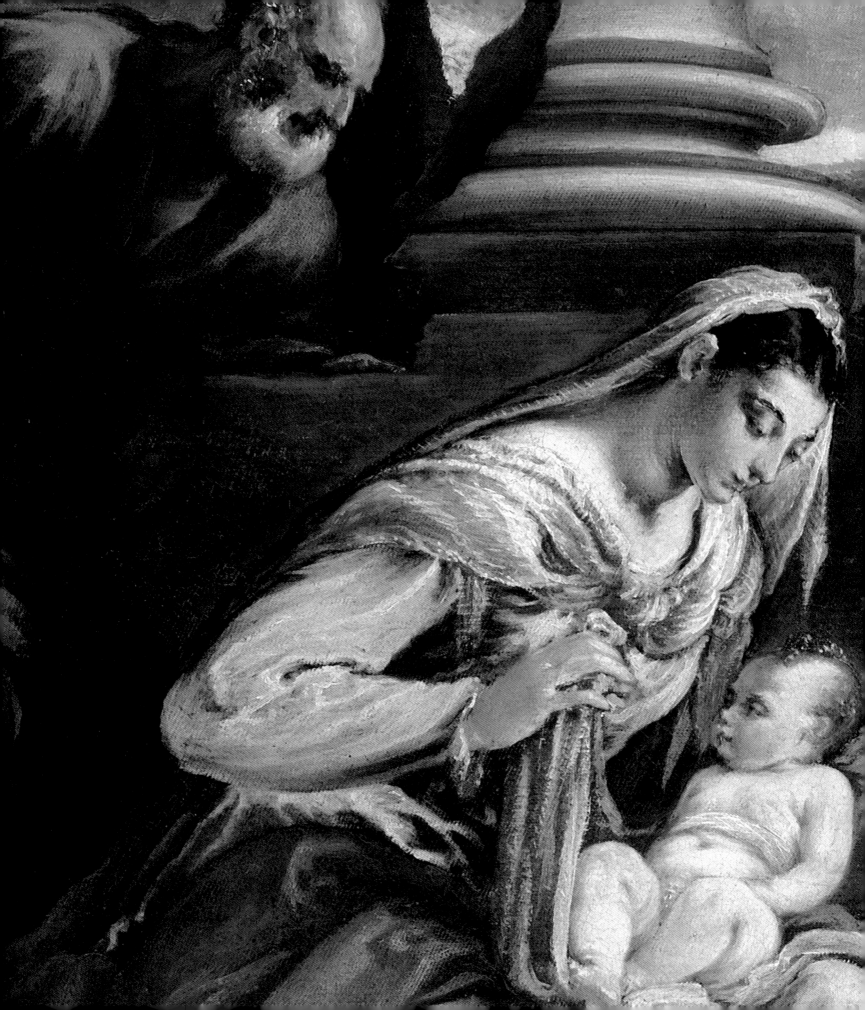

Bassano

Jacopo da Ponte, known as Bassano (1510/1512–1592), was born in Bassano del Grappa, a small town along the banks of the Brenta that takes its name from the nearby peak of Monte Grappa. A contemporary of Tintoretto (1519–1594) and Veronese (1528–1588), he was the son of a local painter with a busy workshop and was sent to Venice to complete his education. Mannerism constituted an important point of reference from the start of Bassano's career, but his sources of inspiration were in fact manifold: from Albrecht Dürer (1471–1528) to Raphael (1483–1520), from Lorenzo Lotto (ca. 1480–1556) to Titian (ca. 1488–1576). Through print reproductions he came to know the Mannerist painters of the Emilia-Romagna region, and he was particularly fascinated by Parmigianino (1503–1540). Though he spent most of his life in the provinces, at the margins of the artistic center that was La Serenissima, Bassano kept up-to-date on developments in Venice, and the work of the Venetian masters provided constant incentive for innovation.

A close bond to his homeland was perhaps the greatest strength of this fine artist, whose work has only recently been reevaluated by art historians; despite constant experimentation, Bassano never lost sight of the milieu in which he lived and worked. His paintings demonstrate a sensitivity to nature and its inhabitants, whether they were peasants or animals. He may be credited with the invention of a religious-pastoral genre that placed biblical scenes within Venetian landscapes. The popularity of these compositions led Bassano to establish, in the tradition of the Venetian workshops, an efficient system of production in which his sons, his primary assistants, helped him fulfill his commissions. Through the numerous altarpieces he produced for churches on the Venetian mainland, Bassano developed an iconographic repertoire that remained extremely desirable well into the seventeenth century. Part of his success may be traced to an increasing interest in the countryside on the part of Venice's aristocracy, which sought to diversify investments through the acquisition of land.

The scale of his production and the popularity of his pastoral subjects have resulted in a somewhat negative critical response to Bassano, who has been labeled a painter of animals. The seventeenth-century critics Carlo Ridolfi and Marco Boschini, however, recognized the merits of his work, highlighting the experimental quality that characterized his style. In *Le maraviglie dell'arte* (The marvels of art), Ridolfi identified three primary modes in Bassano's oeuvre: the youthful, the Mannerist, and the mature. In the eighteenth century Giambattista Verci perfected this analysis, further dividing the Mannerist output into two categories: the Parmigianinesque, and the Raphaelesque and Michelangelesque. *Adoration of the Magi* (pl. 44), Bassano's most famous work at the Kunsthistorisches, clearly demonstrates the influence of Parmigianino. It portrays the moment in which the three magi pay tribute to the newborn Jesus. The holy family is united under a straw canopy that has been placed over the ruins of a building. At their feet kneels the eldest of the kings, resplendent in a green robe adorned with fur; light plays over the garment in characteristic Bassano style. The rays of the star

that guided the magi on their journey illuminate the baby Jesus in his mother's lap. (The star is no longer fully visible due to a later reduction of the canvas along the top edge.) The softness of the child's alabaster skin is almost tactile. In the background, Joseph leans down toward his family, and his pose is counterbalanced by the position of the old king. The compositional rhythm in this section of the painting is relaxed, while the right side of the canvas is crowded with men and animals, their bodies intertwined in classic Mannerist fashion.

Bassano's enormous technical skill is evident in his virtuosic rendering of highlights on metal (the magi's gifts, the crown on the ground, and the dagger attached to the young page's belt); on the folds of the draperies; and on the almost frothy whites. His refined use of precious pigments, in combination with the formal genius with which he delineated his figures, contributes to an effect that verges on abstraction. *Adoration of the Magi* represents the moment of Bassano's greatest affinity with central Italian Mannerism.

A distinctive capacity for observation and an interest in landscape are the central threads of Bassano's subsequent output, manifested for the first time in 1558 in *Saint John the Baptist* (Museo Civico, Bassano del Grappa). In that painting, the figure of the saint is surrounded by scenery depicted with a naturalism that would have been unthinkable for the artist just a few years earlier. In his fully mature work, Bassano struck a balance between the expressive qualities of color through the unifying use of natural light within compositional schemes that were increasingly liberated from Mannerist devices, bringing him closer to Titian on the one hand and Veronese on the other. This is the period that Verci describes as characterized by a style composed of "heavy, straightforward, and well-placed strokes, with warm, bright tones . . . everything is truth, nature, and picturesque fire."

A Veronesian interest in monumental figures and a tidy "classicism" of composition are evident in *Tamar Led to the Pyre* (pl. 45). Genesis 38:1–30 tells the story of Tamar, the wife of Er. Judah's eldest son, Er, had died young, leaving Tamar childless. According to Jewish law, to secure the continuation of Judah's lineage, Tamar had to marry Er's brother Onan, although their children would still be considered her first husband's. Onan, reluctant to father children he could not claim as his own, was punished by Yahweh with death. When Judah's third son, Shelah, came of age, Judah did not summon Tamar, fearing that Shelah might die as well. So Tamar disguised herself as a prostitute and propositioned her father-in-law. Judah agreed, promising to pay her the following day; he left his staff, seal, and cord with her as collateral. The next day, however, the woman was nowhere to be found. Months later, her pregnancy obvious, Judah accused Tamar of prostitution and ordered her to be burned to death. Tamar then sent Judah the staff, seal, and cord he had given her, declaring that their owner was the father of her child. Judah recognized the items as his own and released Tamar from her sentence.

Bassano has set the scene in an open space defined by architectural details that hint at a city square, in the middle of which burns an impressive fire, clearly the central character. The flames dissolve in a gray pillar of smoke, dividing the scene in two. On the right, three soldiers push Tamar toward the site of her execution as a crowd looks on. On the left, Judah stands in profile, receiving the staff, seal, and cord from a young boy. The gesture of Judah's left hand indicates his acknowledgment of responsibility and of Tamar's innocence. The painting reveals an extraordinary mastery of pictorial technique and virtuosity in the naturalistic representation of the fire as well as the play of light on the boy's clothes, on the foamy whites of Tamar's veil, and on the soldier's chain mail and armor. The depiction of the bystanders is incisive: their faces, vaguely outlined with brief strokes of color, are picked out from their surroundings by a shaft of light that travels across the composition from left to right. The two male figures conversing in the background, sketched simply over a vast blue sky, represent a masterpiece of impressionistic rendering.

The story of Tamar is rare in sixteenth-century Italian art; it was far more common in the Netherlands, and an engraving by Maerten van Heemskerck (1498–1574) was Bassano's likely source of inspiration. The oval composition suggests that the painting was meant for a specific place, possibly a room with decorative woodwork or a fanlight window. This, in combination with the rarity of the subject, leads us to assume that it was a commission from an as yet unidentified patron.

During the 1560s, the decade in which *Tamar* was created, Bassano's pastoral paintings developed more complex and specific themes. The painter's success with such compositions prompted an intense collaboration with his son Francesco, who played a significant role in the workshop's production. In 1578 Francesco opened a Bassano workshop in Venice; he was later assisted by his brother Leandro. With the Bassano del Grappa studio now overseen by his sons Giambattista and Gerolamo, Bassano could focus on attracting commissions and supervising his enterprises. Yet he never stopped experimenting with his craft, taking color to its extreme under the dramatic influence of light. According to Ridolfi, at the end of his life, the painter poignantly declared that he would not regret that he must die, if not for the fact that he could learn no more, "for I am only at this hour beginning to understand the good of painting."

— *Francesca Del Torre Scheuch*

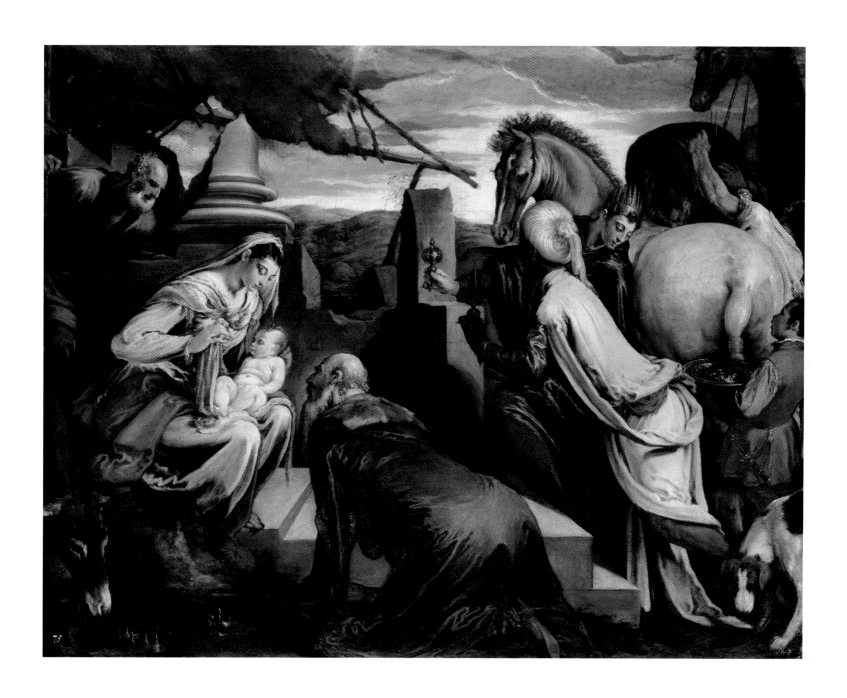

44　Jacopo da Ponte, called Jacopo Bassano (1510/1512–1592)
　　Adoration of the Magi, ca. 1563–1564
　　Oil on canvas
　　36⅜ x 46¼ in. (92.3 x 117.5 cm)

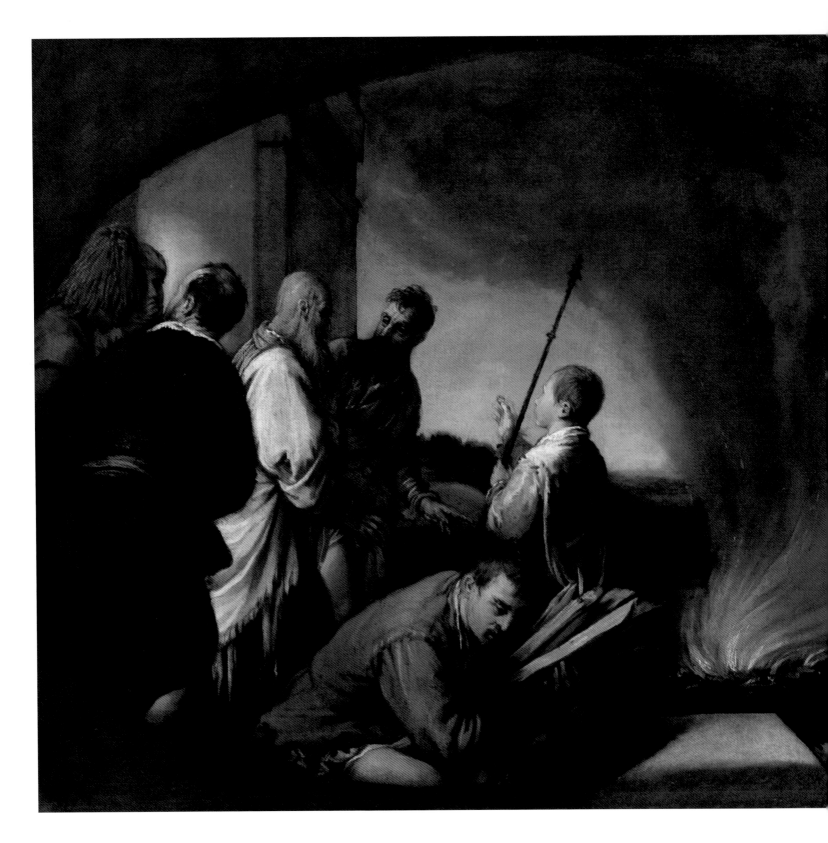

45　Jacopo da Ponte, called Jacopo Bassano (1510/1512–1592)
Tamar Led to the Pyre, ca. 1566–1567
Oil on canvas
21⅝ x 45⅝ in. (55 x 116 cm)

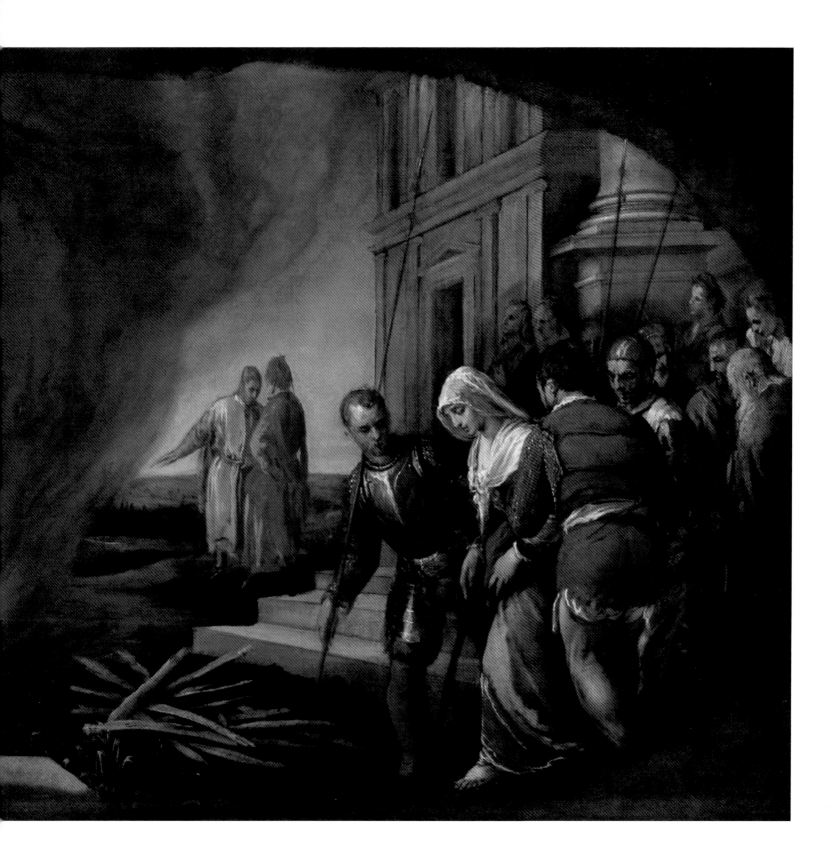

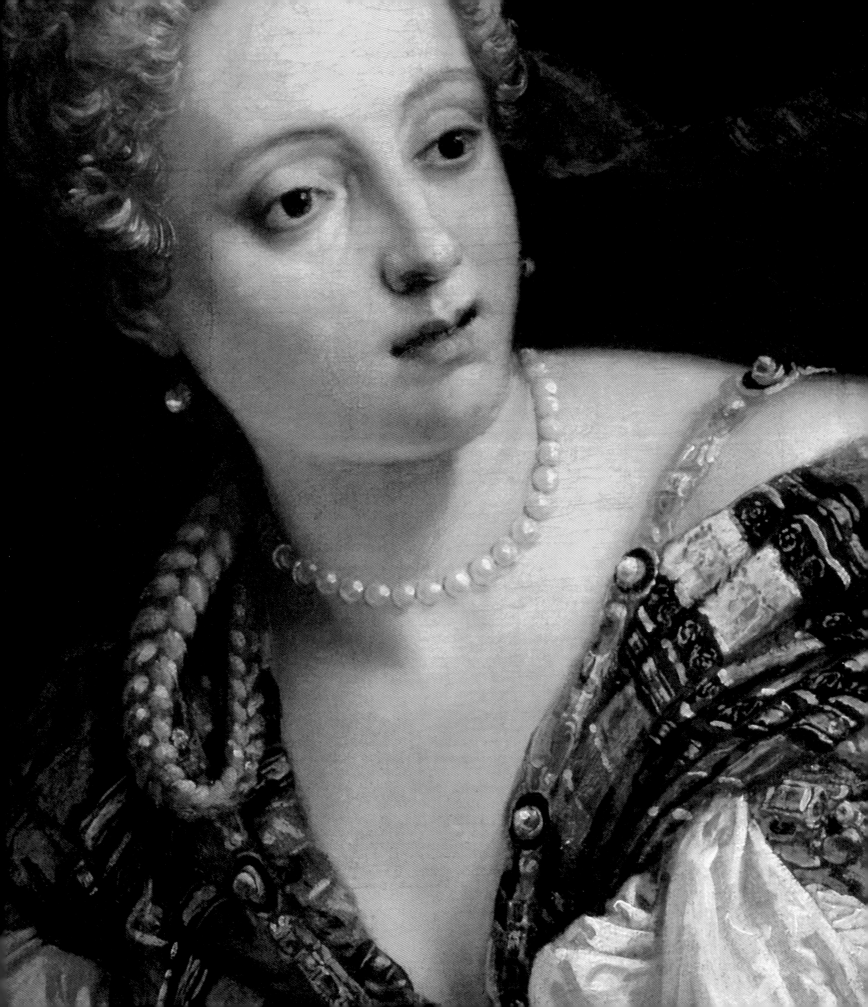

Veronese

The paintings of Paolo Caliari, known as Veronese (1528–1588), are the embodiment of the Venetian sense of spectacle. With shimmering, decorative color, Veronese wove expansive, tapestry-like compositions of great visual excitement that often sacrifice narrative or religious intensity for gorgeous pageantry and exquisite sensation. Steeped in the divergent styles then operative in Italian artistic centers, Veronese combined elements of solid Tuscan and Roman classicism with the artifice of Mannerism, all the while exploiting the flashy potential of the relatively new oil-on-canvas medium. Terisio Pignatti, a scholar who has eloquently documented Veronese's career, described the optical impact of his technique as an "explosion of light, a butterfly-fluttering of iridescent reflections that make solid forms appear almost weightless." This peerless command of the brush wielding dazzling color, coupled with Veronese's ability to synthesize different modes of representation into a personal vocabulary of daring opulence, assured his place alongside Titian (ca. 1488–1576) and Tintoretto (1519–1594) in Venice's sixteenth-century artistic triumvirate.

Veronese's career began in the 1540s in his native Verona, where he trained with several minor sixteenth-century artists, including Antonio Badile IV (1518–1560), his future father-in-law. These artists were conservative painters, whose modernity consisted of grafting motifs from innovators such as Giulio Romano (1499–1546) and Raphael (1483–1520) onto their own retardataire style, and they had no lasting effect on Veronese. But also active in the city were adherents to the *maniera* then fashionable in nearby Mantua and Padua and, of course, in the more distant Florence and Rome. This consciously artificial style, seeking to create both beautiful surface designs and startling spatial effects at the expense of realism, held a natural attraction for the young Veronese. Working together with contemporaries of like artistic temperament, including Paolo Farinati (1524–1606) and Giovanni Battista Zelotti (ca. 1526–1578), Veronese participated in numerous local projects, building his own reputation as a skilled innovator.

Celebrated early paintings include *Christ Revives the Daughter of Jairus* of 1546 for the Cappella degli Avanzi in Verona's church of San Bernardino. The *modello* (Musée du Louvre, Paris) for that lost canvas already exhibits a verve for color, light, and staging consistent with Veronese's mature works. Also in evidence are design calculations that adjust the compositional arrangement and pictorial space to take into account the viewer's actual vantage point: in this case Veronese's large painting was positioned above eye level and experienced obliquely. This negotiation between the physical world of the spectator, who stands in a specific architectural setting, and the fictional painted world, which seemingly expands beyond the wall, occupied Veronese throughout his career.

Artistic precedents exploring such viewer-object relational challenges were close at hand. Before he reached Venice, Veronese had absorbed the lessons of spatial illusionism as handled in groundbreaking fashion in the fresco cycles of Andrea Mantegna (1430/1431–1506) for the Palazzo Ducale, Mantua, and the Ovetari Chapel, church of the Eremitani, Padua; of Giulio Romano

(1499–1546) for the Palazzo del Te, Mantua; and of Correggio (ca. 1489–1534) for San Giovanni Evangelista, Parma. The Mannerist idiom of Parmigianino (1503–1540) was also known to Veronese through paintings in public locations, such as the frescoes in Santa Maria della Steccata, Parma, and through the intimate medium of drawings, specifically an album of sketches belonging to Verona collectors Cristoforo and Francesco Muselli. Thus Veronese was well prepared for the artistic challenge when he received his first state commission in Venice in 1553. The collaborative project, decorating the ceiling of the sumptuous Sala del Consiglio dei Dieci in the Palazzo Ducale, provided Veronese with an opportunity to display his many talents. His contributions, including a depiction of *Youth and Old Age*, announced a mastery of complex foreshortening, beautiful Michelangelesque form, and perfectly tempered light and color, creating an ideal world above and beyond the viewer's own space. Now permanently established in Venice, Veronese embarked on a meteoric career.

From this early Venetian period dates Vienna's *Anointing of David* (pl. 46). Based on the Bible (1 Samuel 16:1–13), the scene depicts the ritual signifying that David, the young shepherd, had been chosen by God over all others to be king of Israel. This Old Testament episode prefigures Christ's baptism in the New Testament. The painting's provenance can be tracked since the early seventeenth century; recorded in the inventories of Charles de Croy, Duke of Arschot (Schloss Beaumont, Hennegau, Germany), and George Villiers, first Duke of Buckingham, the work first appeared in the inventory of the Habsburg imperial collection in Prague in 1718. Recently restored, it exhibits the figural elegance and coloristic splendor that are hallmarks of Veronese's style. The shallow, stagelike arrangement of the players close to the pictorial surface enhances their sculptural quality, and our attention is pulled in and out of the composition by the drapery rhythms. Conversely, draperies realized in luscious burnished hues of cantaloupe and persimmon seem to dance across the composition, animated by the figural choreography and accentuated by the highlights applied freely with the brush. Few figures in Western art create such a suave arabesque as the woman on the right; seen from behind, her decorative stance is so appealingly graceful we willingly accept her impossible proportions. Simply put, such artifice in the service of beauty is visually seductive. Tucked within the shadows are other faces and details of considerable charm, including the beautifully rendered silhouetted head of a bull. With grand proportions and refined theatricality, this painting manifests the Venetian taste for opulence. It also exemplifies the alternative inflection that Veronese, the sublime colorist, offered in contrast to the more moody and militantly Mannerist style of his rival Tintoretto.

From this date forward, Veronese attracted wealthy and powerful patrons from church and state, from civic organizations and private individuals in Venice and beyond. A sequence of brilliant altarpieces, ceiling paintings, portraits, and fresco cycles followed; in typically Venetian fashion, many were, considering the sheer surface area to be covered, vast undertakings. Significant projects include

his 1557 collaboration on the decoration of the magnificent Libreria Marciana (Library of San Marco), newly constructed directly opposite the Palazzo Ducale. The commission-turned-competition, judged by architect Jacopo Sansovino and Titian, won Veronese a gold chain for his winning contribution. Several additional projects engaged the artist for extended periods, such as the ceiling paintings for the church of San Sebastiano, which spanned the 1550s and 1560s.

One of Veronese's great accomplishments, and indeed one of the greatest monuments of the sixteenth century, is the incomparable landscape and figurative frescoes executed for Daniele and Marc'Antonio Barbaro in their country residence, the Villa Barbaro (now Villa Volpi), in the Veneto near Treviso. Here, playing off the architecture of Andrea Palladio, Veronese crafted a coordinated thematic program. With sophisticated wit and visual delight, his illusionistic designs fill, complement, and expand the actual spaces in a manner akin to ancient villa decoration.

But certainly the name Veronese is now synonymous with a suite of enormous canvases representing biblical banquet scenes. *The Wedding Feast at Cana* (Louvre), begun in 1562–1563 and painted for the refectory in Palladio's San Giorgio Maggiore, initiated the series. During the 1560s, Veronese produced several monumental compositions — *The Feast in the House of Levi* (Gallerie dell'Accademia, Venice) measures some eighteen by forty-two feet — that integrate scenographic architectural settings with a host of figures. In each work the few characters central to the biblical narrative are joined by a large cast of supernumeraries, not unlike the staging of a grand opera production.

Demand, as well as Veronese's natural propensity to work on an expansive scale, necessitated a large workshop. And as was common at the time, the studio became a commercial enterprise dominated by members of Veronese's extended family: his brother Benedetto and eventually his sons Carlo and Gabriele, among others. Even after Veronese's death, the workshop continued to execute commissions, most likely relying on his preparatory designs, at times signing works *Haeredes Pauli* (heirs of Paolo Caliari Veronese).

Veronese's fame brought commissions from distant princes, including the Habsburg emperor Rudolf II in Prague and the eighteen-year-old Carlo Emanuele I, recently named the duke of Savoy. For the latter's court in Turin, Veronese designed a suite of four enormous paintings featuring Old Testament subjects. Inexplainably, by 1635 the murals had been separated and today only two — portraying Solomon and Sheba and the finding of Moses — survive (Galleria Sabauda, Turin), while the other two, of David and Goliath and Judith and Holofernes, are only known through small *modelli* (Royal Collection, Hampton Court Palace, Surrey).

This project, unlike so many works in Veronese's long career, can be securely dated to autumn 1582, because initial ideas for the latter two compositions were drawn on a letter dated September 18, 1582. This sheet of animated sketches (National Gallery of Art, Washington) records Veronese's quickly evolving thoughts for the figural unit of Judith and her maid, who receives the severed head

of Holofernes. The calligraphic beauty of the drawing underscores Veronese's skill with a nervous but spirited penmanship, augmented by form-defining washes that alight delicately across the paper or pool to suggest deep shadow. This technique is particularly well suited to the nighttime setting of the Judith narrative.

It is to the now-dispersed Turin project that the Vienna *Judith with the Head of Holofernes* (pl. 47) has been thought to relate. Until recently it had been assumed that the canvas was significantly cut down and that its dimensions once matched those of the Turin pictures. However, it is not possible to determine reliably if this is the case. Several other paintings (now presumably lost) representing Judith and Holofernes were recorded in early seventeenth-century collections, any of which could refer to the Vienna picture, including a version with half-length figures that belonged to Veronese's nephew Giuseppe Caliari. Regardless, the Vienna composition parallels Veronese's reworking of the Judith figural group in the Washington drawing. Today the image, with its tightly cropped figures, exudes simmering emotions heightened by the requisite nocturnal lighting.

The *Judith* in Vienna's collection is complemented by another Veronese depiction of ancient feminine heroism, *Lucretia* (pl. 48), also datable to the early 1580s. Both paintings appear in the 1659 inventory of Archduke Leopold Wilhelm, although by what route they came to the Habsburg collection is unknown. As told in ancient texts—including *Ab urbe condita* (*The History of Rome*) by the historian Livy, who lived in Rome at the time of said events—the story of Lucretia recounts the incidents that precipitated the revolt leading to the founding of the Republic of Rome. A tale of seduction and death in the name of honor, the subject was a favorite of European artists. Veronese strips down the narrative to its most basic component: the dishonored heroine. But rather than emphasizing the blade with which she commits suicide, the artist diverts our attention to the creamy skin of a bared shoulder, blond tresses, luminous jewels, and most particularly the gorgeous patterns and textures of the fabrics that monopolize more than half the pictorial surface. The overall sunny tonality of Veronese's earlier compositions is darkened here and in other works from his later years, as he experimented with the emotional possibilities of a deeper chiaroscuro. Nonetheless, in *Lucretia*, Pignatti's "butterfly-fluttering of iridescent reflections" is given full voice, glistening at the heart of tragedy.

Two late mythological paintings now in Vienna suggest the growing taste among sixteenth-century collectors for works of delectable size and subject matter. Veronese's *Hercules, Deianira, and the Centaur Nessus* (pl. 49) and *Venus and Adonis* (pl. 50) are renderings of the amorous exploits of the gods as related in Ovid's *Metamorphoses*. Of almost identical dimensions, the two small easel paintings are perfectly sized for a connoisseur's private delectation. Both share the same provenance and are documented from the early seventeenth century. Cited together in the holdings of the Venetian collector Bartolomeo della Nave, they then passed to Basil, Viscount Fielding—the English ambassador to Venice who also

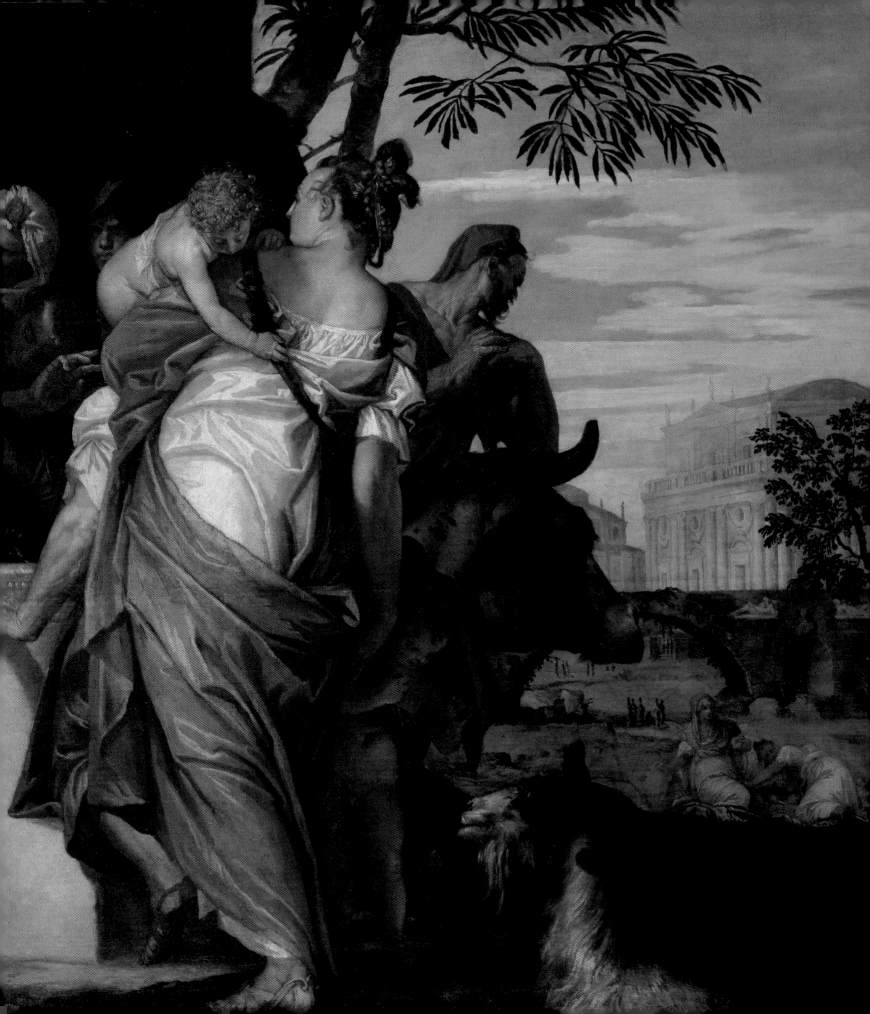

acted as agent for his brother-in-law, the voracious collector James, the third Marquess (later Duke) of Hamilton—before appearing in the 1659 inventory of Leopold Wilhelm's collection.

Following Ovid, and suggesting Veronese's renewed interest in landscape painting, the Hercules narrative is set in a tapestry-like landscape of feathery trees. The actors probe the limits of the pictorial space: Hercules strides toward the viewer, while the centaur Nessus charges into the distance with Hercules's wife Deianira struggling in his arms. The setting and violent nature of the story are at variance with the other work, an erotic painting depicting fabled lovers. Also staged in a landscape, *Venus and Adonis* is dominated by the entwined figures and billowing drapery; a dancing light caresses both. The unguarded exchange of glances and embrace convey a delicious moment that keeps the hunter Adonis from his destiny with death. In the same way that Venus holds him to her, the artist mesmerizes us with passages of luminous skin and light-catching silken fabrics that cast shimmering reflections.

Veronese's ability to entice the viewer to linger over his painted surfaces for the pure sensual pleasure of the decorative color and brushwork is the eternal appeal of his art. His biographers recognized the strengths of his distinctive voice, praising his commanding control of form and perspective and his incomparable mastery of color. It is no wonder that the paintings of Veronese grace the most important spaces of sixteenth-century Venice; found in the staterooms, churches, and palaces of La Serenissima, his sweeping canvases ultimately celebrate the beauty of the physical world.

—*Lynn Federle Orr*

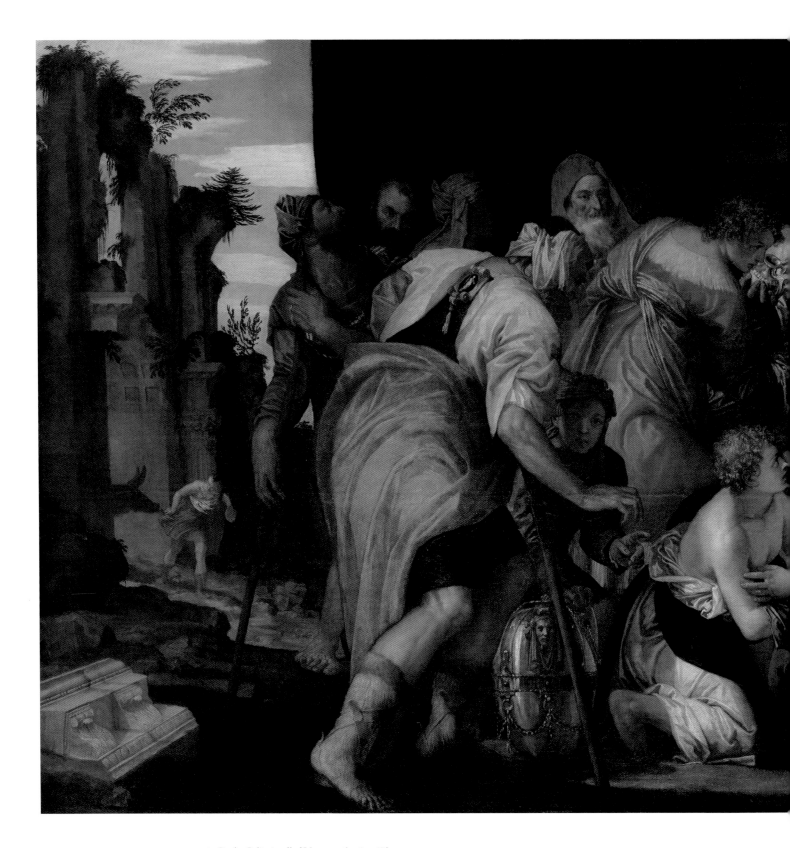

46 Paolo Caliari, called Veronese (1528–1588)
The Anointing of David, ca. 1555
Oil on canvas
68⅛ x 143 in. (173 x 364 cm)

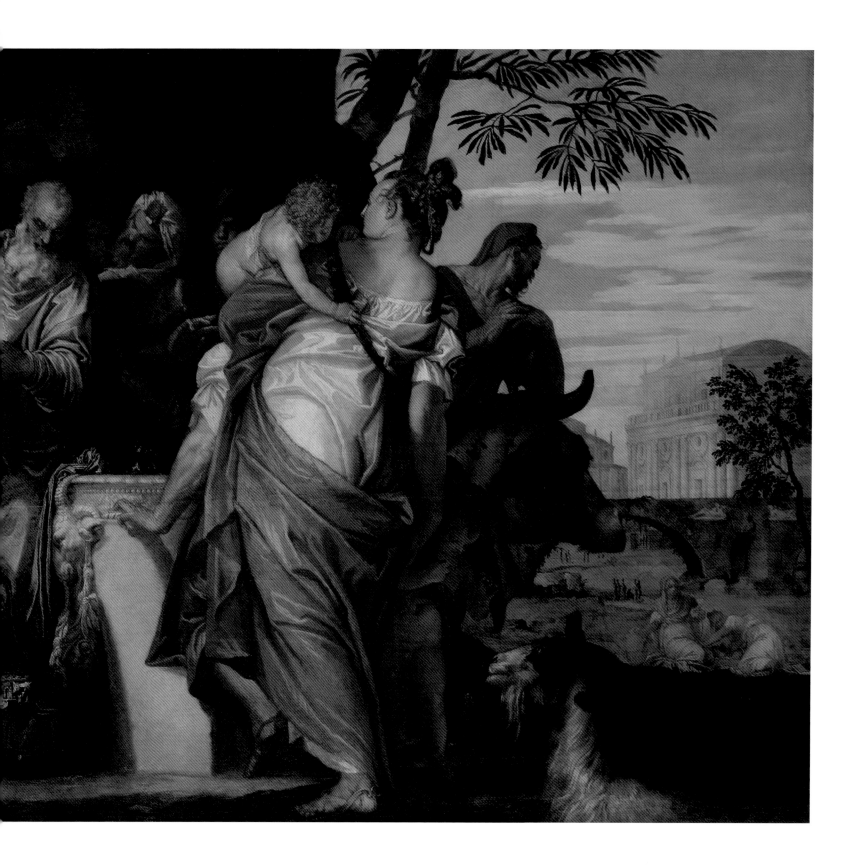

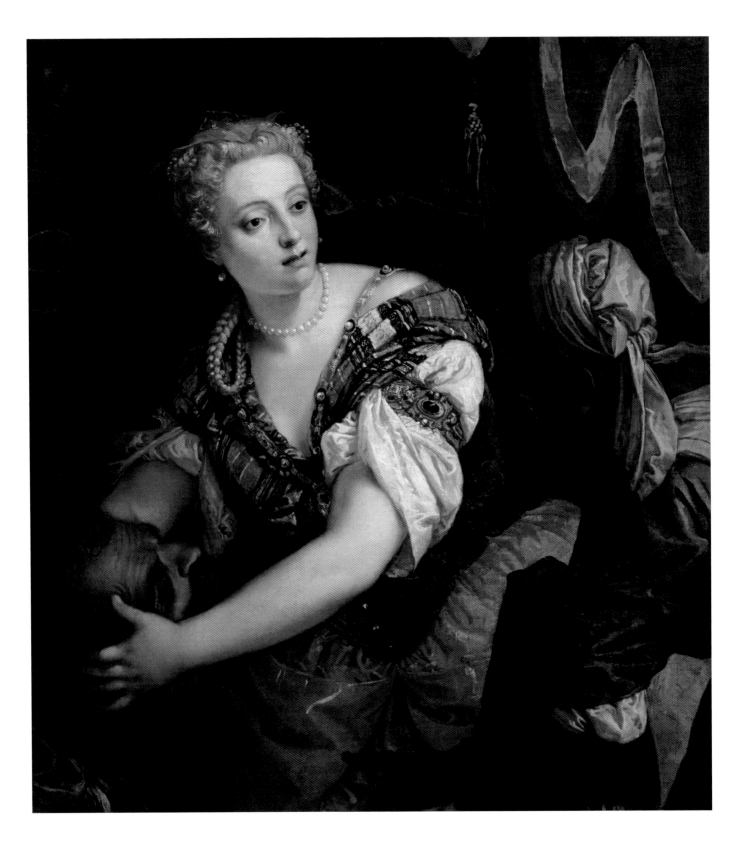

47 Paolo Caliari, called Veronese (1528–1588)
Judith with the Head of Holofernes, ca. 1580
Oil on canvas
43¾ x 39⅝ in. (111 x 100.5 cm)

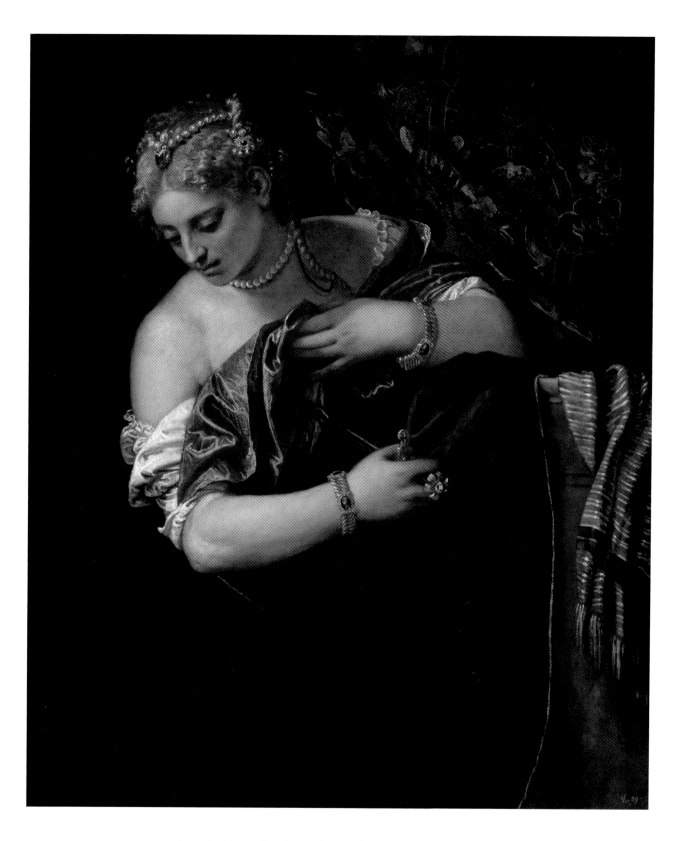

48 Paolo Caliari, called Veronese (1528–1588)
Lucretia, ca. 1580–1583
Oil on canvas
42⅞ x 35⅝ in. (109 x 90.5 cm)

49 Paolo Caliari, called Veronese (1528–1588)
Hercules, Deianira, and the Centaur Nessus, ca. 1586
Oil on canvas
26¾ x 20⅞ in. (68 x 53 cm)

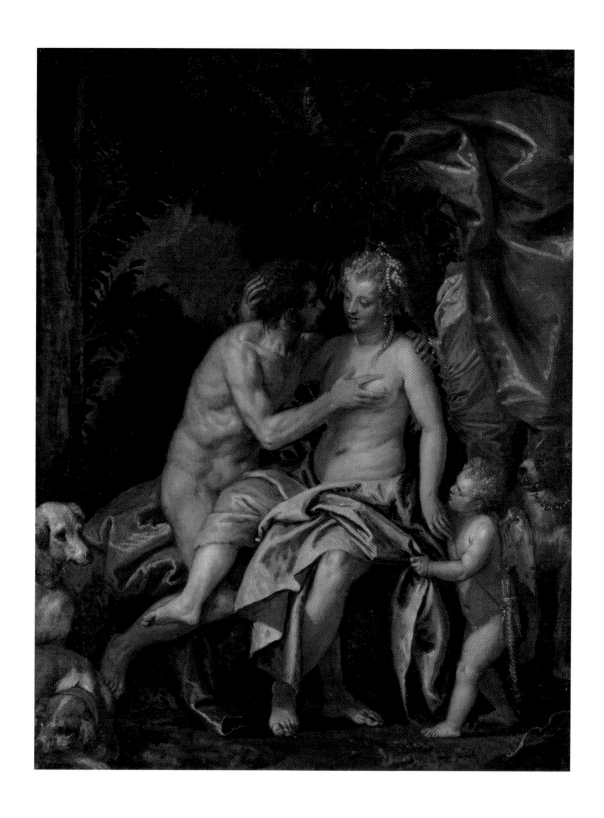

50 Paolo Caliari, called Veronese (1528–1588)
 Venus and Adonis, ca. 1586
 Oil on canvas
 26¾ x 20½ in. (68 x 52 cm)

Suggested Further Reading

COMPILED BY MELISSA BURON

Ames-Lewis, Francis, ed. *New Interpretations of Venetian Renaissance Painting*. London: Birkbeck College, University of London, 1994.

Anderson, Jaynie. *Giorgione: The Painter of "Poetic Brevity."* Paris: Flammarion, 1997.

Bischoff, Cäcilia. *Kunsthistorisches Museum: History, Architecture, Decoration*. Vienna: Kunsthistorisches Museum / Christian Brandstatter Verlag, 2010.

——. *Masterpieces of the Picture Gallery*. Vienna: Kunsthistorisches Museum, 2006.

Bowron, Edgar Peters, ed. *Titian and the Golden Age of Venetian Painting*. Atlanta: High Museum of Art; Minneapolis: Minneapolis Institute of Arts; Houston: Museum of Fine Arts, Houston; in collaboration with the National Galleries of Scotland, Edinburgh, 2010.

Brown, Beverly Louise, and Paola Marini, eds. *Jacopo Bassano ca. 1510–1592*. Fort Worth, TX: Kimbell Art Museum, 1993.

Brown, David Alan, Sylvia Ferino-Pagden, et al. *Bellini, Giorgione, Titian, and the Renaissance of Venetian Painting*. Washington, DC: National Gallery of Art; Vienna: Kunsthistorisches Museum, 2006.

Brown, Patricia Fortini. *Art and Life in Renaissance Venice*. New York: Harry N. Abrams, 1997.

——. *Private Lives in Renaissance Venice: Art, Architecture, and the Family*. New Haven, CT: Yale University Press, 2004.

Carboni, Stefano, ed. *Venice and the Islamic World, 828–1797*. New York: Metropolitan Museum of Art, 2007.

Chambers, David, and Brian Pullan, eds. *Venice: A Documentary History, 1430–1630*. Oxford: Blackwell, 1992.

Cooper, Tracy E. *Palladio's Venice: Architecture and Society in a Renaissance Republic*. New Haven, CT: Yale University Press, 2005.

Dal Pozzolo, Enrico Maria. *Giorgione*. Milan: 24 ORE Cultura, 2009.

Dunkerton, Jill, Susan Foister, Dillian Gordon, and Nicholas Penny. *Giotto to Dürer: Early Renaissance Painting in the National Gallery*. London: National Gallery, 1991.

Dunkerton, Jill, Susan Foister, and Nicholas Penny. *Dürer to Veronese: Sixteenth-Century Paintings in the National Gallery*. London: National Gallery, 1999.

Fenlon, Iain. *The Ceremonial City: History, Memory and Myth in Renaissance Venice*. New Haven, CT: Yale University Press, 2007.

Ferino-Pagden, Sylvia, et al. *Giorgione: Myth and Enigma*. Milan: Skira, 2004.

Ferino-Pagden, Sylvia, and Giovanna Nepi Sciré. *Late Titian and the Sensuality of Painting*. Venice: Marsilio, 2008.

Freedberg, Sydney. *Painting in Italy: 1500–1600*. 3rd ed. New Haven, CT: Yale University Press, 1993.

Garton, John. *Grace and Grandeur: The Portraiture of Paolo Veronese*. London: Harvey Miller, 2008.

Gentili, Augusto, Giandomenico Romanelli, Philip Rylands, and Giovanna Nepi Sciré. *Paintings in Venice*. Boston: Bulfinch Press, 2002.

Goffen, Rona. *Renaissance Rivals: Michelangelo, Leonardo, Raphael, Titian*. New Haven, CT: Yale University Press, 2002.

Goy, Richard J. *Building Renaissance Venice: Patrons, Architects, and Builders, ca. 1430–1500*. New Haven, CT: Yale University Press, 2006.

Hope, Charle. *Titian*. New York: Harper and Row, 1980.

Hope, Charles, Jennifer Fletcher, Jill Dunkerton, and Miguel Falomir. *Titian*. Edited by David Jaffé. London: National Gallery, 2003.

Humfrey, Peter. *The Altarpiece in Renaissance Venice*. New Haven, CT: Yale University Press, 1993.

——. *Painting in Renaissance Venice*. New Haven, CT: Yale University Press, 1995.

——. *Titian*. London: Phaidon, 2007.

——, ed. *Venice and the Veneto*. New York: Cambridge University Press, 2007.

Huse, Norbert, and Wolfgang Wolters. *The Art of Renaissance Venice: Architecture, Sculpture, and Painting, 1460–1590*. Translated by Edmund Jephcott. Chicago: University of Chicago Press, 1990.

Ilchman, Frederick. *Titian, Tintoretto, Veronese: Rivals in Renaissance Venice.* Boston: MFA Publications, 2009.

Kennedy, Ian G. *Titian*. Cologne: Taschen, 2006.

Krischel, Roland. *Jacopo Tintoretto, 1519–1594*. Cologne: Könemann, 2000.

Martineau, Jane, ed. *Andrea Mantegna*. New York: Metropolitan Museum of Art, 1992.

Pedrocco, Filippo. *The Art of Venice: From Its Origins to 1797*. New York: Riverside, 2002.

Pignatti, Terisio, and Filippo Pedrocco. *Veronese*. 2 vols. Milan: Electa, 1995.

Rearick, William R. *The Art of Paolo Veronese, 1528–1588*. Washington, DC: National Gallery of Art, 1988.

Ridolfi, Carlo. *The Life of Tintoretto, and of His Children Domenico and Marietta*. Translated by Catherine Enggass and Robert Enggass. University Park: Pennsylvania State University Press, 1984.

———. *The Life of Titian*. Translated by Julia Conaway Bondanella and Peter E. Bondanella. University Park: Pennsylvania State University Press, 1996.

Romanelli, Giandomenico, and Claudio Strinati. *Veronese: Gods, Heroes, and Allegories*. Milan: Skira, 2004.

Rosand, David. *Painting in Sixteenth-Century Venice: Titian, Veronese, Tintoretto*. Rev. ed. Cambridge: Cambridge University Press, 1997.

Rylands, Philip. *Palma Vecchio*. Cambridge: Cambridge University Press, 1992.

Salomon, Xavier F. *Veronese's Allegories: Virtue, Love, and Exploration in Renaissance Venice*. New York: Frick Collection, 2006.

Segre, Renata. "A Rare Document on Giorgione." *Burlington Magazine* 153, no. 1299 (June 2011): 383–386.

Vasari, Giorgio. *The Lives of the Artists*. Translated by Julia Conaway Bondanella and Peter E. Bondanella. Oxford: Oxford University Press, 1991.

Villers, Caroline. *The Fabric of Images: European Paintings on Textile Supports in the Fourteenth and Fifteenth Centuries*. London: Archetype Publications, 2000.

Wethey, Harold E. *The Paintings of Titian: Complete Edition*. 3 vols. London: Phaidon, 1969–1975.

Index

Page numbers in **boldface** refer to showcased artists. Page numbers in *italics* refer to illustrations.

Published by the Fine Arts Museums of San Francisco and
DelMonico Books • Prestel, on the occasion of the exhibition
Masters of Venice: Renaissance Painters of Passion and Power.

de Young Museum, San Francisco
October 29, 2011–February 12, 2012

This exhibition is organized by the Fine Arts Museums of San Francisco in
collaboration with the Gemäldegalerie of the Kunsthistorisches Museum, Vienna.

MAJOR PATRONS
Penny and James George Coulter
San Francisco Auxiliary of the Fine Arts Museums

PATRONS
Athena and Timothy Blackburn
William G. Irwin Charity Foundation

SPONSORS
T. Robert and Katherine Burke
Samuel H. Kress Foundation
Mrs. James K. McWilliams
Greta R. Pofcher

Education programs presented in conjunction with the exhibition are sponsored by
Wells Fargo and the S. D. Bechtel, Jr. Foundation.

This exhibition is supported by an indemnity from the Federal Council on the
Arts and the Humanities.

Unless otherwise noted below or in captions, all artworks reproduced in this
catalogue are from the collection of the Gemäldegalerie of the Kunsthistorisches
Museum, Vienna; photography © the Kunsthistorisches Museum, Vienna. Figs. 5,
9, 17: Scala / Art Resource, NY; fig. 8: Erich Lessing / Art Resource, NY; figs. 11,
12: Cameraphoto Arte, Venice / Art Resource, NY; fig. 18: Réunion des Musées
Nationaux / Art Resource, NY; fig. 19: bpk, Berlin / Gemäldegalerie Alte Meister,
Dresden / Hans-Peter Klut / Art Resource, NY.

Library of Congress Cataloging-in-Publication Data
Masters of Venice : Renaissance painters of passion and power from the
Kunsthistorisches Museum, Vienna / edited by Sylvia Ferino-Pagden and
Lynn Federle Orr.
 p. cm.
 Issued in connection with an exhibition held Oct. 29, 2011–Feb. 12, 2012,
de Young Museum, San Francisco.
 Includes bibliographical references and index.
ISBN 978-3-7913-5168-1
 1. Painting, Italian—Italy—Venice—Exhibitions. 2. Painting, Renaissance—
Italy—Venice—Exhibitions. 3. Painting—Austria—Vienna—Exhibitions.
4. Kunsthistorisches Museum Wien—Exhibitions. I. Ferino-Pagden, Sylvia.
II. Orr, Lynn Federle, 1947– III. M. H. de Young Memorial Museum.
IV. Fine Arts Museums of San Francisco.
 ND621.V5M28 2011
 759.03—dc23
 2011027623

Fine Arts Museums of San Francisco
Golden Gate Park
50 Hagiwara Tea Garden Drive
San Francisco, CA 94118-4502
www.famsf.org

Karen A. Levine, Director of Publications
Leslie Dutcher, Managing Editor

Edited by Jennifer Boynton
Translations by Chris De Angelis
Proofread by Carrie Wicks
Index by Susan G. Burke
Designed and typeset by Katy Homans
Separations by Robert F. Hennessey
Production management by Karen Farquhar
Printed and bound in China by C&C Offset Printing Co., Ltd.

DelMonico Books is an imprint of Prestel, a member of Verlagsgruppe Random
House GmbH

Prestel Verlag	Prestel Publishing Ltd.	Prestel Publishing
Neumarkter Strasse 28	4 Bloomsbury Place	900 Broadway, Suite 603
81673 Munich	London WC1A 2QA	New York, NY 10003
Germany	United Kingdom	TEL: 212 995 2720
TEL: 49 89 4136 0	TEL: 44 20 7323 5004	FAX: 212 995 2733
FAX: 49 89 4136 3466	FAX: 44 20 7636 8004	E-MAIL: sales@prestel-usa.com
www.prestel.de		www.prestel.com